THE MEMORY OF WATER

THE MEMORY OF WATER

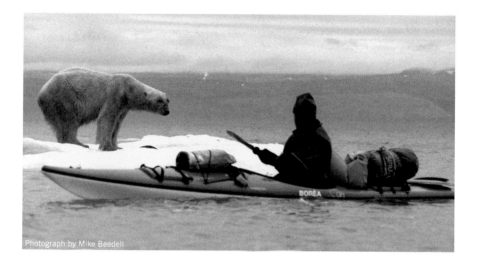

Photograph by Mike Beedell

ALLEN SMUTYLO

WILFRID LAURIER
UNIVERSITY PRESS

Wilfrid Laurier University Press acknowledges the financial support of the Government of Canada through the Canada Book Fund for our publishing activities.

Canada Council Conseil des Arts ONTARIO ARTS COUNCIL
for the Arts du Canada CONSEIL DES ARTS DE L'ONTARIO

Library and Archives Canada Cataloguing in Publication

Smutylo, Allen, 1946–
 The memory of water / Allen Smutylo.

(Life writing series)
Issued also in electronic format.
ISBN 978-1-55458-842-8

 1. Smutylo, Allen, 1946– —Travel. 2. Water and civilization. 3. Animal–water relationships. I. Title.
II. Series: Life writing series

ND249.S624A2 2013 709.2 C2012-907172-2

Electronic monograph in multiple formats.
Issued also in print format.
ISBN 978-1-55458-876-3 (PDF).—ISBN 978-1-55458-877-0 (EPUB)

 1. Smutylo, Allen, 1946– —Travel. 2. Water and civilization. 3. Animal–water relationships. I. Title.
II. Series: Life writing series (Online)

ND249.S624A2 2013 709.2 C2012-907173-0

Published by Wilfrid Laurier University Press
Waterloo, Ontario, Canada
www.wlupress.wlu.ca

Cover design by: Sandra Friesen. Front cover image: *Greenland Passage* by Allen Smutylo; oil on canvas, 21" x 54", 1991. Back cover image: *Northern Coast – Greenland #2* by Allen Smutylo; etching, 12" x 18", 1990. Text design by Daiva Villa, Chris Rowat Design.

This book is printed on FSC recycled paper and is certified Ecologo. It is made from 100% post-consumer fibre, processed chlorine free, and manufactured using biogas energy.

Printed in Canada

Every reasonable effort has been made to acquire permission for copyright material used in this text, and to acknowledge all such indebtedness accurately. Any errors and omissions called to the publisher's attention will be corrected in future printings.

To Paul and Casey

CONTENTS

ACKNOWLEDGEMENTS

Bringing these stories and images together in a thoughtful and cohesive book benefited from the caring, the suggestions, and the editing of Catherine Marjoribanks, Lori Ledingham, Hazel and Andre Lyder, Tom Smart, Gayle Fairchild, Stacey Spiegel, Terry Smutylo, and the staff of Wilfrid Laurier Press, particularly acquisitions editor Lisa Quinn. And I am very grateful for the considerable support offered this publication by Peter and Noreen Little and David and Grace Black. Also to the Mira Godard Gallery, Circle Arts, and Thielsen Gallery, for their ongoing and generous help.

This book covers a good chunk of my adult life. In this matter I feel incredibly fortunate, being able to live a creative life (for lack of a better phrase). Expressing oneself is one thing, but being able to do so as one's livelihood is something else again. Such a pursuit can happen only with the interest, encouragement, and support of friends, family, and a whole host of other people. Individually acknowledging such a list of people is a bit foolhardy, given the many deserving people who would inadvertently be omitted, considering the time span.

Nonetheless, added to the names above, I would like to give deep thanks to Sandra Whitehead, Marty Rosen, Sandra and Rob May, Ben Goedhart, Martin Kimble, Peter Oliver, Gale and Jane Jensen, Fab and Virginia Vatri, Dr. George and Dawn Harper, Jim and Fran McArthur, Gilles Couet, Susan Sparks, Ann Smutylo, Gary and Rose McKay, Paul Stott, Dr. Gord and Linda Edwards, David and Leslie Bloom, Steve

Lee, Stephen Hogbin, Don Kerr, Eve Baxter, Mike Graney, Mark and Shiva Herman, Bob Turbitt, Mark Kelner, Mike Beedell, Geoff Green, Jean Lemire, Pete and Nora Dean, Michelle Gillette, Giles Ardiel, John Gibson, David L'Heureux, Doug and Diane Heal, Ms. D. Favor, John Francis, Gordon Robinson, David and Marilyn Conklin, Sandra and Andrew Goss, Larry and Sally Luoma, Willy Waterton, Audrey Armstrong, Tom Thomson Art Gallery, Rick and Carol Herman, John and Nancy Deputter, Laurie Adams, Ann and Roly Fenwick, Mary Jane and Winston Young, Dr. Gord and Lindsay Taylor, Tom and Wendy Frisch, Kent and Joni Rathwell, Mike and Brenda Snow, Dr. Gordon and Carol Schacter, Olaf and Mary Catherine Clancy, Dr. David Driman, Ian and Jan Gibson, Dr. Marnie McArthur, Joan and Torben Hawksbridge, John and Sampa Martin, David and Phyllis Lovell, Audrey Cheadle, Edith Galloway, Jim Halliday, Peter Harrison, John and Helen Harrison, Lauriel Moore, John Newton, Dick and Carol Capling, Jacques Thibault, Giles Ardiel, Rob and Mim O'Dowda, Albert and Gloria Smith, Kerry Lackie, Joan McCracknell, Ruth Ann English, Michelle and Jeff Sziklai, Doug and Harriet Grace, Dr. Ewan and Cynthia Porter, Jan and Peter Middleton, Carol and John Rothwell, Ken and Judy Thomson, and Stana and Lachlan Oddie. And also to the scores of other supportive people in Tobermory, Owen Sound, Toronto, Big Bay, London, the Arctic, Maui, Greenland, Ladakh, Delhi, Varanasi, and places in between: please forgive the incompleteness of this list.

INTRODUCTION

The seas are the heart's blood of the earth. Plucked up and kneaded by the sun and moon, the tides are the systole and diastole of its veins.
—Carl Sandberg

The stories in this book are autobiographical, and they took place between 1970 and 2010. Some are written from diary entries and notations made at the time or shortly thereafter. Others I wrote from memory. Given the forty-year time span, they are an idiosyncratic mix, with aspects of memoir, storytelling, ethnology, adventure, environmentalism, religion, travel, and art. Underlying all ten stories, sometimes obliquely but more often directly, is the presence of water. After assembling this book it occurred to me that water not only connected the writing and artwork, but, like a diviner's dowsing rod, seems to have directed much of my life's course.

⚬∿

When the Earth was first photographed from outer space it recalibrated my, and probably everyone's, perceptions of our planet. Floating in vast nothingness, we lived in a home wrapped in water. The images of this little, pale-blue jewel helped prompt the distinguished scientist James Lovelock to theorize that the Earth is a single organism, a concept he termed Gaia. But although water is a life-giving element for this

organism, there are times it can easily be mistaken for something else. Persuaded by the wind or urged by fluctuating temperatures, it can be an unsparing plunderer. As a liquid, it regularly inundates riverbanks and invades coastlines. In a solid state, it has bulldozed mountain ranges and ripped open ships' hulls like tin cans. Held aloft as a gas, it can blacken the sky for hundreds of kilometres before unleashing torrents of raining hell.

Yet with all its potential to wreak havoc, water remains our chrysalis, life's common denominator. A connector, a therapist, a facilitator, and a mystery; like outer space, it has secrets that go to the genesis of our evolution and our wonder. Its transparent, born-again molecules carry the memory and the future of life, and its Siren call reminds us that we are still part of the underwater dance.

I

HIGH ARCTIC SUMMER

Is it the fire-Titan Surt himself that plucks at his mighty silver harp,
so that the strings shiver and glitter?... Here is the kingdom of the giants,
here Surt rules the heavens, and the frost giants rule the earth.
— Fridtjof Nansen

Bounding across water and land it comes on fast. Light and colour flee, and the heavens go pallid as if shrouded in the cloak of Dracula. Without the sun, warmth is vanquished. Seawater becomes paralyzed, thickening to a jelly-slush, before turning white and rock hard. Living things must leave, hide, or die. What remains is dark silence. This is winter's arrival—radical change in truncated time.

But this cold place that can compress months into days has another side. Its counterbalance is found between the end of one long High Arctic winter and the beginning of the next.

It's a brief period, but so alluring and intoxicating that while in its presence winter's fangs and claws can hardly be imagined. Amid swaying grasses and a colour field of wildflowers, time and change are held in abeyance. The early-morning, mid-afternoon, and late-evening intensities and angles of light that normally announce and define a day's rhythms are absent. As if entering a dream continuum, time relaxes and stretches out. In the summer, without a setting sun the

normal measuring and marking of day ceases. Round and round, the day circles and repeats, skipping like a scratched record on a turntable.

Maybe in the High Arctic the altering of time is aided by the spin of the earth—much slower near the pole than towards the centre. Or else our basic orientation—the north, east, west, and south quadrants—no longer apply. Every direction is south.

In the High Arctic, when what was can be difficult to distinguish. One can stumble upon what was abandoned last week, last year, or a thousand years ago. Preserved in its own deep freezer and with little compositional breakdown, a bone, a lead-soldered can, a burin, some charcoal from a stone hearth, a tuft of bloodstained feathers, an ivory amulet, or a shotgun shell can lie side by side. The past and the present can be hard to differentiate.

<center>⁓</center>

As usual, I couldn't say for sure what hour it was. It might have been nine or closer to midnight. The angle of the sun doesn't help much in the High Arctic summer; it is always low. Being that it is light all the time, exactly when to get up, eat, and paddle is dictated by things other than the hands of a clock. However, without the darkness of night I found the transition from tired to sleep difficult. As I did most evenings, I went walking.

The light was warm and evenly spread across an ocean of milky, pale cerulean. Unfiltered, with nothing to absorb it, it was so strong it hurt the eyes. The wind had died and the sea had flattened. That had been a late-day pattern all week. In the stillness, a hundred songs, calls and cries from far and near carried to my ears. Birds were everywhere.

Far from shore, four pristine icebergs were moving west in slow procession, their deep keels carried by the outward tide and powerful current. The strong rays of the sun accentuated their forms. Their shapes were clean and sculptural. They contained straight, angular faces, and also some ripped surfaces, a characteristic of recent calving. Other places, the icebergs were smooth, with sensuous curves that came from exposure to sun and the wear of water. Like architectural cornices, a few had diagonal striations running across or around their surfaces, mementos of previous waterlines. The size of the icebergs were hard to judge, but measured against the surrounding sea ice they appeared huge.

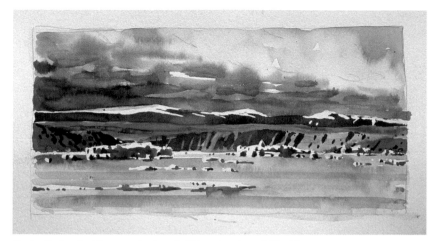

Bache Peninsula, Ellesmere Is. Aug. 1, '98, watercolour, 6.5" x 9"

Golden ribbons of ice floes were stretched and laced over the water. The entire mass of pack ice was drifting, but more slowly than the icebergs. Small icebergs and bergy bits were scattered across the sea like confetti on a wedding carpet. Unlike the four imported giants from Greenland, the little pieces, probably no bigger than a house, were made locally.

Behind me the land's interior moved steadily upwards to the base of a high bank of rock that climbed farther, almost vertically, before its thrust ended at a pointed, snow-capped pinnacle, the smallest in a long spine of peaks that stretched into and then under a monstrous icefield. The mountain snow and ice cap were bathed in faint hues of peach and lilac.

One could have camped anywhere along that coast. There were no restrictions, no application forms, no admission fees or posted rules on metal signs. Some flat land to place a tent and running water were all that mattered. And even if an area lacked a nearby river or stream, melting iceberg bits was always a drinking water option.

But the campsite had lots of fresh water. A series of streams cut through the middle of a field of tundra hummocks. Its source was a melting glacier that clung to the west side of the nearest rise about two kilometres away. The meltwater cascaded down the rock face for perhaps 300 metres before disappearing into the lush ground cover.

I bent down at one of the tributaries and cupped my hands to drink some water. It overflowed at my lips and trickled down the sides of my

neck. Even warmed over a distance of two kilometres, the water was still so cold it hurt. Its taste, however, was remarkable—nourishment frozen in time for hundreds or thousands of years. Some part of me wanted to keep drinking even though my thirst was quenched.

The stream divided into dozens of braids, meandering all over the mini-watershed. Glacial melt helped feed the wildflowers that were growing everywhere. Occasionally an oversized bumblebee droned above the ground cover like an underpowered motorboat.

Mountain sorrel lay beside light-pink cushions of moss campion, glowing patches of purple saxifrage, and little pockets of alpine azalea. Mop-headed cotton grass gleamed brilliantly, surrounded by a mix of sedges, rushes, and grasses. Arctic heather's dark-green leaves shyly hid its tiny white flowers. Tight to the ground, the limbs and foliage of arctic willow and crowberry were inconspicuous but profuse.

It was a remarkable display considering that it wasn't supported by rain. The tundra's few centimetres of active soil draw water from glacial streams but mostly from the permanently frozen ground beneath. In some places the permafrost extended down 600 metres.

A denser display of flowers was on a rise of flat land above the stream bed and around some low, stone-walled shapes. They were the remains of Palaeo-Eskimo dwellings, several hundred years old. Many of the places along that coast had sites like those.

Whoever they were, they were sea hunters. Hundreds of bleached and partially fossilized bones of sea mammals were scattered every-where. Some were unidentifiable, some I knew. Whale vertebrae of various sizes, walrus skulls, heavy whale rib bones, some two and a half metres in length, a few broken pieces of ivory from walrus or narwhal tusks, and hundreds of sharp-toothed jawbones, probably of hooded or bearded seals. There were two enormous bowhead whale skulls as well. They had sunk into the permafrost and were covered in splotches of black and green lichen and moss. They measured a metre and a half across, with blowholes as big as a fist. Other skulls, either wolf or dog, along with a lot of caribou antlers, were there too. They were preserved in an almost perpetually frozen state—the compositional breakdown of bone, antler, and ivory is negligible in the High Arctic—allowing entrance into what was essentially a Palaeo-Eskimo museum.

Farther back, to the right of the dwellings, there were a number of pillars made from large rocks placed one on top of the other. Most had

Stone and Bone, watercolour, 10.5" x 14", 1999

toppled over. The highest was just over a metre. They could have been boat racks to store skin-covered kayaks, out of reach of their dogs.

Without warning the serenity of the evening was broken by a deafening, whip-cracking sound. It was an iceberg, either splitting up or rolling. I had heard it happen many times before but the sound always startled me. It began like a rifle retort or a thunderclap. It was followed by a ripping or tearing noise that went into a deep rumble, punctuated by more cracking. I felt a slight vibration through the ground. Scanning the ocean with the loud noise continuing, one would have expected to see a massive upheaval of ice and water, but everything looked exactly the same, completely serene.

Finally, after the racket had ceased, I spotted the location of the disturbance. One of the larger bergs was rebalancing, with rings of waves radiating from its right side. Although it sounded like it was beside me, the iceberg in question was far away. A scattering of ice debris beside the iceberg was all that told of the isolated bit of pandemonium.

Gradually the evening sky and ocean blended together in a single, golden gradation. The sky, water, and ice became indistinguishable. Thousands of birds of all descriptions, each with its own itinerary, flew through the reflective glare. Some plovers, their feathers skimming the

surface, flew west, parallel to the shore. A couple of hundred king eiders were bunched in a floating colony half a kilometre away. Thick-billed murres whistled past, six metres above the water. They seemed to have to beat their wings twice as hard as others to stay airborne. Higher up, some snow geese alternately flapped and glided, moving towards the valley interior. A coal-black raven flew an irregular course, squawking over a two-octave range. A faint reply came from somewhere in the distance. A number of fulmars hung suspended, almost motionless, high overhead.

On a gravel spit at the far end of the cove, Arctic terns had nested. These are polar migrants. Their flight to Antarctica and back, over 40,000 kilometres yearly, qualifies them as the most travelled species on earth. Glaucous gulls were trying to hit some of their nests, but these tenacious, aerobatic fliers are highly territorial, and an uproar ensued.

A pair of mergansers, likely nesting nearby, swam quietly along the shore. A guillemot in tuxedo breeding plumage crashed the water and then was out again, some sort of flapping creature in its beak. Two different sizes of sandpipers bobbed up and down on the beach in search of food. Both were similarly mottled brown and light beige. They were right in front of me, but I had missed seeing them until now. The larger one was silent; the smaller one was periodically making a peeping sound. It continued on like that—the cast changed but the performance never stopped. The breeding season is not long, every hour counts. In less than a month they and their young will gather to leave.

As I closed my eyes the surrounding acoustics became intoxicating. Scores of new, distant calls were audible, and near calls were accentuated. Listening closely I could distinguish the sounds of different feathers winging past, one species from the other. Small waves slid onto the beach and then back again, the sun's reflection briefly mirrored in their memory. The tide continued to be called out by the moon, leaving the wet shore sand cold and darkened.

Hundreds of older tracks of feeding birds were imprinted above the high tide mark among the flat shore rocks, their details blurred by the enclosing grains of dry sand. Some very different tracks were there too, set much deeper. These moved with purpose, parallel to the shore. There were two sets and they were massive. Polar bear: mother and cub. I knew the cub trailed the mother because occasionally the smaller track was imprinted inside the larger. They were going west.

Perhaps the mother had picked up the scent of food, or the unmistakable odour of a large male, causing her to move to safety. Or maybe she was just following some internal directive, obeyed without question. The age of the tracks was difficult to assess in the semi-dry sand. They were probably not new, but my quickening pulse betrayed the fact that I wasn't sure.

Higher up on the beach, deposited by a storm or very high tide, lay long, twisted strands of parched seaweed, kelp, pieces of driftwood, and other debris. A heavy piece of weathered driftwood caught my eye. It was notched at one end, like a tuning fork, with a large hole bored through the middle and two more holes down the side that were not drilled through. It lay along one of the waterlines farthest from the shore, surrounded by arctic willow and low sedge grass. It had been there for quite a while. A squared iron spike was easily released from the driest part of the timber. It appeared to be hand forged and was heavier than it looked. It was eroded with deep pockmarks, and its sienna colouring was spotted with metallic purple and cobalt blue. Where it was almost eaten through, the iron changed to a bright powdered orange.

The wood was oak. Apart from its greyed, weathered surface, the integrity of the wood was uncompromised. Its presence, lying on a beach, would have been unremarkable anywhere else, but in the High Arctic, wood, particularly hardwood, is alien and historically coveted. What it was, where it came from, or how it had got there, I couldn't tell. It could have been part of a dock, ripped away by a storm or sea ice along the north Norwegian coast and carried by ocean currents. Or a piece off a New Bedford whaler that had floundered on a submerged shoal, perhaps weighed low by its brimming hold of bowhead blubber. Or perhaps it was English oak, cut from the King's forest, a ship of the Royal Navy, commissioned to find and chart a shorter route to the Orient. If so, it was from one of many square-riggers that had departed to the sound of twenty-one-gun salutes and naval brass bands, only to end up strewn in pieces across the waterlines of the polar frontier.

Mankind's self-importance is seen everywhere on this planet, but apart from a few artifact scatterings, it was not evident here, not then. Clear evidence of our being was surely there somewhere: high up in the ozone, in an analysis of the air, ice, soil, and water. But my view of the land and the ocean that evening was empty of people or anything of our constructs, as it would have been for millennia. What if all the Earth

Fading Away, etching and chine collé, 18" x 24", 1998

were like that, without people anywhere? Apart from our own kind, I had a hard time imagining that anything out there would miss us.

My thoughts were pulled back to the moment. My ear suddenly picked up something. Not particularly loud, but quite unmistakable. A brief, deep, cavernous huffing sound, which rapidly trailed off. It was repeated once, twice, four, maybe seven or eight times, then nothing. I lifted my binoculars. It could have been whales…maybe walrus. I scanned the expanse of ocean and ice but it was so vast, their location was impossible to determine. The light was too bright; it hurt my eyes. I exchanged the binoculars for sunglasses.

Then I saw, without hearing the sound: two oblong, vaporous circles slowly floated above the water like hovering spaceships. Haloed by the backlighting of the sun, their breath glowed against the evening light. They were closer to shore than I'd thought. Then, right behind them, another puff, and another, three, four more…five more orbs suspended momentarily in space.

And the sound: the first two, *huhhaaaa…hhhaaa…* and then the rest. They were whales, but I couldn't tell what kind. In the energy of bouncing light, shape and space were altered. I fought the glare, catch-

High Arctic Passage, etching, 7" x 14", 1992

ing only momentary glimpses of them. The sounds of their breathing were perfectly clear, as though they were right next to me, but their physical forms remained obscured and distorted. They surfaced once more to breathe, fluked up, and dove deep. Moving east, their identity stayed unknown.

A bank of low-hanging clouds blocked the sun's rays, reminding me where I was. With the plummeting wave of cold air I turned and headed back. The sandpipers continued bobbing along the shoreline, feeding on the little crustaceans snuggled in their homes of wet sand just below the surface. Trusting in the gravitational rhythm of earth and moon, they burrowed tiny air-pocket lodgings before each high tide.

High overhead the sun's rays highlighted a slowly expanding jet stream that chased a barely visible metallic dot. To the south its trail disappeared, bleeding into wisps of delicate horsetails. North American–Asian routes now regularly cross the Arctic. They say it saves almost an hour.

Within a few weeks the northern earth would lean back on its axis and once again the huge star would begin its death spiral. Almost everything that swims, walks, or flies would gather, often in vast numbers, to follow it south. Round and around, hour by hour, day by day, inexorably, the shadows would spread. It's then the ice giants awaken to rule the land, and the silent aurora commences its long, lonely dance.

II

TOBERMORY, 1970

...those grand fresh-water seas of ours — Erie, and Ontario, and Huron, and Superior, and Michigan — possess an ocean-like expansiveness... They are swept by Borean and dismasting blasts as direful as any that lash the salted wave; they know what shipwrecks are, for out of sight of land, however inland, they have drowned full many a midnight ship with all its shrieking crew.
—Herman Melville, *Moby Dick*

The middle portion of my career as an artist was focused exclusively on the Arctic. During a fifteen-year period I made over twenty backpacking and sea kayaking expeditions there and with the energy of relative youth, eagerly explored and depicted a wide array of Arctic themes from Alaska to East Greenland. How this particular passion came to manifest itself in me can be better understood when seen through the influences of another place, in an earlier time.

The years I spent at art college in Toronto coincided with a time that the American writer Hunter S. Thompson called "an era of extreme reality." My mind wasn't in the self-confessed, self-induced wasteland of Thompson's, nonetheless the phrase seemed to fit my life back then.

My world evolved around tranquil, skylit studios, where I tried to tame unruly carbon pencils and coax interesting images out of copper plates, hydrochloric acid, etching inks, and a roller-bed press. At the

same time, out on the streets and on the TV screens, in black and white, a cauldron of discontent was roiling. The news and its daily images portrayed a society feeding on itself: anti-war, pro-war, anarchists, idealists, traditionalists, separatists, Black Power and the power of love, raging mobs, burning draft cards, freeloading demagogues and leather-jacketed outlaws, Molotov cocktail throwers, napalm droppers and tear gas lobbers—a circus of rambling chaos. What had just happened could hardly be assimilated before the next series of events unfolded. We watched our heroes—songwriters, politicians, student advocates, agitators, philosophers, poet gurus and pseudo-revolutionaries—weird or otherwise, rise and then inevitably fall. The media showed us cities that were under siege or on fire. It appeared that truncheons arbitrated between the status quo and a new order. The so-called counterculture considered every topic a subject for protest and marches, or at least scrutiny and labelling. Simply being young or old, rich or poor, black or white, long-haired or short-haired, how you dressed, what you drove, drank, or smoked thrust you into the role of accuser or defender.

Gradually, through that smoky haze, one thing was becoming more or less clear—youth had found a voice and the confidence, or naïveté, to question, if not oppose, everything that the previous generation valued.

After art college, like many my age I was looking to get away, get away from everything. I decided I would start my life as a young artist in Tobermory, situated at the end of a 75-kilometre-long, lonely tilt of lime-stone rock that juts out and separates Georgian Bay from Lake Huron.

With five other students from the Ontario College of Art I moved to this five-hundred-person village on the Bruce Peninsula to create a studio-gallery cooperative. Helping facilitate this idea was Gale Jensen, a philanthropic professor from the University of Michigan, who made available for rent a rambling old building he owned in the town.

None of us had been to Tobermory or even knew where it was. The available space had been an old hardware store and needed a lot of renovating to make it a gallery. None of us had any money; in fact, we were all heavily in debt with student loans. Among the six of us we owned one old wreck of a station wagon and a motorcycle. We started our gallery, called Circle Arts, with no business plan, no sales projec-tion charts, and no cost–benefit analysis. We had no money and no bank loan approval or any prospect of an approval (the town didn't have a bank anyway). We had no business or retailing experience and no cohesive philosophy regarding the products we would sell, and our

artistic abilities were, to be kind, under development. Even a phone and business cards were luxuries we either couldn't afford or didn't deem necessary. Perhaps worst of all, we had been put together as a group without really knowing one another.

Most would see this as a prelude to a business disaster. Yet for those of us in the new counterculture, all of that meant absolutely nothing. Breaking the previous generation's rules and their ways of doing things was what we were about. We jumped at the proposal. To various degrees, our Tobermory gambit was being repeated by tens of thousands of suburban kids across North America. Cities were places of violence and degradation and were to be avoided if possible. Rural life, on the other hand, was suddenly hip—and the more rural, the better. All over the place, puzzled backwater country folk were gazing out from their porches and kitchen windows, muttering and scratching their heads as they watched city kids turning their neighbouring lots, farms, and acreages into meditative getaways, mind-expanding retreats, and New Age communes. There was a sudden flurry of interest in cultivating strange-looking plants, making ponchos, cooking on woodstoves, selling tie-dye T-shirts, and stringing beads together. What we were attempting to do in Tobermory was practically the gold standard in that movement—our generation's highest calling. We were following the sixties blueprint for being cool. Timothy Leary termed it "turning on, tuning in, and dropping out."

Starting a co-op... "Far out."
With no money... "Right on."
Selling crafts and artwork to the common man... "Cool."
Living in the country... "Yeah, man."
In a shack, heated with firewood... "I'm diggin' it."
And did I mention, no job?... "That's so cool. You guys are sockin' it to the man!"

There were a thousand sound reasons why our little enterprise should have failed. Looking back on it, it's hard to imagine it could have succeeded. But it did. (In 2012, Circle Arts celebrated its forty-third year in business.)

Tobermory's clear waters and natural harbours and the provincially run ferry service to Manitoulin Island drew lots of summer tourists. But it was also in an isolated spot, far from any sizable city, with fewer than five hundred permanent residents.

Upon our arrival in 1969 we immediately became the talk of the village. To the people of The Tub, as it was referred to locally, we perfectly fit the phenomenon that they had read about and seen on TV. For the first time, they got a close-up view of this rebellious and infamous hippie culture. There was no mistaking it: the long hair, the sloppy clothes accented with beads and sandals, the motorcycles, marijuana, and bra-less young women, living in sin. And, of course, an absence of money or normal employment.

Quite apart from our appearance and lifestyle, our approach to commerce—what we made and tried to sell—was pretty mind-boggling to most of Tobermory. On one occasion, a Circle Arts artist did a painting of a local fisherman's old punt tied to a dock. A relative of the man who owned the dory saw the painting and brought the fisherman into the gallery to see it. The fisherman looked at the watercolour and then bent down to look at the price and said softly, "Well, I'll be dammed. That there painting of my boat is worth more than my boat."

To their credit, all but a few of the locals soon put aside their preconceived notions and, if not quite wholeheartedly embracing us, resisted putting us down for being different. The fact that we lived in dwellings that had no water, or toilets, or bathing facilities, and often no effective heat source, had no bearing on how they viewed us. They didn't seem inclined to make class distinctions. As I got to know the people better and learned some of the history of Tobermory (pronounced *Tubermury*, locally), I better understood the origins of that live-and-let-live attitude.

It came in part, I think, because they themselves had felt what it was like to be stereotyped. On the peninsula, Tobermory carried the reputation of being a wild and raucous place—a place of heavy drinking and hard living. That notion came out of Tobermory's early lumbering history but mostly from its years as a commercial fishing centre.

In 1970, fish, in declining numbers, were still commercially pursued. But most of the locals on the Bruce Peninsula looked to their woodlots and to mixed farming to eke out a living. The fishermen and the farmers both had unpredictable incomes, but the two livelihoods were made up of, or drew, very different people. I think that fundamental difference evolved from how they made their living. A farmer's modus operandi didn't require sharing or competing with neighbours over the same resource; they didn't plant and harvest the same crops in the same field. Commercial fishermen, on the other hand, were always competing with one another for the same fish stocks in the same body of water.

Father and Son, oil on canvas, 22" x 32", 1980

A commercial fisher's (or anyone else's) approach to an open resource is clearly to get what you can and as much as you can for as long as you can, before someone else does. This hones an approach to life that encourages living for the moment, in contrast to the farmer's inclination towards long-term planning, cooperation, and conservatism.

Yet apart from, or maybe because of, this relationship to the water, the people of Tobermory were proud of who they were. Anchoring and underlying the character of those rugged types was a generous nature and empathetic heart. I saw it demonstrated many times, often in extreme conditions, by way of their willingness to help anyone, at any time, who was in distress — the long-standing code of the mariner.

Still, their livelihood was based on competition over a common resource in a common jurisdiction. The results have been disastrous for the Tobermory fishery and for all of the Great Lakes fisheries. Unrestricted harvesting, even in areas as large and as seemingly inexhaustible as the oceans, has led to the wiping out or alarming depletion of all the world's saltwater fish stocks. "The tragedy of the commons" is the term applied to the results. Rehabilitating a commercial fish stock, once it has been decimated, has ranged from difficult to impossible.

Northend Buoy, oil on canvas, 19.5" x 42.5", 1980

As a young artist I was drawn immediately to the town's maritime culture. For a century, the people of Tobermory had fished the surrounding Georgian Bay and Lake Huron waters to survive. In earlier days, before reliable charts, weather forecasts, and navigation aids, ships and boats with their crews had disappeared with alarming regularity. The renowned gale-force winds of the Great Lakes, combined with Tobermory's offshore islands and hidden shoals, had left the local waters littered with more than a hundred shipwrecks.

I was enthralled with the water's wildness and with the mysteries that lay in its depths. Conceptually I was fascinated with the idea of

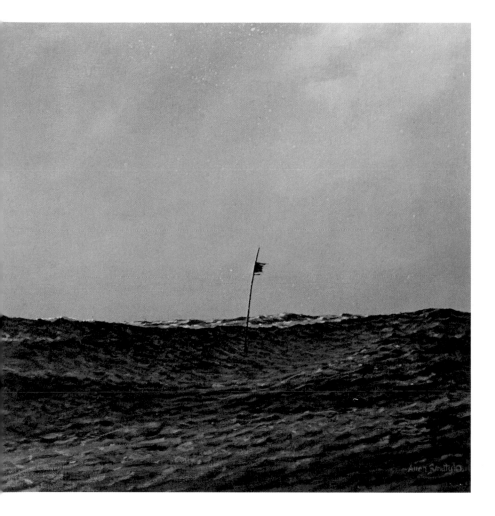

a hidden three-dimensional world accessible to men with boats only in the second dimension. One can float along the top, drop lines and nets into it, probe it with sonar, but one cannot enter. Only in tragedy, when boats capsize and men drown, do they gain access to water's third dimension.

But behind that more philosophical view was the embarrassing realization that, as an artist, I really didn't know how to depict moving water. My first attempts at portraying large waves were humbling. I felt I had just wasted four years of art college. On the one hand, waves appeared predictable and repetitive. On the other, they contained unfathomable

detail flowing over a chaotic form—seemingly impossible to convincingly portray.

In time I saw that the reflective plane of flat water, when rough, breaks into thousands of smaller planes. While some of these smaller surfaces continue to reflect the surroundings, usually the sky, others that are more vertical lose all their reflectivity and reveal the water's interior darkness. When the angle is somewhere between the flat and vertical, the plane of water correspondingly combines both reflective and penetrative values. Understanding this broken plane principle greatly helped me describe undulating water.

On a visceral level I always had a feeling of unease on rough, deep water—a fear that has never left me. In rough conditions I was often on the verge of being seasick. Apart from that, the reality of commercial fishing on the Great Lakes is far from pleasant. When it's really cold, ice can form everywhere on a steel deck, making for a rocking and rolling, foot-slipping and potentially head-cracking workplace. When large amounts of fish are hauled aboard and processed, the tug's interior turns into a gruesome, sloppy slaughterhouse of gore and guts. At times I would try to help the fishermen, but it was clear I did not have the stomach for it.

Even physiologically I was unable to do certain tasks. My hands were almost ripped to shreds when I tried to carry out the setting-back procedure. This is where the boat moves slowly forward through the water as the gill nets are set out the back. The setter lets the mesh fly out between his hands, in a way that allows the cork line and lead line to separate and open up over the setting bar before entering the water. Anything the nylon monofilament mesh can attach itself to, it does. If it attaches solidly to clothing or a boot, it can pull you overboard. Even a slight nail edge, cuticle, or knuckle wrinkle will, because the boat is moving, be grabbed and ripped by the strong, fine, fast-moving mesh. Fishermen's hands, I started to notice, are consistently puffy and smooth as a baby's bottom.

Susan, my girlfriend (later my wife), and I rented a cabin and prepared to spend our first winter in Tobermory. It was a nice little house with a porch, small kitchen, living room, dining room, and bedroom. It had no heat source, no water, and not even an outhouse. The woman who owned the place didn't want us to build an outhouse on the property—hence, a rent of ten dollars per month. We got a wood stove and a little oil burner, put a chamber pot on the porch, and got a key to the

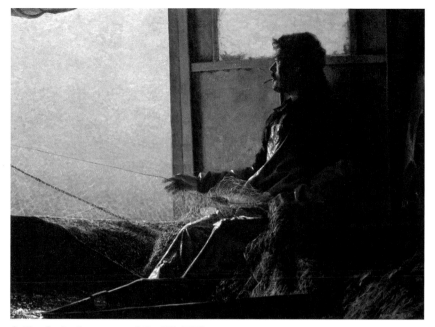

Setting Back, oil on canvas, 24" x 32", 1979

community hall, just down the street, where we could get water and use the facilities. We showered on occasion at a neighbour's place. For the winter, to try and keep warm, we closed off the bedroom and moved the bed into the living room, which doubled or tripled as studio space.

Regardless of our lack of amenities and scarcity of money, personally I was never happier. More than for anyone else in our group, Tobermory fit me like a glove. Part of it was the town and the individualistic character of its people, part of it was the clean, wild water on my doorstep, and part of it was surely my youth. Perhaps more than anything, though—as I was able to recognize only later in life—it was because I was at an "edge"—not just where land and water meet, but where cultures, economies, philosophies, and values were colliding.

As winter approached, I decided to continue the work I had started in the fall on the commercial fishing theme. I was hoping to do a portrait or two of some of the older, retired fishermen. With the onset of winter weather, my intention was to get one of them to sit for me, perhaps in his kitchen. But at that time I was still new in the community and only knew these guys by reputation.

Being ambitious and naive, if not outright daring, I decided to ask the most renowned fisher in town if I could do a portrait of him. His name was Orrie Vail. He often went by O.C. Vail.

Approaching him was daring for three reasons. Portraits are a challenge even for experienced artists. A likeness is often an exasperatingly illusive thing to achieve. Everyone from the corner grocer to the little kid down the street will instantly judge and evaluate a portrait by its likeness. I hadn't really done many portraits at art college, and certainly not in oils on a large canvas, which was what I had in mind.

Another reason it was daring was that I didn't know what O.C. Vail even looked like. In the time that I'd been in Tobermory, I had never seen him. But I had sure heard a lot about him...and he about us.

That was the last reason it was daring: he hated us.

O.C. Vail was born in 1893, but the Vails and Tobermory went way back. In the 1870s, Orrie's grandfather was one of the first settlers in the area. Orrie wore that bit of history like a frontier marshal's silver star. The Vail house, outer cabins, and workshop were right on the water, at the northwest point of the town, beside the big government ferry dock.

Like his father Marmaduke, Orford Cleveland Vail grew big and grew strong. Like many of the local men, he had built a boat or two in his life, fished while there were fish, hunted when there were deer, cut timber now and again, and later in life guided boat charters, taking southerners to isolated places on the North Shore to fish and hunt. Too old to run charters any more, or simply uninterested, Orrie had started making things in his workshop, mainly knives and lures, which he sold to tourists.

He'd been married, but his wife Edith had died the year I arrived in Tobermory. His daughter Jane, who had a family of her own, lived in a house beside him. One of Orrie's grandsons, Jane's boy Timmy, was ten or eleven when I came to town. He hung out at the gallery a lot of the time—I think he had a crush on Mary, one of the Circle Arts artists. Timmy would come wheeling up on his bicycle after school, always with his large, shaggy dog Cubby running to keep up. The dog was smart, with only his loyalty to Timmy overriding his intelligence. He would sit and wait for Timmy all day in front of the two-room schoolhouse until classes were over. One time Cubby failed to spot Timmy leaving school, so the dog sat there waiting for his master deep into the night.

From Timmy (although he didn't like to talk about it), from other locals, and especially from tourists, we heard numerous reports and quotes coming from Orrie Vail about us, the artists at Circle Arts. The "Tubermury Oracle," as I liked to call him, was not at all pleased that long-haired hippies, living in sin, had invaded his town, the town his grandfather had founded. From his workshop, such talk was apparently filling the ears of anyone who would listen. The line that got conveyed to us most often was, "That bunch oughta leave town if they know what's good for them, because I got my shotgun loaded and it's sitting by the door."

Given that, I didn't know what to expect when I entered his workshop that cold afternoon in early December. I didn't even really know why I wanted to do a painting of him, but I did. I wasn't going there to try to make up, or appease him; nor did I want to challenge him. I didn't envision a painting that would romanticize him; nor did I want to bring him down to size with a caricature. Being totally inexperienced in painting portraits, I didn't know myself exactly what I would do.

I walked up the path to his weathered, cedar-shake-clad workshop with no drawing materials that day. My plan was to simply ask if I could return to do some sketches of him. The main workshop had a few smaller add-ons, with old artifacts such as an anchor and some fishing buoy poles and wooden pulleys leaning against or nailed to the building. The only evidence suggesting any form of retailing was a hand-painted sign outside that read "Fishing Tackle." The entry area was through an enclosed back porch so low it looked as though it had sunk a foot into the ground.

Without knocking I ducked and stepped into an entryway that contained stacks of firewood and a grinding wheel. It had a dirt floor, was dark, and carried the thick scent of history and vaporized steel. Seeing no one, I turned right and stepped into the workshop area. The heels of my leather boots announced my entrance on the raised plank floor. One bare light bulb over a small work table illuminated the windowless room. Partly facing the table and partly facing out, a man of enormous size sat and quietly worked.

In the crammed space of the low-ceilinged work area the man I observed looked absurdly big. The wooden captain's chair disappeared behind his huge haunches, shoulders, and arms. The tool he

was handling seemed miniaturized. He wasn't overweight; he was just damn big, all over. Someone once described him as being carved out of granite.

Orrie regarded me for only a second, then looked back down, resuming what he was doing, saying nothing. I had rehearsed what I wanted to say. I knew I probably had just one chance at this. I was hoping the prospect of having his portrait painted would feed his ego, or at least interest him enough to negate his desire to kick me out or grab his shotgun.

"Hello, Mr. Vail...uh, I'm Allen Smutylo. Uh...I'm an artist, and I would like to do some drawings of you for a painting I have in mind...if that's okay?"

He didn't look up or say anything. Since we had never met I was pretty sure he didn't know my name. Maybe at that moment he was trying to figure out who the hell I was. I had decided in my introduction not to implicate myself as being *one of them*—no sense waving a red flag in front of the bull. Still, I was pretty sure he knew, and even if he didn't, he would find out soon enough from Timmy or his daughter Jane. What a dilemma: Run the city hippie out the door or have him be your portrait artist?

During and after my introduction he never did look up. There was a long pause, and then he said, "You...do a portrait...of me."

He didn't phrase it as a question.

"Uh,...yeah."

Another long pause. I didn't move a muscle. I hardly took a breath.

He finally muttered, his eyes still riveted to the work in his hands, "If you want. But you'll have stay out of my way...I got a lot of work to do...a lot of orders."

Delighted, overjoyed really, I got out of there as fast as I could before he changed his mind. I figured that when I returned, if I just shut up and stayed out of his way, he wouldn't kick me out, even if he had by then confirmed who I was.

During those uncomfortable first moments, as contradictory as it may seem, I knew that the decision to come there was not just a daring idea but a good one. But I felt something more. I had a very clear sense, although it didn't come from anything specific, that things between us were going to work out fine. I knew that his "run them out of town" edicts were widely issued and probably rarely acted upon. And I knew

they weren't restricted to the hippies of Circle Arts. Anyway, I never did take it personally. But beyond that, I knew I was on to something there in his workshop. Like the unique scent of the room, it was a strong feeling but hard to describe. It must have been a combination of things: what he made, what he wore, what little he said, and the fascinating stuff that surrounded him.

As a young artist, that day at Orrie's I learned that the simple act of saying what you want to do, even if it sounds improbable, is half the effort to getting where you want to go. I returned to O.C. Vail's at mid-morning two days later with a bagged lunch and my drawing materials.

⌒⁘⌒

Orrie did keep a heavy work schedule. He rose early, got to his shop just after dawn, and often worked well into the night, with short breaks up at the house for meals. He made a variety of lures for sports fishermen but his primary work was making knives. He sold his stuff to tourists, who were right at his doorstep. Scores of people waiting for the ferry would wander into his shop to get a knife or a lure, along with unsolicited advice on any number of things.

He made a variety of knives in assorted sizes: some for kitchen use, ones with sharply serrated spines for scaling fish, hunting knives, and a few for skinning. He even made some vicious-looking machetes. Every summer the demand for his knives outstripped the supply. The following winter, he would ramp up production, but year by year the demand kept growing. Even in winter, orders came by mail, requests from chefs in California and trappers in northern Quebec. He claimed that even the White House kitchen had a set of his knives.

But Orrie's reputation predated his knife-making skills. In the 1950s he claimed to have found the French explorer La Salle's *Griffon*, a forty-five-foot barque that was the first sailing ship built on the upper Great Lakes. On the *Griffon's* maiden voyage in the late summer of 1679, La Salle had sailed west from Niagara Falls across Lake Erie up Lake St. Clair and Lake Huron, into the northern part of Lake Michigan. There, after taking on a cargo of furs, he had left the ship, instructing the crew to return to the Niagara River.

Although the *Griffon* was navigating inland lakes, they are not named "Great" for nothing. Except for being freshwater, they're more ocean than lake, and accordingly treacherous. During the ship's return

voyage, a month and a half after its launch, the *Griffon*, with its load of furs, its two brass cannons, and its entire crew, disappeared without a trace. For three centuries the ship's whereabouts remained the most perplexing marine mystery on the Great Lakes.

Orrie claimed that he had located the wreck of the *Griffon* in a hidden cove on Russell Island a few kilometres off Tobermory. Although many people in town knew of this cove's unidentified wreck, Orrie claimed that the ship's remains had been a closely guarded family secret for three generations. Without telling anyone, in the spring of 1955, he hauled pieces of the wreck—a few big hunks of the decayed keel and some rusted bolts and nails—and hid them in his workshop. A reporter friend from the *Toronto Telegram* and a couple of other investigators were convinced that his artifacts did indeed belong to the *Griffon*. On 16 August 1955, the *Telegram*, one of the main Toronto papers of the day, ran a front-page double-decker headline that read "Ship Sought for Three Centuries / Fabulous Griffon Found." The release of *The Fate of the Griffon*, a book by reporter Harrison MacLean telling the story of the ship's discovery, soon followed. O.C. Vail became nationally known. He was a mystery guest on CBC's popular current affairs quiz show *Front Page Challenge*. He stumped the distinguished panel, of course.

Shortly after, though, upon more careful investigation of the artifacts and a further survey of the Russell Island site by others, it was determined that Orrie's wreck wasn't the *Griffon* after all. It was in fact an old boat of undetermined origin from the mid-1800s. Nothing, however, ever could or ever did dent Orrie's belief that he had found La Salle's ship.

⁓ℳ⁓

Although he didn't sit for me (I wouldn't have dared ask), because of the production-line nature of how he made knives Orrie often stayed in the same position for an hour or more at a time. When he got up and moved to another operation, I moved as well, pulling out the previous drawing of that procedure and continuing with that study.

He wore a train conductor's hat and a high-bibbed apron around his waist. A heavy canvas coat was always worn over various shirts and sweaters. A large, bright-red hanky, with white polka dots, was usually tied around his neck.

His shop walls and ceiling and much of the floor were lined with a lifetime of making and collecting. Big hunks and large beams of dried

walnut, red oak, ironwood, hickory, cherry, apple, and white ash were stacked on the floor along two walls. Some of it was from logs older than he was that he had hauled up from deep, sunken log booms preserved in Georgian Bay's cold water. That wood, and racks of moose, caribou, and deer antlers piled here and there, provided the raw materials for his knife handles.

A thousand little items arched around his main work station, positioned like a symphony orchestra awaiting its conductor: screwdrivers, gougers, clamps, strands of wire, burins, drill bits, files, calibrators, dye patterns, paintbrushes, lacquers, varnishes, hand vises, cleaners, rivets, polishing paste, oil cans, cutting shears, rolls of tape, jars of glue, cans of tacks, boxes of screws, cups of washers, pads of sandpaper. There was no end to it.

Crammed into less conspicuous places were old ship's lanterns, propellers, sailing winches and pulleys, ice-block saws, picks and lifting tongs, gaff hooks, trolling lines, lines for reading water depth, and numerous wooden crates loaded with fish netting, leads, and floats—the physical remnants that tied Orrie to the water. In various degrees it was like every other retired fisherman's net shed and workshop in Tobermory.

Commercial fishing has always been tough work, done by those who are equally tough. As one of the fishermen explained, "Three hours before the sun comes up, you get out of a warm bed and get into a cold truck. When you get to the dock, you leave a warm truck and get onto a cold steel boat. By the time you get the boat's wheelhouse warmed up, you're back out on a cold, open deck, where you then proceed to get knocked around while pulling up freezing-cold gill nets out of freezing-cold water to detach freezing-cold fish."

The 1970 version of Tobermory retained traces of a nineteenth-century fishing village, but tourism, with its hotels, restaurants, and trinket shops, had taken root and was rapidly growing. The little commercial fishing there was, was mostly done in the stormy months of the year, in the spring after ice breakup and in the late fall. Four or five fish tugs, each with a three- or four-man crew, continued to string out long lines of gill nets in pursuit of an ever-diminishing resource. The lake trout had long ago been wiped out. Whitefish were getting scarce, the coho even scarcer. Chub, a freshwater herring previously regarded as a junk fish, was the only catch that could be more or less relied on.

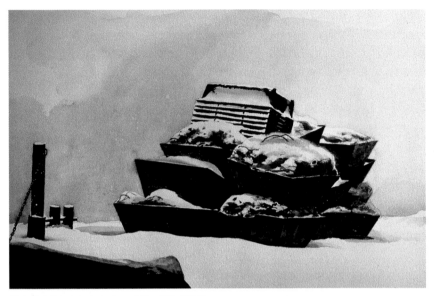

Fish Net Trays, watercolour, 18" x 24", 1972

Over the following week I went to Orrie's workshop daily, drawing him among his surroundings and in the warmth of a pot-bellied wood stove. The long silences started to lift as the days passed. Instead of rising abruptly, he began to warn me when he was about to change working locations, sometimes even asking me if that was okay. He also started to tell me about himself and his accomplishments. His claims covered a wide range of things. For example, he told me that the industrial hacksaw blades for his knives were made from tempered steel so hard that they couldn't be drilled through by any drill bit yet devised…but he and only he had found a way to do it. He said his technique to drill and rivet the handle to the blade was a guarded family secret.

He was proud of his boat building and his skills on the water. He boasted that in forty-four years as a commercial fisherman he had never needed a tow. Such a distinction would have had great currency before there were roads and automobiles. When the first road was finally put in, Tobermory changed, and according to Orrie, not for the better. He said that back then the road was so terribly bumpy "it would slap your ass like a flat-bottom boat in a big sea." Locals had a saying for it: "over the washboard and into the tub."

Day after day he became more talkative and the claims kept coming, from knowing the rich and the famous to owning a Stradivarius violin. Personally, I didn't really care if they were true, partly true, or not true at all—I enjoyed listening to him. He didn't ask me about myself, which suited me fine.

During my time with Orrie, I never heard him rant about the people or things he didn't like. And he avoided going into his often-heard bluster about hippies. On that particular subject I wondered why he saw such a huge chasm between himself and hippie types. In many ways we shared an approach to life. We both had a high regard for values found in nature, for working with our hands, and for the traditions and skills of the past. And we both had rejected societal tendencies that the generation "in between" had embraced—consumerism, modernity, and growth.

After a week I thought I had enough material for at least two oils. When I told Orrie I wouldn't likely need to come back, he wished me luck with the painting and said goodbye.

⌒⋎⌒

In early May of the following year, we swept and cleaned the gallery in preparation for hanging and displaying our group's winter work for the summer opening. I had done two paintings of Orrie; the one I called *Knifemaker* was a large, almost square canvas. It depicted him from a side angle, sitting and working at his finishing workbench. The other painting was smaller, darker—a more ominous view of him, masked and goggled, at his grinding wheel.

The larger piece was hung in the gallery's prime viewing spot. It dominated the room, which seemed fitting. On a quiet early evening in mid-May, still a few days away from the gallery's official opening, Timmy, with Cubby giving chase, came wheeling up on his bike and sauntered into the gallery. He looked at the painting of his grandfather hanging on the wall for a few seconds; then, without saying a word, he turned on his heel and was back out the door and on his bike, whipping down the street before the gallery's screen door could slam behind him.

Within fifteen minutes, an old Nash Rambler with faded greyish-blue paint crawled to a stop in front of Circle Arts. The man who got out was only slightly smaller than the car. He had on a grey conductor's hat and working clothes. We watched this uncommon event unfold

through the gallery's large picture windows, as if in slow motion. I could feel my heart race. I said to myself, in a voice that the other artists in the room heard, "My God…it's Orrie."

Orrie was *never* seen in town. I didn't know why that was. I suppose he expected people to go to him. So for him to drive to town with the sole purpose of entering what he had previously labelled the den of depravity was, well, startling and quite unbelievable.

As he walked up the sidewalk the others in the group were practically giddy. I was a jumble of nerves. He very slowly opened the screen door and paused. We all had time to fully absorb his frame filling the threshold. He nodded slightly to me but he didn't say anything. He carefully stepped into the middle of the gallery, turned, and saw the painting.

I stood a bit to his left as he gazed at the canvas. He held a visual lock on the painting for some time. There was a halting attempt to talk but his words didn't want to come out. I looked up at him. He was still transfixed. Water had begun welling up in his blue eyes and tears started to run down his cheeks. He bowed his head to wipe his eyes with the red hanky that was around his neck. The tears kept coming and he started to sob. He leaned over and put his hand on my shoulder and kept it there. The other artists in the room were behind us, watching silently from a distance. I couldn't see them but I could feel them smiling. Finally, in between sobs and sniffling, Orrie blurted out, "You did it, you did it." Then he turned and stared at me red-eyed with tears still flowing. "You really did it." He looked at me like I was his long-lost prodigal son. He kept his hand on my shoulder, staring into my eyes.

There was nothing that could have prepared me for this. It felt like an out-of-body experience, as though I was watching it happen in a dream. Given his previous tirades against us, the whole thing seemed too bizarre to be real.

Having done the painting, I don't know what I expected from Orrie: indifference, curiosity, or perhaps some sort of mild interest, although I wouldn't have been surprised if he hadn't bothered to come in and see it at all. The last thing I expected was Orrie Vail's tears falling on the Circle Arts gallery floor because of my painting. Given that it was the first portrait I had painted and that it was of someone who had previously hated me, intermixed with being a bit embarrassed, I was pretty impressed with myself. I marvelled at how paint on canvas was able to

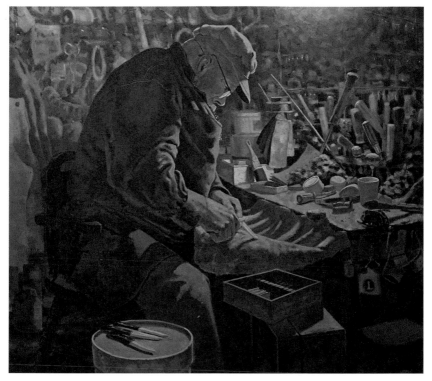

Knifemaker, oil on canvas, 28" x 31.5", 1972

make a tough-as-nails seaman weep. I wondered if I really possessed that sort of power, the power to turn hate into love.

Orrie bent over and read the label: *Knifemaker,* Allen Smutylo, oil on canvas, $375. To us, $375 was a king's ransom.

About a half an hour after Orrie's car pulled away he returned, walked into the gallery, handed me $240 in cash and said, "I want to buy my painting. I'll head on down to Lion's Head and withdraw the rest tomorrow. If that's okay."

I said it was.

After the gallery opened, the painting stayed on display at Circle Arts for three or four weeks, after which it went to Orrie's. He decided that it needed to be where people could see it so he brought it from his house to his workshop. To display it, he wedged the painting around some old cardboard boxes and atop a pile of weathered lumber, right up against the ceiling. Illuminated with a bare bulb, it sat across from

his main workbench—the prime viewing spot. He draped a sheet of clear plastic over the painting but would lift it back if he deemed any visitor worthy of a clear view of his portrait. The fact that his shop was very dark, dirty and cramped didn't seem to bother Orrie in the least.

The moment that Orrie saw that painting, his view of Circle Arts, and of me in particular, like a weathervane after a storm, did an about-face. Now, just like his past vilifications, his new-found praise was over the top. I would go over to visit him every week or two, and with every successive visit the story of "the painting and the artist" kept building.

One time he told me (complete with dramatic pauses), "Al...they're coming from Detroit...they're coming from Cleveland...they're coming from California...everybody...everybody is coming to see the painting."

He also got to recycle his favourite line into the story of the painting. On one occasion he leaned over, placed both of his big hands on my shoulders, and whispered so only I could hear, "Al, there's an out-a-towner...some sort of artist fella that's been snooping around." As if guarding my fishing grounds from an interloper, "Don't worry...My shotgun's loaded and sitting by the door."

The summer was almost over when I was visiting Orrie and he revealed the following to me. "Al," he said, "God created seven special gifts to give to man. If you're truly blessed you are given one. And Al, you're truly blessed, he gave you one." Still looking me straight in the eye, he added, "He gave me all seven."

He never told me what God's seven gifts were, but humility seemingly wasn't one of them.

I was finding it difficult to adjust to Orrie's constant adoration. I had taken a secret pride in knowing that narrow-minded rednecks and I didn't get along. Nonetheless, I loved hearing those Orrie-isms, although it was often hard to keep a straight face while listening to them. For years after I dined out on retelling them.

Over a period of a dozen years I proceeded to do major canvases of many of Tobermory's retired fishermen, boat builders, guides, horsemen, and homesteaders. These were Orrie's contemporaries, people like Lloyd Smith, Jimmy Rae, John Desjardin, Percy Adams, George Lee, Sy Simpson, Bill Spears, and Lottie Wyonch. *Knifemaker*, however, was probably the most talked about, and not always in a positive way. Many of those older people I painted and that I got to know had, of course, interacted with Orrie their whole lives. Some of them told me

they resented the praise and attention my painting was bringing him, commenting that if I had known Orrie when he was a young man I never would have painted him. "He was a mean son of a bitch," one of them told me.

As the number of tourists and the consequent clamour for his knives increased, Orrie grew testier. He started refusing to sell to certain people, for whatever reason came to him: their dress, hair length, where they were from, or any number of other things. One day he flatly declared to me that he was now refusing to take American money, which shortly after led to refusing to sell to Americans altogether. However, those decrees could be quietly rescinded if he liked the cut of your jib. Just as in the "Soup Nazi" episode on *Seinfeld*, the more unpredictably cantankerous Orrie got, the more tourists flocked in to see him and buy his knives. But things were about to change. In a dark irony, what helped create the overflow of tourist admirers was about to destroy his life.

The *Norisle* and *Norgoma* ferries that serviced the route between Tobermory and Manitoulin Island could no longer keep up with the growing volume of cars and trucks. To rectify that problem, the provincial Ministry of Transportation decided to replace the small, aging ships with a big, high-volume, high-speed ship—a B.C. ferry duplicate. To handle the increased number of vehicles that such a ship could carry, the old ferry dock area would have to be rebuilt and greatly expanded. It was announced that the surrounding land would be expropriated for this, including the land where Orrie's house and workshop stood.

News of that rumbled through the town like the tremors of an earthquake. It was followed by rumours of other large-scale public and private projects coming to Tobermory. Some of the locals saw that as good news: more business, new jobs, more jobs, and better jobs. Others of us saw the destruction of a unique fishing village.

Concerned, I helped start the Tobermory Club for Environmental Quality and a little activist newspaper called *The Tobermory Warbler*. Both were based out of the Circle Arts gallery. Our aim was to try to stop, or at least influence, what was beginning to look like a developers' onslaught. The issue was much bigger than Orrie's personal fate, but I knew that his was a compelling story, one that might strongly interest the southern media. We sent out an avalanche of submissions, briefs,

critiques, and press releases. I was widely interviewed for radio, news-papers, and TV. We contacted *The Globe and Mail*, and, remembering Orrie's *Griffon* notoriety, they sent up Scott Young, their top reporter, to do a story. He wrote a full-page article for their national edition that added fuel to what was already a firestorm of controversy, in and out of town. In its aftermath, we discovered, among other things, that our little group was up against some local and provincial heavy hitters who carried a ton of weight. And it was weight they were well prepared to use against us.

Although we were trying to speak for the well-being of the town, in truth our local support was paper-thin. Most of the villagers *wanted* new development. As for O.C. Vail, his personal plight, by and large, wasn't something too many in Tobermory were about to chain them-selves to his workshop over. Many of the cottagers were very supportive, but most really didn't want to get involved in what was shaping up to be a bare-knuckle brawl. The town's situation was of interest to the outside world, but inside the town the issue tended to isolate Orrie, myself, and my activist pals.

The pending expropriation of Orrie's land, land that he felt a four-generation custodianship towards, started taking a toll on his health. A year and a half after the announced expropriation, Orrie suffered a major heart attack. He was rushed down to the little Lion's Head hos-pital, where the early prognosis for recovery wasn't good.

Orrie's condition became the talk of the town. His health must have created a dilemma for senior bureaucrats in the Transportation Minis-try. Although they were well accustomed to wielding their authority to expropriate what they wanted, it wasn't good PR to have their actions indirectly killing people, particularly if the media were watching.

In his hospital bed, Orrie was getting frailer. He wasn't eating and was rapidly losing weight. When I visited I was shocked. He looked a shadow of himself. I concluded that he was dying. I called his daughter Jane and suggested moving him to the much bigger hospital in Owen Sound. She contacted me a few days later and said the Lion's Head doctor felt he might improve if he had fewer visitors and more rest. The doctor told Jane that from then on only three people would be allowed in to visit Orrie. Jane was to submit three names to the hospital's front desk; anyone else coming to visit Orrie would be turned away. Jane told her father the doctor's decision and asked him whom he wanted on the list.

Jane recalled the conversation to me. The first name he mentioned, of course, was his daughter's. The next was his lifelong friend Ivor MacLeod.

"That's two, Dad. Who else do you want on the list?"

"Al."

"Al? Who's Al?"

"You know…the artist fella."

"Are you sure?"

"Yep."

I felt the weight of being on such an exclusive list. I'd have to visit—and regularly. That wasn't going to be easy. At that point we were living out of town, without a car. To get to Lion's Head I would have to hitchhike there and back—about 85 kilometres up and down a lonely, wind-swept peninsula in the middle of winter.

I visited him about once a week. Mostly the conversation revolved around his health and anecdotes about the painting. Regardless of our narrow range of common interests, I always looked forward to being there, and I think he felt the same.

As winter passed into early spring, Orrie's health steadily improved, and he was finally allowed to go home. The ferry dock construction by that time was in full swing. The ministry, not wanting to appear to be the cause of an old man's death, had decided to temporarily work the ferry dock project around Orrie's house and workshop. They promised him he could remain in his house until he died. This was a major concession for a notoriously heavy-handed government department, and a big relief for a frail old man, but the end results weren't pretty. The construction completely and tightly encircled his buildings, filling in his boat ramp and shoreline. The juxtaposition of his old cedar-shake house and workshop, tightly encircled by chain-link fencing and massively high concrete docking piers a few metres away—with its curbs, aluminum and steel, asphalt, cement, exhaust fumes and twenty-four-hour lighting—was visually and wildly bizarre, like a Salvador Dalí canvas.

In one of the editions of *The Tobermory Warbler* that we published that summer, I wrote an article titled "O.C. Vail Revisited." In it I described Orrie's new extreme reality.

These restricting confines and his failing health have not deterred the annual stream of summer admirers. Urban people mostly, cottagers, campers, summer transients, from all walks of life;

they want to see him and his workshop, buy a knife or lure that he has made, listen to a story or his old-fashioned advice. For them, he and his shop are links to their past, a past rapidly being buried. The meeting of today's generation in an environment such as Orrie Vail's or another "old timer" in Tobermory or elsewhere is a natural and fundamental need and something suburbia doesn't provide. This connection with the past is as valuable a resource as clean air and fresh water, and should be recognized and protected as such.

In 1976, less than a year after the article appeared, Orrie Vail died. He is buried in the Little Dunks Bay Cemetery in Tobermory beside his wife and near his father, and a stone's throw from the waters of Georgian Bay.

Even after death, Orrie continued to lobby for the recognition he had long sought. The inscription carved on his granite tombstone reads:

<div align="center">

Orford Cleveland Vail
1893–1976
Discoverer of LaSalle's *Griffon*

</div>

The ministry tore his house down, and soon after, the ferry dock reconstruction moved ahead as originally planned. Once his land had been sodded and paved over, it was as if four generations of Vails had never existed there.

But his workshop wasn't demolished. Its historic value having been noted, it was hauled away and dropped into a field outside of town. It sat abandoned there for thirty years. Then in 2005, when Parks Canada built its Fathom Five Interpretive Centre in Tobermory, elements of Orrie's workshop, a few of his tools, and some of his story became an important part of the centre's interpretation of Tobermory's commercial fishing history.

I left Tobermory in 1982, but my memory of O.C. Vail and that particular time in my life remains surprisingly vivid. My physical remembrance of Orrie can still be found in my kitchen, in the corner of the counter, beside my cutting boards. His black-oak-handled knives stamped with his name sit ready to peel my vegetables, cut my fruit, and slice my bread. A few of his handmade lures are in my fishing tackle

Late Spring, etching, 4.5" x 13.5", 1972

box somewhere, but as I recall they've never caught much. Then again, there's not much left out there to catch.

After I moved to Owen Sound in 1982, I spent the next three or four years looking for Tobermory and for individuals like O.C. Vail. I did that through numerous painting trips to the outports of Newfoundland. On the accessible-only-by-water south coast I found men and women of the sea who spoke an English or French dialect three centuries old. I drew and painted their weathered faces, their fish shanties, their double-ended dories, and their brightly painted houses held up out of the sea with bracken wood poles.

I was there just prior to the total collapse of the cod stocks and the drastic altering of a way of life that followed.

While there, I was enticed by something I hadn't expected. As I accompanied fishermen in their small dories out on the grey-mountain swells of the North Atlantic, I caught sight of flotillas of drifting white ice the height of Italian cathedrals. No matter how grey the day, they glowed with a powerful ethereal presence. I imagined their birthplace to be some magical, faraway sanctum, like Superman's Fortress of Solitude. Their sight was captivating—their origins called to me.

That singular experience enticed me farther north to the cold coast of North Labrador, where my Arctic contagion fully took hold.

III

CAPE DORSET, 1989

Beware of silent dogs and still water.
— Portuguese proverb

When we were done outlining our plans, the warden stopped drumming the pencil's eraser on the map that was spread across his desk. He sighed slightly, set down his glasses, and rubbed his eyes with his thumb and forefinger.

What followed was more warning talk. We had heard similar things from the Inuit whom we had already met.

The Cape Dorset warden explained in some detail that we were in an area of extremely high tides, some of the highest in the world, which create powerful rip currents between landforms. Also, he said, the South Baffin coast was totally exposed to the open ocean and to westerly, southerly, or easterly winds, making boat travel, especially by kayak, highly challenging.

He forcefully reminded us of the dangers of polar bears and walruses. In water, a 900-kilogram male walrus might charge anything in his territory, including a small boat. On further questioning, however, he admitted that neither mammal had been seen in the area we were headed to in the previous two years. Regardless, he insisted that we take his twelve-gauge shotgun, along with a couple of boxes of shells and a large communications radio. We agreed to call him at prearranged times.

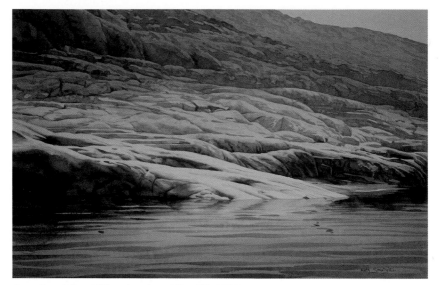

Cape Dorset Coast #1, watercolour, 14" x 21", 1989

To me, the warning talk was a bit overdone. I viewed our expedition as safe and simple: kayak east, hugging the South Baffin coast, explore the land, and return to Cape Dorset two weeks later. I also thought that carrying a cumbersome communication system in the Arctic, particularly in the hatch of an often wet sea kayak, was more trouble than it was worth. It set up expectations at the other end, expectations that, when not met, could create a lot of unnecessary anxiety. As for the shotgun, we were already carrying a flare gun and a bear-bammer, which are exploding projectiles, to frighten off bears that were already regarded as rare in the area. However, I kept my opinions to myself, as the others in my group were delighted with these additional grown-up toys.

The last warning we got was never to set foot on any of the many islands that dot the coastline. The Inuit left their sled dogs on islands to run free in the summer instead of tying them up in town. We were told they became quite wild and very savage on the islands, particularly if their owners hadn't been out to feed them for a while.

The expedition was an exploratory trip initiated by Black Feather, a well-established Canadian adventure outfitter. From the town of Cape Dorset on Baffin Island's southern tip we would paddle east with the

objective of assessing the area's feasibility for future kayaking trips. Our little expedition included four others and myself.

Jean Huard was our guide. In his mid-thirties and bilingual, he was big and handsome and smiled all the time. Everything he did had grandness to it. He ate big, laughed big, and lived big—he could have been a *coureur de bois* in another life. But behind his jocular nature, Jean was prudent and careful, essentials for a good guide. When the warden was issuing his cautions, Jean paid careful attention, at the same time never conveying any sense of worry. He accepted the radio and the shotgun without reservation, but then again, he liked to hunt.

For this exploratory trip, Jean had asked two travelling buddies to join him for what he called "a bit of a romp." Thierry and Jacques were both adventurer types from the Gaspé. The final group member was Tyler, a young guide in training from Toronto. He sold outdoor gear at a retail store in the off-season. I had travelled with Tyler two years previously on a Greenland expedition, where he was an assisting guide.

In the afternoon, after the briefing by the warden, we purchased fuel, sorted through our equipment, and finished selecting and packing our food. We hauled everything down to the water, where a small crowd of local Inuit gathered to watch.

Our mode of transportation was sea kayaks, one plastic hard shell and two folding tandems. The kayak was something the Inuit onlookers knew more by reputation than through hands-on experience. They watched as the two foldable tandems' long, heavy canvas skins, with their various cockpit and storage-hatch holes, zippers, and rubberized bottoms were unfolded on the ground. The inner framework consisted of dozens of colour-coded aluminum rods that needed to be connected and inserted. The small pieces had to be joined and fitted inside the boat's hold in a specific sequence. Even if one had done it before, which we all had, putting a tandem together was still a tricky, frustrating, and knuckle-skinning procedure that repeatedly elicited the question, "Are you sure this fits here?"

As the Inuit watched us trying to put the boats together, their friendly banter and joking trailed off. It was my guess that they viewed as worrisome our trial-and-error attempts to turn a pile of metal poles and a long canvas bag into a seaworthy boat. As Jean, Thierry, and Jacques worked on one boat, singing "Vive la Canadienne" and lapsing into gales of howling laughter, the onlookers began to drift away. I was

sure their thinking was that not getting to know us better meant they wouldn't have to mourn the news that we had been lost at sea. They must have been wondering if these good-natured southerners were about to perish in Arctic waters because they were crazy gung-ho types or simply naive city fools.

Ironically, a few years later Jean was hired by the producers of *Black Robe*, a film based on the conflict between French Jesuits and Native people. He went on location in northern Quebec to work with the local Indians who had been hired as extras for the film. His job was to teach them how to paddle a canoe.

Fear of sea kayaking is not uncommon among the Inuit of the Canadian Arctic. They happily abandoned the kayak after the gasoline motor and the open boat were introduced. Even back when kayaking was first documented, before there was a choice between paddling and driving a boat, the Inuit regarded hunting in sea kayaks as deadly work. Their oral tradition to this day retains stories about capsizing kayaks. Their kayaks were made for hunting: narrow at the beam for silence and speed, and correspondingly easy to tip. Embedded deep in their culture was the understanding that travelling across rough, ice-cold water in minimally constructed boats, hunting large, thrashing sea mammals, was a perilous undertaking.

In both materials and design, the modern sea kayak is a very different craft from its ancestor. It is much wider, contains flotation compartments, and when loaded properly is safe for travelling in moderate seas. The foldable tandems are particularly stable in rough water. The risk of capsizing, however, is always there. What makes the Arctic so dangerous is the water temperature. Survival in that water, after a dunking, is measured in minutes.

As we were about to load our kayaks, the warden came down to the shore and said he had found a motorboat that we could hire to take our stuff and us up the shore to start our trip. Cape Dorset is on Dorset Island, and he considered it risky to paddle across the three or four kilometres of open water to Baffin Island.

I felt as if I were still living with my parents, with my dad driving my date and me to the show. Jean, however, thanked the warden for his thoughtfulness and concern. He hired the boat, and in doing so showed respect for the warden's opinion and authority, helped the local economy a bit, and started to build bridges in the town that might

prove to be very useful should regular sea kayaking trips out of Cape Dorset become a reality.

The open twin outboard banged and slapped its way across the wide channel to the southern end of Baffin Island. We plied the shoreline looking for a place to land and unload, and found a spot six kilometres along the coast. In the light of the midnight sun, we set up camp.

When we awoke the following day, everything had changed. Our little bay had practically disappeared. Instead of being near our tents, the water was hundreds of metres away. The extended shore exposed a mucky slick of seaweeds, sloughs, puddles, pools and mud flats, half-buried boulders, shellfish, jellyfish, tiny alewife, invertebrates, and scads of unidentifiable stuff.

The Cape Dorset coast is subject to ten-metre tides, depending on the moon's phase. We knew this and had all visualized what a depth of ten metres would look like, but seeing it happen along a low coastline was startling. Across a horizontal expanse the tide's measure was made in hundreds of metres, if not kilometres, depending on the depth of the water. It meant that landforms would appear in the morning and disappear by afternoon, or vice versa.

The tides there have a roughly thirteen-hour cycle: six and a half hours out and six and a half hours back. It sounds simple to account for but it isn't. We ended up having to make our arrival, departure, and paddling plans based not on what we were doing, how we were feeling, if we had eaten, or the weather, but on the tide cycle. The one consoling factor was that in an Arctic summer we could paddle throughout the night if we wanted or needed to.

At that first camp, Jean acquainted us with our little arsenal of weapons. We went over how and on what occasion we would use the bear-bammer and the flare gun. We all practised the loading, carrying, and firing procedures for the shotgun. Jean said that only he would do the shooting but that the rest of us should know how to fire the rifle, just in case.

Our route was east along the coast, which meant that most of the time we were subject to paddling in open water and to the mighty swells of Hudson Strait. The wind pattern was usually light to moderate during the day, dropping somewhat towards evening.

According to our chart the southern coast of the Foxe Peninsula was to our left. It is a huge land projection on the southwestern extremity of

Baffin Island. To our right, at least in theory, were some small islands and then open ocean. In reality, however, the tides made the coast a confusing jumble of inlets, coves, islands, and bays that had the pesky habit of disappearing and then reappearing.

A few days out, we camped at the back of a big bay. We didn't know exactly where we were, so after supper Jean and Thierry took one of the tandems and the area map and paddled out to open water, attempting to pinpoint our location. I watched them leave in the late evening while doing a watercolour on shore.

The watercolour was a simple composition of sky, land, and water. The sky was cast in a deep orange-coral that moved to a faded salmon and then to a warm, clear grey before a transition to blue-mauve. The gradation was marked with blurred slashes of clouds and a few brilliantly lit jet streams.

That evening there was to be a solar eclipse, and I wanted to try to paint the effect. I had been in the shadow of the moon before, but not in the Arctic.

The sun was just below the horizon when I noticed a dark veil begin to shadow the sky and earth. It started in the west and slowly crept east like an approaching storm, with unseen clouds. The light and energy on the land and water dulled and quieted, as if muffled by a translucent shroud. The squawking of waterfowl ceased, as did their flight.

The sun's diameter is four hundred times that of the moon, and, as it happens, four hundred times farther away. This extraordinary correlation gives the illusion that the sun and moon are of identical size. Science long ago accounted for this day darkness; nonetheless, an eclipse still arouses more than simple curiosity. As it has done for millennia, the occurrence stirs the soul and invites one to stray from the path of linear thinking.

The ancients explained eclipses in many ways but inevitably tied them to the approach of something ominous. The Chinese believed they were evidence of a celestial dragon devouring the sun. The Egyptians understood them as a mythic sea serpent pulling down the sailing ship of their sun god. For the Greeks, they foretold the overthrow of the natural order. The word "eclipse" is rooted in the ancient Greek *ékleipsis*, meaning "abandonment" or "downfall."

When it was over and I had returned to my painting, nothing was the same. The light in the sky had changed a bit, but the foreground

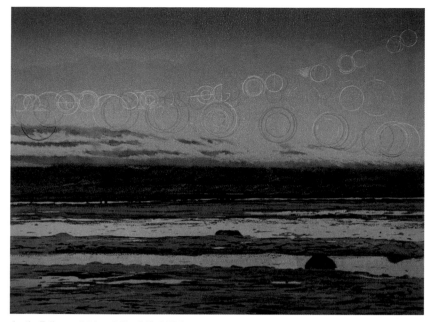

Arctic Eclipse, etching, 18" x 24", 1989

was gone. The large bay was totally drained of water. It must have been of even depth, because it had gone from a reflective inlet to a two-kilometre stretch of mud in half an hour.

Sometime later, I spotted Jean and Thierry with my binoculars. They were about two kilometres out, carrying the tandem on their shoulders and slogging through the bay's mucky sea bottom. Plodding along, shouldering the heavy tandem, it took them over an hour to reach camp. True to form, the first thing Jean said to me when he clomped up on dry land and put the kayak down was, "Geez...wasn't that an amazing sky!"

The land there was mostly rock, metamorphosed granite, old, worn, and part of the Precambrian Shield. Inland, far to the north, the Foxe Peninsula rose more prominently, but nothing along the coast was much above 10 or 15 metres high. That area must have been what the Norse saw a thousand years ago, when they went exploring west from Greenland. They called Baffin Island *Helluland*—the place of flat rocks. According to Norse

sagas, chief among their reasons for venturing off into the unknown were to find wild grapes for wine and large trees to build boats.

Smooth, rolling rock dominated the terrain, but in the notches, crevices, and low areas, enough soil had collected to sprout a variety of cushion plants, avens, saxifrages, and bell heather. In the deepest and dampest depressions, small shrubs and miniature willows and poplars grew a couple of metres high. Furry pads of mosses, and discs and tiny splatters of ochre, orange, and charcoal lichens, clung to the rocks and boulders.

Local sculptors had found a variety of interesting carving rock somewhere there that included peridotite, a dark-green and black stone, as well as skarn rock, an unusual type of yellow-green marble. James Houston, an artist and government administrator, travelled to the Arctic in 1949 to explore ways for the Inuit to supplement their income and is credited with introducing them to the concept of making stone, ivory, and bone carvings that could be marketed in the south. In the late 1950s, printmaking techniques were introduced to the Inuit and Cape Dorset became the leading Arctic community to use this technique. The Inuit made their images on large, flat stones, carving them like wood blocks and then inking and printing small editions on a block or litho press. The demand for the prints, as for the carvings, was immediate, both in Canada and around the world. A sophisticated promotion and marketing network followed, helping Inuit artists become an important force in contemporary art. Cape Dorset's reputation as an artistic community was one of the reasons I had been asked to join this expedition. I was to help assess if the region's art would be of cultural interest to future trippers.

꒰ꕤ꒱

Paddling in the tides was not a concern, even when they demonstrated their strong riptide effects. But making and breaking camp was unusually hard work, mainly when getting the boats into the water or when disembarking onto dry land. With a soft bottom, a tandem can't be dragged like a plastic boat. A fully loaded tandem is very heavy and generally requires eight people with carrying straps to lift into or out of the water. With only five of us, moving the loaded boats was made even harder by the severe tides. Leaving or arriving at any time but high tide was nasty business.

When the idiosyncrasies of our radio and its 60-metre ground antenna wire allowed, we phoned in our location to the Cape Dorset warden. We didn't see any walrus or polar bears but we did pass an island occupied by at least a dozen dogs.

Due to the effort needed to deal with the high tides, we began to spend less time paddling and more time exploring the land. We often spotted ptarmigan, grouse, and Arctic hare. Barren ground caribou wandered the interior individually or in family groups. They have poor eyesight, and if one is upwind, it will sometimes get quite close before running. Jean said that putting our arms up in the air would often cause them to mistake us for other caribou. The difficult part of that getting-close technique was not breaking out in laughter, seeing several men holding their arms in the air out on the tundra.

Jean asked the group if we had any qualms about hunting. Jean hunted, as did Thierry and Jacques. Tyler didn't hunt, and I don't think he approved of the idea. However, I surmised that Tyler was reluctant to voice an objection to our group's he-men. Jean said that we would eat whatever we shot, so strictly speaking, it was hunting for food. I didn't make a big thing out of it but I offered my opinion, saying I thought it was appropriate to hunt for food if we needed food, but since we had three boatloads of food, we had no right to go around shooting animals.

A few days later, after an afternoon spent individually hiking the interior, we regrouped for supper. As the evening meal was being served I noticed an odd, nervous silence descend over the rest of the group. When my bowl was passed to me and I went to take my first bite I felt everyone's eyes on me. When I looked up, Jean, Thierry, and Jacques were wearing suppressed smiles. I looked down and trolled through my vegetable stew to find a wee clump of meat clinging to a tiny leg bone, which, I presumed, had once belonged to a local ptarmigan. I picked up the precious little morsel in my spoon and, saying nothing, held it aloft while issuing my sternest glare at the lads. There was a moment's silence before everyone broke out into rolling laugher.

We did carry a plentiful supply of food. In fact, we had more food with us than on any other trip I've ever been on. Jean's philosophy regarding food, and most other things, had a controlled wildness to it that I liked. His pre-trip instruction to the group was simple and direct: "If you're hungry and see something you want to eat, eat it." Backpacking trips were something Jean either refused, or was never asked, to guide.

Compared to Thierry, however, Jean was practically a timid school-boy. Thierry was about six feet tall, with a full beard and bushy brown hair like a grizzly bear. He walked with big strides in his non-flex, thermal-lined, white plastic boots. He wore pants that had foam-insulated pads sewn onto the knees and rear so that he could always sit or kneel in comfort. Unless it was raining, Thierry never slept in the tent. He'd take his sleeping bag to the top of the nearest rise of land to spend the night sleeping under the stars. Jean had great respect for Thierry and loved to introduce his friend using his exaggerated backcountry Quebecer's accent, something like, "Dere he come, de Mad Mountaine Man!" which was always followed by Jean's maniacal laugh. Thierry was no madman. However, he was as at home in the wild as anyone I've ever seen—an authentic explorer of silence.

One morning, Tyler got up before the rest of us and went for a long walk. When the rest of us had finished breakfast, Tyler still hadn't returned. While cleaning up, Thierry took the remainder of the porridge a couple of hundred metres from the camp and emptied the pot out on the tundra. He said it was for a fox that he'd noticed following us as we'd been travelling the coast. When Tyler returned, he asked if there was any porridge left. Thierry said there was and asked Tyler if wanted some. Tyler said yes. Thierry wandered away from the camp and scraped up the porridge into Tyler's bowl. Seeing this, Tyler thought Thierry was kidding. Then, realizing he wasn't, and not wanting to appear wimpy, he ate the retrieved porridge.

Several years later, Thierry Petry carried out several major expeditions, including a 1,300-kilometre trek to the South Pole. Thierry with a companion did it unassisted, becoming only one of a handful of people to do so. He suffered severe frostbite on the expedition, which called for the removal of a number of fingers. Against all advice, he devised his own groundbreaking medicinal remedy, which saved and rehabilitated his fingers.

About halfway through our trip we awoke one morning to still air and a hard rain. We paddled in the downpour until the noon sun broke through and bathed us in warmth and humidity. We stopped on an indent of land facing the open ocean with a couple of narrow offshore islands in view. Our lunch was pancakes deep-fried in butter, with syrup, some Florida oranges, and a fresh-brewed pot of coffee.

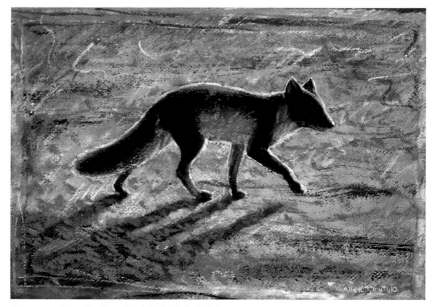

Scavenger Fox, mixed media, 10.5" x 14", 1990

While we ate, relaxing in the sun, we noticed some movement among the shadows on one of the offshore islands. It was about half a kilometre away. With binoculars we counted six dogs, noses in the air, picking up the smell of our food. We observed the lead dog, followed by the others, move along the shore to where the wind was carrying the scent of pancakes. It was clear they were becoming increasingly fixated on what we were cooking, but they didn't make a sound. Given that there was a lot of water between them and us, we found their interest in our food amusing. Buoyed by our full stomachs, we yowled out numerous howls, taunting the dogs like young pranksters.

Our behaviour belied the fact that we all knew how exceedingly dangerous Inuit dogs can be. They are not pets. They are raised to work, and from their wild lineage, tough environment, and the fact they are often not treated well, they demonstrate an aggressive, "survival of the fittest" pedigree. At almost every Arctic village I ever visited, I heard recent stories of dogs snapping chain restraints to go after people, usually children. Death from dog mauling is not at all uncommon there.

After lunch we packed up and launched our boats, taking a swing by the island to get a better look at the dogs. They didn't see our approach, nor had they recently been paying attention to us. But at about 60 metres, the lead dog spotted us and quickly alerted the pack. They gathered in silence, standing motionless, their feet at the water's edge, their eyes glued on us. Paddles at rest, we eyed each other across 40 metres of still water. Then, to our astonishment, the lead dog led the pack into the water and they started swimming directly towards us. Our first reaction was stunned incredulity. We sat and watched what we were sure was going to be a very quick about-turn in the icy water. But no, they kept coming, their eyes fixed on us. And they came with surprising speed.

In no time they were halfway to us. Without saying anything, at least anything that could be said in polite company, we all started paddling like crazed maniacs. Whacking each other's paddles in a froth of white water, we managed to get our boats turned around and headed away from our pursuers. We dug in and pulled hard and fast. After a minute or two we stopped paddling and looked back, expecting to see demoralized dogs turned around and heading back to the island. But, my God, they were right behind us, we had barely gained on them. We paddled at the fastest stroke rate that was in us. But they wouldn't give up. Again we put our full force into it, and only gradually were we able to pull away from them. One by one the trailing dogs turned back until only the lead dog remained. He pursued us for over a kilometre before he finally gave up.

By late afternoon a west wind had rid the sky of clouds. The air was charged with blinding light. The fireball glowed a tinged white as it slid diagonally towards the ocean. As the sun's glare started to mellow with the earth's atmosphere, two sundogs began to appear on either side of the sun. They were connected around the sun by a giant half-circle of light, as if an arched doorway to heaven had been left ajar. The curved band's coloration ran through the light spectrum, from mauve closest to the sun, to red, orange, yellow, green, and finally fading into blue. Above the horizon, at twenty-two and a half degrees' separation, balanced on either side of the sun, slivered halos of bright light split open into two mock suns—sun dogs.

At that moment both land and sea were perfectly still, seemingly devoid of life. The low sun and its twin companions gave me the feeling of suspended reality, as if I'd been transported to a parallel world, a mythic land, or an alien planet.

Sun dogs are not infrequent in the Arctic sky, and not surprisingly, they feature in Inuit mythology. An important Inuit legend has it that long ago, two sun dogs were duty-bound to pull the sun across the sky, giving continual daylight. One day one of the sun dogs fell in love with a beautiful, lonely land maiden called Avilayoq. The sun dog decided to leave the sky to join her. On land they made love, and out of Avilaloq's womb came the human race. The remaining sun dog, too weary to pull the sun across the sky by himself, rested. Night and cold fell across the land when he stopped, and perpetual daylight was no more.

Lacking food in the cold darkness, Avilayoq and her people built a boat of driftwood and skins to go on the water to seek food. Her sun dog lover declined to go, so Avilayoq departed onto the sea without him. Great winds and a rolling sea caused the boat to tip, and Avilayoq fell into the deep ocean. She drifted to the bottom, and it was there that Avilayoq changed to become walrus, seal, polar bear, and whale—the animals required to feed her people. Thereafter she became known as Sedna, the sea goddess. With a broken heart, the sun dog returned to the sky, but he never recovered the will to continually pull the sun across the sky.

With our trip essentially over, we made our last campsite at the back of a long, rocky inlet, a day's easy paddle from Cape Dorset. Jean was scheduled to fly out of Cape Dorset the following evening to lead a Nahanni River canoe trip. The rest of us had flights out the day after. Jean asked the group if we wanted to paddle back with him the next morning or come the day after that. We all agreed we would prefer to spend the extra day on the land.

The morning saw a beautiful, crisp, clear sky. We took a group photo before Jean left, the five of us hamming it up with our travelling arsenal of bear-bammers, flares, our gun, the radio, and any other pointy or shiny objects we could find. After loading his solo boat, with a big smile, Jean waved goodbye and pointed his kayak towards the outer bay and the open ocean. His paddle flashed and glittered like welding sparks on the water's smooth surface. As I watched his boat disappear, I felt his absence immediately, although I didn't know why.

That evening, Tyler and I hiked to a rise of land near our camp, the highest we'd seen along the coast. There we watched a line of ominous clouds building rapidly over the ocean, coming from the southeast and glowing a sulphur-grey in the evening light. The effect produced a brief but crystal-clear rainbow that terminated directly at our campsite. It was stunningly vivid considering that it was so close. By the time

we got back to camp, big spatters of rain had started to fall. The rain continued, gaining in intensity throughout the night, blown by a stiff southeasterly wind.

In the morning, under a tarp, the four of us ate breakfast in the pitter-patter of a light drizzle. The cold wind had let up some, but the sky, land, and water remained a slate of monotone grey. We packed up, stuffed our wet tents, tarps, and bags into the holds of our tandems, and departed.

Tyler and I were in one tandem, Thierry and Jacques in the other. Thierry and Jacques, who spoke only French, constantly sang Québécois standards. Jacques was a disc jockey in the Gaspé and knew lots of songs. He was small in stature, strong and quick, and full of energy. He seemingly needed at all times to be walking, paddling, singing, or talking.

Leaving the bay, we hugged the coast in the lee of the wind. We stayed close together. By noon we had rounded the rocky point of the long bay, and with the protection of the inlet behind us we were presented with formidable ocean swells and a mass of wind-whipped whitecaps from Hudson Strait. Our progress slowed to a crawl. The coastline, our route, was now straight, containing no inlets or bays, with only a smattering of tiny offshore islands offering us anything by way of a windbreak. The town of Cape Dorset sat at the far end of that exposed coast, across an open channel.

For two hours we inched forward within 50 metres of the coast as the sea lashed and pounded its rock walls. Over that time it grew clear to me that the wind's force was building. Increasingly it was picking up wave crests and delivering a spray of salt water over us. I watched the front third of Thierry and Jacques's kayak hang momentarily suspended in midair before the wave continued under the boat, plunging the tandem downward into the trough, completely submerging the same front third, until another wave lifted it back up again. The boats were leaking and were carrying a lot of sea water inside the cockpits and hatches. We had to use the hand pumps every twenty minutes to bail out the boats. They were well-seasoned, battle-weary rentals that had been used and abused for years in dozens of Greenland and Eastern Arctic expeditions. I wondered if their patched and scraped fabric skins, and the narrow, aluminum-rod frames, could still withstand that type of stress.

I was growing more and more uneasy about proceeding but didn't see any obvious alternative. Big, rolling breakers were crashing against the high-walled coast to our right, making landing impossible. Our

destination seemed tantalizingly close, with the large, white oil-storage tanks of Cape Dorset visible among the low-flying clouds in the distance. Yet at our current rate of progress, about a kilometre or two an hour, we were at least three hours from Cape Dorset, maybe more. Reaching it would be hugely difficult, if not impossible, if the storm continued to intensify.

Tyler told me he had similar concerns about the building storm and about us proceeding. But when we broached the subject with Thierry and Jacques, they wanted none of it, telling us we had no choice but to keep going. We tried rafting up behind a small knob of an island to talk it over but the swells made it impossible. Wet and chilled, we munched down a few granola bars and continued on. The storm was indeed escalating, building to a new level of ferocity. The wind and water, void of colour, melded together into one collective fury. It brought to mind a line in Gordon Lightfoot's "The Wreck of the Edmund Fitzgerald": "Does anyone know where the love of God goes / When the waves turn the minutes to hours."

We inched on, minute by minute, every paddle stroke increasingly committing us to proceed. Our effort made revisiting our plan and reversing our route all the more difficult to contemplate. The four of us shouted back and forth over the lashing wind. In broken French and English, we tried to reach a consensus on what to do. The Quebecers were absolutely steadfast in their desire to keep going. I believed it was too risky, that we needed to turn back. Furthermore, I didn't think it a close call. The wind was now consistently driving wave crests over our cockpit spray skirts. We avoided the peaks of the rolling walls of water by regularly lifting our elbows and paddles as waves washed our torsos. As the storm grew in strength we neared the most exposed and dangerous part of the journey—a two- or three-kilometre channel crossing of totally open water.

Tyler now suggested a middle ground. He proposed paddling a little farther along the coast until we reached the last island before the crossing. There, in the lee of the island, we would stop for a break if we could, eat something, and make a final decision. Thierry and Jacques begrudgingly nodded, clearly fed up with the two *Anglais* telling them what should be done.

A half hour later we halted in the lee of the last island. We were out of the wind, but with the surrounding furor, the sea was heaving and

falling more than a metre against the shore rock. Getting out was going to be a trick. I wasn't at all certain that it was even doable. I could see the Quebeckers were really not thrilled with this going ashore idea. Since I was the plan's strongest proponent, I thought I should be the first to attempt it. Tyler and I manoeuvred as close as we dared to the rock, trying hard not to rip the kayak's soft undercarriage. We found a small shelf that looked as though it might offer a foothold. I prepared myself as Tyler steadied the boat as best he could. At the high point of the surge I managed to get out, and held on with a death grip to the green sea growth that clung to the barnacled black rocks. The following surge carried up my legs to my waist. I managed to keep my balance and my hold. I wasn't worried about getting soaked; I was already wet all over. I helped the others climb out of their boats and onto a narrow rock shelf. We temporarily slid the kayaks up onto a seaweed rock bed out of the water and tied them securely to some rocks higher up. By the line of sea growth on the rocks it appeared to be about two metres from high tide, but we weren't sure if it was coming in or going out.

We were soaked, tired, and hungry and soon to get cold. But acute anxiety, worry, and tension overrode everything. Just above our little landing spot we set up a tarp and the stove from one of the boats and made some soup inside a narrow crevice.

In broken English, Thierry made it clear that he wanted to keep going, feeling that we were wasting time stopping. When I mentioned that the storm was building it just reinforced Thierry's feeling that stopping on the island was a stupid idea since the storm, he said, could last for many days. Jacques, who didn't suffer waiting easily, felt the same. For me it was clear that this storm was moving towards gale classification, if it wasn't already there. In my mind, leaving would be crazy, literally suicide. Tyler knew, as did we all, that one thing was certain: whatever we did, we had to do it together. If ever I missed Jean, it was then.

While soup was heating, Thierry noticed that in our immediate vicinity there were traces of dog feces, bits of chewed bone and tufts of hair. I hoped they were old or had somehow washed ashore. Uncasing and loading the shotgun, Thierry and Tyler went off to see exactly what we had landed on. The island was oblong in shape, about 100 metres long and 50 metres wide, with a six-metre height above the high-tide mark. They reported that fresh signs of dogs were everywhere, includ-

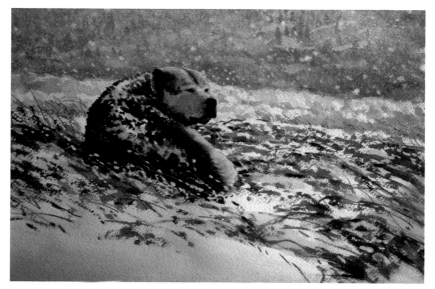

Sled Dog #1, watercolour, 10.5" x 14", 1984

ing a couple of chewed carcasses of young ones, but that there were no dogs on the island. Before I had a chance to feel relieved, they added that on a very small adjacent island, only 30 metres away, on the opposite side of us, there were lots of dogs. By staying low, out of their sight, Thierry and Tyler had counted a pack of at least fifteen. It wasn't possible to determine if the dogs had swum to the adjacent island or walked there at low tide. Even though they were right beside us, they couldn't pick up our scent as the wind was blowing from them towards us.

That discovery immediately stiffened Thierry's and Jacques's resolve to leave, no matter what. Although I understood and shared the fear of being attacked, particularly given our experience with dogs a few days earlier, I still strongly disagreed. I suggested to Thierry that if we left we might be in a situation within an hour where we would give everything we owned to be right back here. Thierry countered with the opposite scenario, saying that in an hour's time we might deeply regret not having paddled on.

We left it at that. Emotions and tensions were high, and a consensus appeared out of reach. My feeling was that if we stayed on the island the worst-case scenario would involve being attacked, which might result in some of us getting bitten. But with our shotgun and a full box

of shells, I figured the dogs would come out on the losing end if that happened. On the other hand, if we left, the worst-case scenario was that some or all of us would drown. I was certain that no one could survive capsizing out there. A kayak rescue just wasn't plausible in such a gale. Anyone who tried would surely go under too.

The final decision was ultimately made for us. Within the next half hour, the sea became a frothing, raging tempest. The spray from the crashing waves was reaching us from the other side of the island. Any open boat, no matter its size, would be in peril in such a sea. The Quebecers ceased their advocating. Until the wind dropped, the four of us were going nowhere.

We surveyed the island for a spot where we could camp. We found a small, irregular rocky ledge out of sight of the dogs and partly out of the wind. We had to position our two tents so that the doorways were jammed together. On that barren and rocky outcrop, finding rocks to anchor our tents was a big problem. We first combed the island and then resorted to fishing rocks out of the sea. We carried them up the slippery slope of the island's steep incline to our meagre site. Every sizable rock that we could find was required to keep our tents from becoming airborne. Next we secured our kayaks well above the high-tide surge. All activity was restricted to our side of the island, out of the dogs' view.

We ate what cold food we had, not wanting to create any cooking smells. The water that had collected in small pools and puddles on top of the island contained too much salt to drink. The waves continued to hammer and thunder as we went to bed. Tyler and I were in one tent, Thierry and Jacques in the other. Thierry and Jacques had the shotgun; Tyler and I had the flare gun and the bear-bammers. Given that the tents' doorways were jammed tightly together, I wasn't sure which was a greater threat, getting mauled by dogs or shot by the Quebecers. At that moment, though, I was too exhausted to care. The last thing I remember hearing before falling asleep was a cartridge being pumped into the shotgun's firing chamber.

I was awakened repeatedly throughout the night by the flapping and whipping of our tents' nylon surfaces and guide ropes. Amazingly, the first light of morning dawned bright, fresh, and clear, with only a moderate wind. We munched a breakfast of apples and granola and talked in whispers. We broke camp, lowered and packed our boats, and departed the island for Cape Dorset.

Last Migration, etching & chine collé, 18" x 24", 1993

We paddled across the sparkling-blue channel with big grins and much merriment. To our surprise and delight, Jean was standing on the Cape Dorset shoreline to greet us. He was overjoyed and much relieved to see us safe and sound. His plane had been grounded due to the storm. Jean's rescheduled flight was departing within a few hours. Over a big breakfast, we had a chance to fill him in on our stormy paddle and our stay on "Adventure Island." I asked Jean what would he have done out there. Without hesitation he said he would have turned back to our original campsite after seeing the size of the sea.

We went to the airport to see Jean off. Then Tyler and I took the radio and shotgun back to the warden's office. The warden greeted us warmly, saying he had been really worried about us as the storm began to build. We told him we'd tried to contact him while on the little island, but the radio, predictably, hadn't worked.

He told us that on the afternoon of the storm Jean was extremely anxious, wondering if we had found a safe place to sit out the blow. Jean felt deeply responsible for our safety and regarded his leaving us as a big mistake.

Tyler offered a remark about the Arctic being a great teacher.

The warden lifted his eyebrows and said, "Yeah, I guess it is, if you survive the lessons."

After I returned home, the expedition's sponsor, Black Feather, asked me to write an assessment of Cape Dorset's suitability for future sea kayaking trips. Arctic outfitters normally look for three things to determine whether a place is commercially desirable for tripping: a stunning landscape, abundant or rare wildlife, and an interesting culture. Having one or two of these qualities is a prerequisite; having all three in one place is great but rare.

The Cape Dorset landscape has its own beauty, at least to my eye, but it wasn't likely to rate high on the scale of "knockout" gorgeous locales. Its significant wildlife was caribou, which were plentiful and easily spotted. But any area's assets have to be measured against its inherent risks, and we'd certainly found a few of those. Ten-metre tides, islands of marauding dogs, and long expanses of exposed coastline conspired to make future sea kayak expeditions for southerners difficult to imagine.

For me, the area's liabilities might have been mitigated had the Inuit artists been in their studios, working and accessible. It would have been interesting, after a kayaking trip such as ours, to see and hear how Inuit artists visually convey their stories to others. Unfortunately, Cape Dorset's printmaking workshops and studios are empty most of the summer. Their artists are out on the land.

IV

THE SYDENHAM RIVER, 1989

If you're going to live by the river, make friends with the crocodiles.
—Indian proverb

As I remember it, that Sunday morning was especially clear and fresh. The sky held a few of those white and dove-grey clouds that are somehow distinctive to autumn. Seagulls called and drifted high overhead in the updraft of an offshore breeze. Like red wine, the air held the musty-sweet scent of decay and the memory of summer.

It was a special day. I had just purchased my first sea kayak and I was going paddling.

That purchase back in 1989 roughly coincided with the emergence of the sea kayak in mainstream popularity. It was starting to be seen as something beyond a boat for elite adventurers or as an artifact of Inuit history. Its acceptance grew to the point that by the end of the twentieth century it had replaced the iconic canoe for dominance in open-water paddling.

Mine was pre-owned, a well-used, if not abused, rental. It was a high-capacity fibreglass boat with a 60-centimetre beam, five metres in length, made by Current Designs, a well-regarded Canadian manufacturer. The model, called Pisces, had, in kayak terms, a "West Coast" look. It was a stable expedition boat, although somewhat staid in appearance.

I thought it elegant enough, yet it did lack the sumptuous upturned bow and the flowing curves of the Solstice, their other expedition model.

At that time I'd been kayaking for only two years. My reason for taking up sea kayaking in the first place was to have a means of moving around in remote areas—areas that I wanted to depict as an artist. The remote area at the time was the Arctic, and since the Arctic had few roads and no ferry service, sea kayaking and backpacking were my travel options. My first major sea kayaking trip was a two-week expedition in the summer of 1988 into the huge fjord complex that lies just north of the town of Nuuk on the west coast of Greenland.

On that trip I learned that sea kayaks carry, within reason, whatever you like. Even packed with hundreds of kilograms of stuff, once the kayak's undercarriage leaves shore you're liberated to a large extent from the forces of gravity. Also on that trip, I realized that the kayak is more than just a way to transport my stuff and me.

The boat connected me with the marine environment, although in rough water that connection sometimes made for arduous work. But even in those wilder times, the control and stability of the sea kayak were vastly superior to a canoe's.

Unlike a motor-powered vessel, the kayak negated all attempts to dominate the environment. That in turn led to more encounters with sea life, with only the paddle stroke adding to the sound of the water.

The sea kayak also worked for me in a visual way. The normal paddling pace allowed elements in the water or on the land to change, but at a rate that could still be absorbed. A kayaker's low vantage point, half a metre off the water, amplified reflections and gave things a more dramatic perspective. The paddling of a sea kayak was done with a physical symmetry, wonderfully compatible with the making of observations. That heightened ability to concentrate on the visual surroundings was enhanced by foot pedals that effortlessly controlled the boat's course, no matter the water currents or wind direction.

⌒⫏⌒

I carried my boat to the edge of my backyard, which backed onto the Sydenham River. The Sydenham is a gentle, medium-sized waterway, fed by sloughs, streams, and wetlands 15 kilometres inland. It meandered through the city of Owen Sound and my backyard before flowing into Georgian Bay.

At my property line I paused to ponder my next move. A steep 10-metre ravine separated me from the river below. I also saw that the riverbank was lined with anglers. A fishing derby was going on in Owen Sound—a ten-day affair sponsored by the Sydenham Sportsmen's Association, with prizes awarded for catching the biggest and specially tagged fish. The event drew plenty of locals as well as anglers from southern Ontario and the northern United States. Most fished on the water in Owen Sound's outer harbour or farther out in Georgian Bay. But along the inner harbour and for couple of kilometres up the Sydenham, those without boats fished from the shore.

Holding on to the bow's throw rope, I slid the kayak down the steep riverbank to the water. Its weight, its smooth fibreglass underside, and a blanket of fallen leaves encouraged it downward in a barely controllable manner. I only partly succeeded in keeping my balance and in preventing the boat from banging off tree trunks and protruding rocks. Heads turned upward as a line of miffed fishermen watched my attempt to use the tow rope as a brake line. Fortunately, I was able to halt its momentum before the kayak launched itself or one of the fishermen into the river. None of the fishers said anything to me, but their collective look was asking, "What the hell is this asshole doing?"

Although in the middle of Owen Sound, that particular section of the river was lined with mature hardwoods, saplings, and unkempt scrub. Well-trodden pathways framed both sides of the water's edge. At times the paths were used as general-purpose walkways to a small levee, called the Mill Dam, a couple of hundred metres farther upstream. But the trail got its heaviest use from fishermen, whether there was a derby on or not.

I put my boat in the water, got in, lowered the rudder, adjusted my foot pedals, put on my life jacket, and attached the spray skirt. After my inauspicious entrance, I tried not to dilly-dally, being at eye level and in uncomfortable proximity to a dozen green rubber boots.

I pushed off from shore, made some final adjustments, and pointed my boat downstream. The feeling of exhilaration and liberation that normally follows launching was short-lived. My eyes were greeted by a hundred lines of monofilament draped from the shore into the middle of the river. Like a float, the only float, in a Santa Claus parade, I was the object of everyone's full attention. But the expression on the faces of my audience carried a total absence of mirth.

River Ice (Sydenham River), oil on canvas, 22" x 34", 1987

As I contemplate the gauntlet of fishermen, rods, and lines that lay before me, two contradictory thoughts took hold. One was a strong impulse to abort the mission. As anyone could see, it was not the appropriate time and place for my kayak's baptism. As obvious as that was, I had already pushed off from shore, and after my grand entrance I saw no face-saving way to retreat. Parallel to that thought and equally strong was a feeling of annoyance. Why should I feel intimidated? What right did a bunch of fishermen, or any special interest group, have to dominate a public waterway? It was not their river. I had as much right to be there as they did.

I proceeded.

The river's width varied but on average was about 20 metres. All the fishing lines cast into the water from both sides left only a narrow passageway to negotiate. I carefully wove in and out down the centre, desperate to avoid entanglement. The difficulty was heightened by a sea kayak's need for more paddling girth than a canoe and by the fact that I wasn't yet familiar with my boat's manoeuvrability. I had the unsure feeling of a newborn, wide-winged insect flying through a maze of spiderwebs.

At last, with great relief, I was under the 10th Street bridge, the railway trestle, past the high, concrete dockage walls of the inner

harbour, and into the outer harbour and the deep, sparkling waters of Georgian Bay.

I paddled out about 5 kilometres: beyond Kelso Beach, the marina, and the golf course. At that point, Owen Sound Bay was only 4 kilometres wide, but with a moderate wind I was far enough out to get a taste of the boat's behaviour in a half-metre chop. As it sliced into the waves and in a trailing sea, the kayak's bow bobbed noticeably, lurching with no weight in its large front hold. Still it tracked well, and its initial and secondary stability seemed excellent.

The water was a deep, cold blue but retained enough of summer's heat to make it about as warm as the air. To the northeast, off Squaw Point, a flotilla of fishing boats were bunched together like resident ducks on a park pond. Farther out were scattered a hundred or more boats. And way off on the horizon teetered a few tiny white sails.

The sound split the bluffs of the Niagara Escarpment like a plunging neckline. The rise of the land, both to the east and to the west, was dotted with houses and barns and slashed with roadways. With crops already harvested, the fields lay barren across most of the open areas. But the dominant land feature was clusters of deciduous trees, their peak of colour not yet fully reached.

<center>⌒⁊⌒</center>

The massive tracts of virgin timber that once surrounded Owen Sound had long ago been levelled – floated and fed into the sawmills that over a hundred years ago ringed the sound's edge. Companies such as Keenan's, J.H. Harrison, and National Table had shipped Georgian Bay maple, ash, beech, oak, and pine products all over Canada, United States, and the world. At one time the North American Bent Chair Company of Owen Sound had been the largest chair maker in the Commonwealth.

Connected to the world by CN and CP Rail, the town's harbour became a major terminal—grain arrived from the west, as did iron ore, coal and timber from the north. Rattling box and tanker cars brought steel, bricks, and oil from the south. Fishing schooners and freighters off-loaded lake trout, beaver pelts, fox furs, and more timber. Ferries, steamers, and passenger trains brought the people a frontier town required: boat builders and barmaids, lumberjacks and preachers.

Even when the area's fish and timber had been exhausted, Owen Sound's early momentum carried it into the twentieth century. The

Industrial Age planted itself along the harbour, churning out products that filled the boxcars of southbound trains. Tanneries, woollen mills, grist mills, foundries, shipbuilding yards, grain elevators, stove and furnace manufacturers, and a cement plant replaced the harbour sawmills. The by-products of industrialization spewed into the air and flowed into the water—evidence, in the early 1900s, of a town's prosperity and potential.

But my current view of the outer harbour bore little resemblance to those days. Transportation of people and goods by ship and rail had given way to roadways, motor cars, transport trucks, and airplanes. Places like Owen Sound were disadvantaged by their inability to compete with manufacturers located in the bigger centres to the south. Gradually, one by one, the city's steam whistles fell silent and its smokestacks went cold. Most manufacturers had closed down or moved out. In the city's new industrial park were only a few smaller industries. The city had transitioned once again to become a recreation, retirement, and service centre.

It was well past noon when I returned to the mouth of the Sydenham. There were more fishermen on the banks than when I had left. I had been living in Owen Sound for a few years but my view along the river that day gave me a new appreciation of Owen Sound's sports fishing culture.

I proceeded slowly up the centre of the river, more confidently altering my course to the left or right to avoid fishing lines. Some fishermen reeled in to accommodate my passing but most did not. They were attempting to catch chinook salmon, but from the lack of angling action it appeared the fish either weren't there or weren't biting. The fish were obeying their reproductive imperative to lay and fertilize eggs upstream. Most of the river's west bank was a narrow, urbanized pedestrian parkway. Tight to the east side was a steep bank holding an unruly assortment of old buildings, bushes, and trees. The last section of the riverbank, near my house, was in a more natural state.

Between the 9th and 8th Street bridges, about halfway up the river to my house, a fisherman on the shore directly to my right had a fish strike his line. The fish broke the surface in the middle of the river, rapidly flipping back and forth so that its head and tail nearly met. It hurled itself a metre in the air before smacking back into the river.

At that very moment another fisherman right beside the first also got a strike. Again the murky flow was riled with a froth of desperation. Anglers up and down both sides of the riverbank immediately reeled in their lines. I pulled over to the opposite shore and watched the action to my right, 15 metres away.

While watching and waiting, my paddle blade resting on the riverbank, a strange feeling came over me. Somehow I was going to be involved in what was unfolding. Why I had such a thought or how I could possibly become involved I didn't know. Yet as I sat and observed the proceedings, I said to myself, as if trying to prevent what was already predestined, "It's okay, nothing bad can happen if I just stay put."

Naturally I was pulling for the fish. I identified with them: trying to manoeuvre upstream, dodging monofilament lines and a dangling menagerie of fish-bait trickery. Anyway, a couple of hundred fishermen lined up shoulder to shoulder, or sitting in rows of lawn chairs with their doughnuts and double-doubles, trying to hook fish that had reproduction on their minds, didn't seem particularly sporting to me. But even as I thought those thoughts, I felt vulnerable, believing they needed to be quietly camouflaged from the fraternity surrounding me.

The second fish wasn't leaving without a fight. Like the first, it propelled itself into the air, sampling a view of the alien's world: a deadly, dry place of gravity and blinding light, with suffocating concentrations of oxygen. The flying, flipping and tumbling acrobatics of the second fish caused the hook to loosen and release. Its escape caused collective exhaling and quiet moans from the fishers around me.

I tried to appear disappointed.

The first fish had a different strategy. After its initial leap it headed upstream in the same direction I was planning to go. These were hatchery fish, a fast-growing strain of salmon that were big, growing to practically a metre in length and weighing almost 10 kilograms. They were full-grown in two or three years, after which time, as I was witnessing, they returned to the river where they had been released, to reproduce before dying.

The first angler's approach was to keep some tension on the line but let the fish go where it wanted—to tire it out before reeling it in, I presumed. It swam towards the 8th Street bridge, 75 metres upstream. The power and intent of the fish pulled the nylon line over the water, like a loose clothesline. Because the action was on the other side of

the river, to my right, and because the surrounding fishermen had all brought in their lines, I was able to slowly inch my way along the river's east bank. The process of landing the fish dragged on. Five, ten, fifteen minutes passed without resolution or really any progress. By the lack of tension on the fishing line it was apparent that both the angler and the fish were playing a waiting game.

I was growing impatient at being held hostage, but I still sensed that somehow, if I wasn't careful, I'd become involved in the drama. Every few minutes as I crept along the shore, my inner voice asked the same question: "Could doing this in some way be interfering?" The answer was always the same: "No, of course not, silly. How could it?"

As I waited, with my hand on the left bank I very slowly but steadily pushed upstream until, after almost half an hour, I had reached the 8th Street bridge. At that point the fisherman was far downstream, but his line was lying on the water beside me, to my right. The position of the line on the water indicated that the fish had crossed diagonally to my side of the river at the bridge. The salmon had gone under the bridge, and it appeared that it had hunkered down in a deep pool beyond the bridge's cement abutment. As the line lacked any tension, I wasn't even sure that the fish was still hooked.

Again…more waiting. I had crept along as far as I could go. The line was lying beside my kayak's right side and then followed the bridge's underside wall. At that point I was partly under the bridge, sandwiched between the fishing line and the cement underpass. Beyond the line, the entire width and length of the river to my right was wide open. My patience, not one of my stronger character traits, was clearly running out. I began to wonder if the fish had already gotten away. I started to imagine waiting there all afternoon.

At that point I would have raised my rudder with my cockpit pull rope and simply paddled across the fish line, but the pull rope that lifted the rudder was broken, one of a number of things on the boat that needed fixing. So, with my rudder thirty centimetres into the water, it wasn't possible to cross the fishing line without snagging it. It was about then that the question my inner voice had been repeatedly asking for the last half hour—"Could this somehow interfere?"—came up with the wrong answer.

I decided to free myself from my predicament by lifting the line up above my head with my right hand. Then I would push off from the

cement abutment with my left hand, float away from the bridge, and pass the line over my head to my left hand and set it back down on the water. I was emboldened by the fact that the fisherman whose line I was planning to manipulate was too far away to make out clearly what I was doing. However, I would still have to pull off the procedure in front of a large and critical audience.

The lifting-of-the-line manoeuvre would have worked perfectly had the line not caught the stainless-steel pulley that worked the rudder at the stern of the boat. Drifting towards the middle of the river, still parallel to the shore, I tried to free the snagged fishing line behind me by lifting it with my left hand. When that didn't work I tried reaching back with my paddle blade to free it. That didn't work either, as my twisted position nearly caused me to capsize.

There was no time to ask or answer questions from my annoying inner voice. I felt the burning glare of anglers and a rising sense of panic wash over me. I tried to stay calm and think this out. I thought I could get out of my entanglement if I angled my kayak perpendicular to the shore and backed up towards the bridge abutment a little. I reasoned that if the line wasn't badly snagged on the upper mechanism of the rudder, it would slide across my rear deck towards me. I would then pass the line from behind me to my front deck and, by continuing to swing my boat around so it faced downstream (opposite to the direction I was going), I would be able to let the line slip off the front of my boat.

Everything went as planned. With my kayak perpendicular to the shore, I backed up under the cement bridge and the line freed itself from the rudder. I reached back and passed it smoothly over my head to the front deck. I could see a way out of this mess... still a bit awkward, but now wonderfully manageable.

It was at that exact moment in my carefully considered escape sequence that a variable I hadn't suspected or accounted for entered the picture. The instant I lifted the fishing line from behind me and placed it across my front deck, its limp profile began to tighten and, to my horror, from below, reversed direction. At that exact moment the salmon had decided to bolt back downstream. Meanwhile the fisherman, feeling absolutely no tension on his line, started reeling in. My boat was still perpendicular to the shore, so the line was tightening right in front of me, over the top of my boat from the fisherman reeling in and also from under my boat from the fish going back

Waterlines #45, monoprint, 19" x 28", 1995

downstream towards the fisherman. Things were now moving past awkward and into barely manageable territory. Even still, I clung to the belief that by swinging my bow downstream the line would slip off the front of the boat.

I was drifting away from the bridge, almost to the middle of the river, moving slowly back downstream. Like a fashion model coming down a runway, I had everyone's eyes glued on me. I was thankful (hopeful) that the angler doing the reeling in was still too far away to know exactly what was going on. I pointed my boat's bow in the direction I had just come and with my paddle blade lifted the fishing line over the decking tie-downs and hatch cover, coaxing it towards the bow. My plan was back on track.

Every now and again I could feel a tugging on the line from the salmon under my boat. Then, suddenly, the tension was gone. There was an ever so slight lifting of my kayak's bow.

Uh-oh.

If I hadn't been sitting in the boat I wouldn't have noticed that slight lift. It was subtle but it immediately precipitated a frantic shortness of breath and stomach churning. There was no tension on the line from below, only the faint whir of wet fishing line being reeled in across my

bow. In a total reversal of my earlier sentiment, I prayed that by some miracle the fish was still hooked.

The boat continued to drift slowly downstream but the line hadn't slipped off the front of the kayak as I'd hoped. It was caught under the deck toggle, at the very front edge of the boat. I thought I could manoeuvre it over the obstruction, as I had done with the tie-downs and hatch cover, but my paddle didn't quite reach. Even holding the very end of the opposite paddle blade and stretching forward as far as I could, I was still an exasperating centimetre or two away from reaching the line and flipping it free. I cursed the kayak's stupid design — how could anyone make a boat whose extremities were completely out of reach of its occupant?

My predicament had gone from awkward to bungling to embarrassing. But I still had new levels of humiliation to enter.

Fifty metres away from the fisherman, who was continuing to reel in his line, I heard the jangle of something metallic on my bow. A gleaming, large silver spoon came into view, trailed by a dangling, bare, three-pronged hook. It sparkled and glistened as it came dripping along the side of my cream-coloured bow. Then at the very nose of the kayak it came to a stop: its sharp prongs had embedded themselves in the rope that attached the toggled handle.

The boat picked up speed — I was being reeled in. The new tension on the line probably initially gave the fisherman hope that his fish was still in play. But once the boat started moving towards shore there must have been a distinctly non-fish-like pull or resistance on the line. That, along with the strange route taken by my kayak, gave rise to what I perceived as a perplexed at first and then a highly agitated look on the fisherman's face.

I had somehow accomplished what anyone but a gifted illusionist would have deemed impossible: in front of a live audience, through a complicated series of interactions between an unsuspecting member of the audience, nylon-line tension, sea kayak design, river currents, and aquatic behaviour, I had replaced a 1-metre salmon with a 5-metre kayak.

Given my strong premonition half an hour before, I figured I really couldn't be faulted for what had transpired; the whole thing was obviously predestined.

There was nothing I could do, there was nowhere to hide; I sat back with my paddle straddling the cockpit as the fisherman pulled in his

catch. He was furious, of course, shouting what the hell was I doing? I tried an apology followed by a feeble defence: something about endless waiting and his line blocking my route.

He bent down and unhooked my boat, at which point I quickly turned around and paddled back upstream, thankful to make it home with only icy stares thrown in my direction.

<p style="text-align:center">⌇</p>

That should have been it, the end of the story. But that evening, after thinking about my river experience, I came to the inexplicable conclusion that others in the community would be interested in my day's observations. Not the getting caught part, but rather a more cerebral overview of the Sydenham—namely, how the river could be put to better use.

I phoned a city alderman, Stu Taylor, at his home that night. I shared my thoughts with him, about the river and how I saw it as an important downtown resource, one that could and should be utilized by a wider cross-section of people. I expressed my opinion that fishermen were dominating its use to the point that the non-fishing public, either on the water or on the pathway, were being discouraged or intimidated from enjoying it. I also talked about the fishermen's litter, which proliferated on the riverbanks.

At first the alderman offered sympathy, but also a familiar refrain: there was a long tradition of fishing in Owen Sound, particularly on the Sydenham, and that wasn't likely to change as long as fish could swim. But the more I talked, the more interested he became. He asked me to come and speak about the river issue at City Council's regular weekly meeting. It happened to be the following evening.

Ironically, Owen Sound's city hall stands on the east bank of the Sydenham, directly across from where my kayak had been hooked and a stone's throw away. I was there at 7 p.m., anticipating a lengthy wait before I was asked to speak, but as it happened I was the lead issue on that night's agenda. Taylor introduced me and gave council a brief summary of our previous evening's conversation.

I prefaced my remarks, saying they were simply observations that I wanted to share with the community's representatives—a fresh perspective from a recent arrival in Owen Sound. I spoke of how, in my view, fishermen were dominating the river, and I described their nega-

tive impact on the environment, particularly along the wooded section of the river behind my home and other residences. I reminded council that while shore fishing (unlike when taking a stroll), people remain in a specific area for many hours at a time, yet there were no garbage bins or toilet facilities, nor was there street access for maintenance vehicles to clean up the area. I suggested that council consider designating the wooded portion of the river as a low-impact walkway for the general public (about one quarter of the length of the river fishing area). I indicated that the remainder of the inner harbour and river, where there was access to toilets and city street maintenance, was better suited for fishing.

When I had finished, there was some discussion from City Council members, reminding me of the long-established history of fishing on the river and that it was part of Owen Sound tradition. I was then thanked, and I left council chambers pleased to have had my say, which was all I'd wanted or expected. To my surprise, a gaggle of reporters from the local TV station, the radio station, and the newspaper followed me out into the corridor. It must have been a slow news week.

Microphones in my face, a series of questions followed.

"What's the problem with fishermen fishing along the river?"

"How do you think fishermen are going to react to your proposal?"

"How many people do your views represent?"

"What do you expect council to do?"

"What are you going to do next?"

What I had planned to do next was go home and forget about it. But that was not to be. Just like the fish on the river the day before, things were in motion, moving in my direction.

In the morning, the local radio station's hourly news led with "Council Considers Sydenham River Fishing Ban." They played a clip of me saying, "It's about the environment and about numbers. Twenty people fishing down there isn't a problem—two hundred is."

That evening the local newspaper, the *Owen Sound Sun Times*, blew onto my doorstep like a bellows fanning smouldering tinder. A side column on the front page proclaimed "Fishing Ban Proposed for the Sydenham."

Fishing ban! Cripes... They sure knew how to sell newspapers.

At home and at the studio, the phone started to ring: outrage, requests for interviews, some tepid support, and a few personal inquiries

wondering who the hell did I think I was? On the local radio talk show, irate callers questioned my claims and described my observations of garbage along the riverbank as completely exaggerated, among other things. The newspaper saw it as an issue that had legs and sent an investigative reporter and photographer to get to the bottom of the story. The next day a front-page banner headline and an article, complete with a large photograph, poured gasoline on the fire. The reporter had found lots of garbage and even human feces. The same article implied that the wooded portion of the Sydenham River was a garbage-strewn dump.

Instead of some measure of vindication, which I had expected, the article set off a firestorm—much of it directed at me. Local gun and tackle shops pinned the article beside their cash registers like a "Wanted: Dead or Alive" poster. A number of anonymous phone callers rang my studio threatening to "get me." One caller hoped I had fire insurance, and another simply said he knew where I lived and worked. The calls to talk shows and letters to the editor mostly attacked anyone who would dare besmirch the wholesome, innocent pleasures of fishing. Riverside memories of long ago were recounted—childhood fishing with dad, and so on. Among it all, a few brave souls in the community agreed with my observations.

City Council had no desire to poke an irascible bear by restricting fishing, that was for sure. But with such a brouhaha stirred up, they felt compelled to do something. To avoid actually having to make a decision, while still looking as though they were taking action, they formed a committee of council, the River Committee, to come up with recommendations. But even trying to do nothing proved to be complicated.

The jurisdiction and supervision of the inner harbour and the outer river had a Rubik's Cube complexity. The harbour, as part of the Great Lakes, was a federally controlled waterway, but the water itself and what was in it was under provincial management—specifically, the Ministry of the Environment and the Ministry of Natural Resources. Of course, the city had some jurisdiction, as did the Conservation Authority, as well as some of the riverfront property owners. Overlaying all of this were the historic and court-upheld water usage rights granted to the Chippewa of Cape Croker.

The River Committee consisted of a member of City Council, the city's parks director, a member of the Downtown Business Association, representatives of the Ministry of the Environment, the Ministry

Waterlines #73, monoprint, 10" x 12", 1995

of Natural Resources, and the Conservation Authority, a couple of members of the Sydenham Sportsmen's Association, and myself, plus another resident from along the river.

I really didn't want to get involved in what I suspected would be a colossal waste of time, but since I'd pulled the fire alarm, I felt obliged to take part. My role was to represent the interests of the other residents who lived along the river. That in itself turned out to be mission impossible, since everyone who lived along the river seemed to have a different point of view. Some were mad as hell that the issue had been raised in the first place, and some just kept their heads down, wishing the whole thing would go away. A few agreed with my position, some took the fishermen's side, and others wanted to restrict everyone from using the river, fishermen or not, essentially wanting land ownership to the water's edge.

I quickly became a lightning rod for all kinds of gripes. An agitated neighbour came to my back door and accused me of duplicity regarding my environmental activism after his young child had watched our family cat kill a bird in his backyard. Another neighbour showed up

steamed over the fact that he now had to deal with angry clients at his workplace—fishermen who blamed him, a river resident, for the kerfuffle. The neighbour told me he was glad the fishermen always used the river. In his opinion they protected river residences from thieves and vandals. He told me that before I came to town the wooded river ravine had been a hangout for pot-smoking hippies and described how "wafting clouds" of marijuana smoke used to rise up from the banks of the Sydenham—something the fishing fraternity had put a stop to.

The meetings of the River Committee were held at City Hall once a month. They quickly took on a familiar pattern, as the other representative of the property owners and I regularly butted heads with the representatives of the Sydenham Sportsmen's Association. We disagreed on everything and agreed on nothing.

Everyone else around the table seemed not to care one way or the other and generally kept quiet. Disappointingly, the provincial ministry representatives that should have stepped up said nothing. The city's parks director, anxious to deliver a unanimous recommendation to Council, pushed for the committee members to agree on something, anything.

The Sydenham Sportsmen's Association was a well-organized club that carried a ton of local clout. In fact, they were one of the most recognized hunting and fishing clubs in Canada. They were the organizers of the Owen Sound Salmon Spectacular, the fishing derby I had become entangled in. Their members' interests lay essentially in hunting and fishing, but they did a lot of local volunteer work, cleaning up and restoring waterfowl and marine habitats. After the newspaper documented the extent of the garbage along the river, it was they, not the city staff, who cleaned up the riverbank.

The Sydenham Sportmen's Association operates the biggest fish hatchery program in Eastern Canada. Their hatch-and-release operation yearly introduces hundreds of thousands of chinook salmon and brown and rainbow trout fingerlings into the rivers that flow into Georgian Bay. They do this to provide a resource for the sports fishery. They also claim that the releasing program provides new predators to help eradicate invasive foreign arrivals such as zebra mussels and round gobies.

But their ambitious fish stocking is not without controversy. The Native commercial fishers and a number independent marine biologists contend that the introduction of so much non-wild stock is having a

negative impact on native species. (Parks Canada claims that since the 1960s an average of 61,000 stocked fish have been released into the Great Lakes *every day*—more than a billion fish overall.) A program that aggressive raises many questions, chief among them being, What is the impact on other aspects of the marine ecosystem? For example, is it altering fish genetics in unanticipated ways?

Exactly why so many native species, such as northern pike, lake trout, sturgeon, and walleye, have diminished over the years is subject to debate. The sports and commercial fishermen blame each other. Quite apart from the debate over releasing hatchery fish, the collapse of the wild fish stocks is compounded by the destruction of fish habitat due to the damming of streams and rivers. Industrial pollution, the draining of wetlands, urbanization, and lamprey eels are also frequently mentioned causes.

But the life in the deep waters of Georgian Bay, or in any of the Great Lakes, is impossible to monitor accurately, let alone manage effectively. Fish are unseen, inaccessible, and constantly in flux; they exist in a vast, alien, and incredibly complex ecosystem that is impacted by forty million people and tens of thousands of industries and that is overseen by a tangled web of state, federal, provincial, and municipal bureaucracies, as well as by native bands and a host of special interest groups. I was highly skeptical of any department, ministry, or group that claimed to be this water's effective manager.

The River Committee meetings continued over the winter and into the spring. It was clear from the start that the Sydenham Sportsmen's Association was there to protect the status quo and that it had no interest in any changes related to river fishing. The SSA representatives reminded the committee that their fishing derby brought in hundreds of thousands of dollars to Owen Sound every year and that their fundraising and volunteer work had contributed to the improvement of the river, the harbour, and the city, including such projects as a new boat ramp. For the City Council representatives, nothing more needed to be said. Without SSA approval, neither City Council nor anyone else was going to change anything.

After six months of bickering, the placement of a few metal garbage barrels along the river trail was about the sum total of what was accomplished. The six-month effort bore no real fruit, was highly frustrating, and left me wondering why I'd got involved in the first place.

In time, however, my feelings about the whole affair softened and got filed away with other battles lost, commonly categorized as "learning experiences."

What did I learn?

That the principal tenet of our democratic system — that is, one person is chosen to represent the views of many — clearly doesn't work.

That those strange inner voices of premonition should always be heeded.

And that fish are a lot smarter than they look.

V

EAST GREENLAND, 1991

They took the animals to their galgi
And brought them alive with dances and singing
They let their souls go
Sending them back to the sea.
—Inuit legend

By the late 1980s I was travelling exclusively to the Far North for my work. By 1990 that work had begun exploring subject matter other than glaciers, mountains, and icebergs. For the following ten years I worked on what I termed "land memory" themes: the Arctic's past people, their culture, and their mythology.

The direct ancestors of the Inuit were the Thule (pronounced *tool-ee*). Among other things, they had introduced the kayak, their elegant watercraft, to North America. The kayak was an amazing creation: high-functioning, technologically advanced, radically minimalist, and remarkably individualized. The boat carried an exquisite aesthetic that I began incorporating into my imagery whenever I could. The kayak was a remarkable bridge, I thought, between a harsh environment and a hunting culture, between animal and man, between the spiritual and the utilitarian, between perishing and surviving.

Although there was an audience for this work, I knew it was well outside any mainstream movement in contemporary art. Regardless,

I remained fascinated and highly motivated to pursue this particular subject matter. It was within those parameters that, while painting in my studio one Friday morning in the winter of 1991, I heard an astonishing assertion.

My morning studio listening at the time was CBC Radio, specifically Peter Gzowski's show *Morningside*. That week, Gzowski was interviewing a series of ethnologists about past cultures in remote places throughout the world. That particular morning's subject was the Thule culture.

The guest talked about the sea-hunting prowess of the Thule, made possible by an extraordinary list of clever tools and devices, chief among them the sea kayak. The listening audience was reminded that the boat was all the more impressive for being fashioned out of a frozen land where nothing grows above one's knee. The Thule's unique sea-hunting technologies were homegrown and developed with few or no outside influences. Either they had no contact with tundra Indians to the south or they simply saw their own technologies as superior. Towards the end of the interview the guest said that the Thule's fashioning from an apparently "empty" land a kayak seaworthy enough to paddle the dangerous and unpredictable Arctic Ocean was an amazing accomplishment. Furthermore, he added, their mastery in successfully hunting huge sea mammals, including the seventy-ton bowhead whale, was considered by many anthropologists to be "the apex of human endeavour."

The apex of human endeavour: full stop. There was no qualifier to the ethnologist's statement, no add-on like "among ancient people" or "among hunter-gatherers" or "among polar people." It gave me a chill when I heard it.

My work at that time had sprung from a handful of sea kayaking expeditions to the Canadian Arctic and Greenland and from a lot of research on the Thule people. I had never expressed myself in those words or heard them uttered before, yet all that I had read and seen had, in a subconscious way, led me to exactly that same conclusion. Those same thoughts had inspired my travels and my work and had pushed me to explore the kayak hunter's world. I also knew that I, like other artists, often employ embellished truths, regardless of their precise accuracy. Whether to romanticize, exaggerate, or vilify a subject, artists use embellishment to unlock doors of perception, to see things in a new light, to tap the creative muse.

That five-word declaration—"the apex of human endeavour"—coming out of my radio that morning gave me an odd sense of empowerment. It legitimized what I'd been doing and pushed me to dive deeper, to further explore the world of the sea kayak hunter. It also gave me a new reply to the dinner party question: "So, what are you working on?"

Now I could reply that I was documenting the Apex of Human Endeavour.

⸻

The Arctic is often perceived as a single, monolithic region. Actually, it is extremely diverse with respect to topography, flora and fauna, climatic conditions, and history of human settlement.

Leaving aside some subcultures, a rough overview of human occupation of the Arctic starts with the Independence people (2500 to 500 BCE), who arrived in the Arctic from Asia. Colder temperatures gradually diminished their culture, leaving some territories totally abandoned for several centuries. A new Palaeo-Eskimo culture, called Dorset (50 BCE to 1000 CE), gradually adapted to the colder climate and commenced reoccupying most of the Arctic. Later, warmer temperatures returned, encouraging the Thule people (1000 to 1700 CE) to enter the Arctic from Asia and spread east. But with colder temperatures and European contact, the Thule culture gradually broke apart and transitioned into the Inuit culture we know today.

When the Thule entered Alaska from Siberia across the Bering Strait around 1000 CE, they brought with them kayaks, umiaks (their larger transport boats), and dogsleds. With these technologies they quickly overran and replaced the resident Dorset settlements along all their coastal hunting territories from the Western Arctic to Greenland. For more than three hundred years, a period archaeologists call the "Arctic Renaissance," the Thule prospered, benefiting from a warming climate that produced less sea ice and more open water. With their boats and sea hunting technology, they had unprecedented access to multitudes of Arctic sea mammals. In the 1400s a cooling trend called the "Little Ice Age" increased the amount and duration of the sea ice cover, severely limiting kayak hunting. Just as climate change led to the rise of the Thule, plunging temperatures contributed to their decline. It restricted their ability to store adequate supplies of sea mammal meat and blubber for winter use.

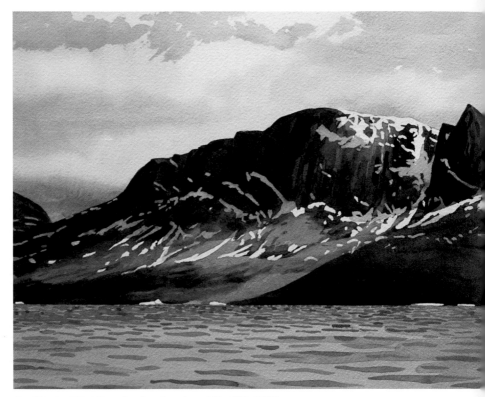

Fiord Sentry (West Greenland), watercolour, 10" x 29", 1988

Early contact with Europeans also had a significant impact on the Thule. Because of their isolation, their immune systems were unable to resist the diseases that came with the first explorers. After contact, the Greenland Inuit continued using the traditional sea kayak much longer than the Canadian Inuit. That was, in part, because the coastal waters of Greenland, although heavy with icebergs, were less liable to be covered in summer sea ice. As well, the pulse and pace of the developed world had less impact on the more isolated native Greenlanders than on the Canadian Inuit or the Native peoples of Alaska.

In Greenland, two places in particular retained a sea hunting kayak culture well into the twentieth century. One was in the high northwest corner, in the vicinity of Melville Bay and the village of Thule. The other was an isolated group of small villages on the east coast, in the Ammassalik area. In the summer of 1991 I went to East Greenland

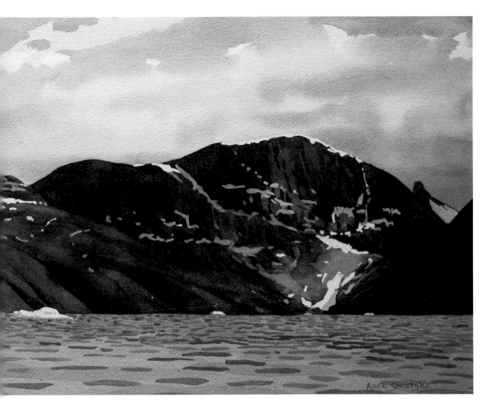

on a sea kayaking expedition. If that culture still existed, I hoped to find it there.

Greenland had always fascinated me. As a young boy sitting in class, the map of North America was always in my front-blackboard view. Tucked under the upper right corner of the pull-down map was the pointy-ended landform of Greenland, its colour a faded green. I thought it extremely odd that even though it is one of Canada's closest neighbours and a place of significant size, we were not required to know anything about it. The only thing we were required to know was its name. A wonderful name that made no sense at all: Greenland, a country covered in ice.

Forty years later, when I was in Newfoundland, there on one of several painting trips, I had reason to contemplate Greenland again. On Bonavista Bay, I was mesmerized by a distant row of huge, glowing-white

ice fortresses drifting south. I was told that those, and all the big ice-bergs that get as far as Newfoundland, had calved off the Greenland Ice Cap.

Greenland is a protectorate of Denmark, which handles its foreign affairs and currency. However, since being extended Home Rule, Greenlanders now have many rights of independence; they have their own parliament, flag, and language. Since the ice cap occupies 85 percent of Greenland, its 56,000 residents live on a narrow strip between the ocean and the ice. Nuuk, the island's capital, one third of the way up its west coast, has one quarter of the country's population. Almost all the rest of the people live in small villages on the west or south coasts. (The southern settlements are located on the southern tip of Greenland but are referred to as the eastern settlements.)

Erik Thorvaldsson (Erik the Red), exiled from Iceland, was the first European to encounter Greenland. He returned to Iceland in 985 CE after a three-year exile and convinced a large group of colonists to immigrate to his newly discovered land. In doing so, Erik the Red became the poster boy of all advertisers. By calling it Greenland, he was able to persuade Icelanders to exchange their warm, fertile home for what was essentially a land of ice. But Erik's branding of that new-found-land as an agricultural paradise, by chance, coincided with the start of a dramatic trend towards much milder temperatures—a trend that would last four hundred years.

After settling in south Greenland, the Norse established a second colony along the western coast. From that Greenland base, with their renowned *knarr* sailing ships, they explored farther afield, including the northwest coast of Greenland, Baffin Island, Labrador, Newfoundland, and even the High Arctic.

The early Greenland settlements grew to an impressive 5,000 people. The inhabitants had converted to Christianity before arriving in Greenland (the earlier Vikings were pagan, but by the time they settled Greenland only Erik the Red refused to accept a Christian God). The influence of the Catholic Church took hold in the new settlements with the building of two monasteries, one cathedral, a nunnery, and seventeen parish churches.

That first attempt to colonize Greenland lasted almost five hundred years. In the late fifteenth century, circumstances snuffed out the colony. According to the *Norse and Icelandic Sagas*, the European

outpost was plagued by increasingly violent confrontations with the Thule people. At the same time, suddenly colder temperatures led to crop failures and more sea ice cover. Meanwhile in Europe, the Black Death, one of the worst pandemics in human history, fractured the lifeline to the Greenland settlements. Supply ships became less frequent and then ceased coming altogether.

⌒⅋⌒

Wendy Grater, the director of Canadian adventure outfitter Black Feather, had developed a passion for Greenland and in the mid-1980s had begun pioneering sea kayaking expeditions there. In early August of 1991, I went with her and seven other Black Feather clients to paddle the waters of Ammassalik Island.

To get there we first flew to Iceland. The potential draw of an authentic Inuit community had encouraged Iceland's tourism industry to schedule periodic flights to Greenland's east coast. The island of Ammassalik doesn't have enough flat land for a runway, so the small Icelandic jet landed on a nearby airstrip on Kulusuk Island with a boat ride connection to Ammassalik. The normal itinerary of the sightseeing passengers included a traditional East Greenland drum dance in costume and other like activities. Typically, after an hour or two, the tourists returned to the waiting plane to go back to Iceland.

The towns of Kulusuk and Ammassalik and the other villages grouped on the east coast straddled a wide cultural fissure. Their society was still based on fishing and hunting but overlaid with a very recent, Western, consumer-driven culture, evident by the number of imported products and by the frequent planeloads of tourists.

East Greenlanders inhabit one of the most isolated places on earth. They are so far off the beaten path that the modern world didn't "discover" them until the early part of the twentieth century. Having escaped outside influences, they retained their sea hunting culture for a surprisingly long time. They speak the national language, Greenlandic, in their own distinct dialect.

Ammassalik has a stunning setting, surrounded by snow-clad mountains, glaciers, icebergs, and drifting pans of sea ice. Both Ammassalik and Kulusuk project out into the cold North Atlantic, and as a consequence, low fog often creeps in from the ocean and shrouds the little hamlets in thick gauze. It was August, yet in some places the townspeople

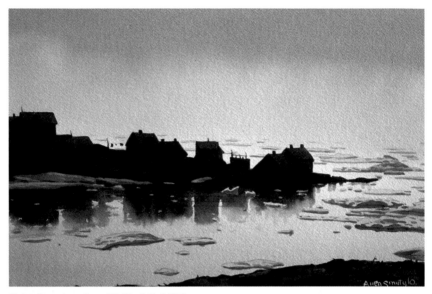

Kulusuk, watercolour, 10.5" x 14", 1992

still had to manoeuvre around and over six-metre snowdrifts. Their houses were positioned close to the water, following the land's contours, giving the layout of the towns a charming randomness. The houses, painted in different colours, had a bit of a Scandinavian look, with high-pitched roofs and clean lines. A town generator provided electricity.

After a couple of days' orientation, the eight of us, in sea kayaks, headed northeast, inland up the Ammassalik Fjord, planning to travel counter-clockwise around the island, a two-week, 200-kilometre trip.

⌒∿⌒

Paddling that first day was slow going, with the fjord acting like an ice highway. Like cars on off-ramps at rush hour, sea ice and icebergs had backed up along the many long-fingered, secondary fjords. Ice was everywhere, but tidal currents and the ocean swell allowed us to pick and weave our way inland.

On our second day we paddled into an area of large icebergs. Breaking the silence were occasional rumblings, like distant thunder, announcing another rolling iceberg.

The icebergs were big but nothing compared to the titans calved in West Greenland. The year before, in Ilulissat, I had paddled among the largest icebergs calved in the northern hemisphere, 60 to 90 metres out of the water, with a visual dominance that makes ocean-going freighters look like Dinky Toys. Of course they are even larger than they look, with 80 percent of their mass underwater. On that trip we had camped beside the entrance to the Jakobshavn Fjord, which offered a great view of the released icebergs. During the evening a local came by our tents and said that where we were camping was very dangerous. He said that if one of the huge icebergs were to roll, a ten-metre tidal wave would hit our campsite.

On the third day up the Ammassalik Fjord, we noticed a particularly huge iceberg directly in our path. The reflecting ice and grey sky gave the water the look of gleaming gunmetal. It was larger than any iceberg we had seen. As we slowly came nearer, some of us got out cameras. The visible part of the iceberg would have covered a mall parking lot and towered six storeys high. Towards us, it gradually rose from the water in a hard, polished curve that steepened at its centre to form a sharp peak. Partly circling the apex was a series of ice turrets, pointing skyward, like a warlord's fortress. We veered to the right of the berg, giving it a wide berth. The side we passed dropped away in a concave wall that undercut the upper crown. The undercut looked freshly ripped, as if a thick block of cheddar had been broken in half.

Icebergs are more than four-fifths under the water, which means that if they lose equilibrium they will start to roll or flip to rebalance. While this is happening, unseen appendages can quickly surface out of the water in unexpected places. When it happens at close range, particularly from the vantage point of a kayak, it is a frightening spectacle. The shifting of thousands of tonnes of ice starts slowly and then picks up speed. If the iceberg rebalances so that the bottom rotates to the top, with only 15 to 20 percent of it above water at any one time, a 180-degree flip takes on the look of a thrashing, tumbling monster set loose. Sometimes the rebalancing creates forces so great that pieces of ice fly off in all directions as the iceberg rolls. I once watched one continue rolling for five minutes until the entire mountain of ice was broken into a million tiny bits and pieces, each fizzing and bubbling like an ice cube in ginger ale.

We approached the big berg with our group fanned out 100 metres apart and with the closest kayak about 100 metres from the iceberg's

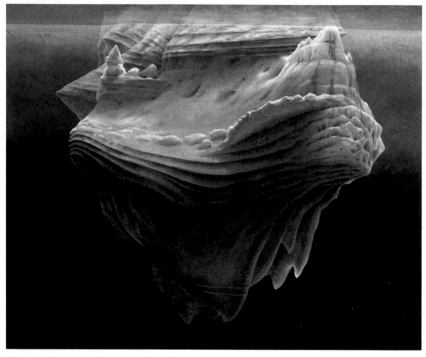

Memory of Water, oil on canvas, 41" x 50", 2001

face. Then, as we were almost even with the upper crown of the iceberg, it let go. An enormous section of the overhanging face, 60 metres across, plunged into the sea.

For a second I saw it happen in total silence, and then it came across the water, a booming thunderclap. Sea water was instantly sucked into the vortex of the fallen ice. Two seconds later the sea catapulted the ice back above the surface with a great lifting swell. The ice and the lifted water sent a huge rolling wave towards us. The couple in the tandem kayak closest to the iceberg started paddling furiously away from what was coming. We all tried to position ourselves in open water away from any floating ice. My main concern, however, wasn't the wave but the iceberg's waterline. If the fallen piece caused a strategic imbalance, the iceberg could roll right over, in which case we would be in serious trouble. I saw the iceberg slowly lift at the waterline, lean, and continue to tilt. It cracked and groaned like timbers on a ship. It lifted a little more, then stopped and stayed.

The wave was now almost on us. It lifted the first kayak, followed in turn by each of our boats. We climbed up and slid down the wave's three-metre crest like floating wine corks. A series of reduced rollers followed until finally everything was still again.

The source of that iceberg, and of all the big icebergs in the northern hemisphere, was the Greenland Ice Cap. Three kilometres thick in places, the ice there is constantly being pressured downward so that it slides into the glacial corridors that eventually calve off chunks into the sea. The weight of the ice cap has pushed Greenland's interior 300 metres below sea level. It holds enough water to raise the world's oceans eight metres. For scientists, this artifact of global cooling has turned out to be very useful for understanding global warming.

Every year, one metre of snow falls on the interior of Greenland. With little melting, most of it stays, building up over time. Each annual snowfall compacts and thins the layers beneath. In the early 1990s, European scientists began to core the entire depth of the ice cap and were able to examine oxygen isotopes and other compressed matter encoded in each yearly layer. Using sophisticated diagnostic tools, they were able to turn back the pages of the Earth's history, year by year, century by century. They found the volcanic eruptions of Krakatoa in 1883 and Laki in 1783, ancient forest fires, industrial pollution, radioactive fallout from nuclear weapons testing, and present-day greenhouse carbons. At 770 metres, the 13-centimetre-diameter core revealed ice 4,000 years old. At 2,500 metres the ice was 40,000 years old, and when they hit bedrock at 3,029 metres the ice was 200,000 years old.

One of the most startling discoveries was the evidence of sudden temperature reversals that preceded and followed the Ice Ages. Those great warming and cooling trends didn't happen slowly, as had previously been believed. Rather, monumental shifts of temperature happened in tens of years, not hundreds or thousands of years. They also found that the climate in the last 8,000 years has been the most stable and predictable of the last 100,000 years.

<hr />

We paddled that day until early evening, when we came across a small, protected cove where we could set up camp. Across its entrance was a shallow reef only a metre or two below the surface, which blocked drifting ice from coming ashore. As we paddled over the reef and into

the cove, the ocean's surge flattened to a dead calm. We hoisted our boats up onto the high tide mark on the beach.

Farther back, high walls of smooth granite surrounded the bay. Greenland has some of the world's oldest rocks, part of the Precambrian Shield, which dates back 3.8 billion years. Everywhere along that coast the rock was rasped and worn bare. Some of the higher mountaintops had escaped the comings and goings of glaciers, and their peaks were still as sharp as darning needles.

The lower terrain of the cove was uncharacteristically lush, deeply carpeted in grasses with occasional rocky outcrops. At the north end of the inlet was a series of terraces defined and secured by huge boulders. To the south of our camp was a bowl-shaped depression—a textbook glacial valley. It, too, was overlaid with mosses, wildflowers, and an assorted mix of tundra. Weeping through and under the foliage was a flow of glacial runoff.

Fifteen metres up from the water were the remains of two stone- and sod-walled dwellings. It was a Thule site. Rock and sod, humped up less than one metre high, enclosed a 15-square-metre living space. The age of the site was hard to tell, but judging from the lichen's growth rings on the upturned rocks, it dated back at least a few hundred years. I wondered why they would have come to that lonely coast. What prompted their ancestors to pick up and leave Asia, to travel into the unknowns of the North American Arctic and push east, all the way to the eastern extremity of Greenland? The climate was more temperate then, and perhaps that had led to the overpopulation of their Siberian homeland. Or perhaps the Thule were fleeing tribal fighting, for when they arrived, they were already familiar with warfare, evident in their Asian weaponry and body armour.

For whatever reason, once they arrived in the North American Arctic, their migration, settlement, and dominance were rapid. They quickly replaced the resident Dorset people wherever the two cultures met. Similarly, the 500-year-old Norse colonies of Greenland disappeared soon after contact with the Thule.

When they were built, the walls and roofs of the cove's two dwellings were likely constructed of double-rock, with a sod layering for insulation. The roof would have been either cantilevered with support rocks or held up with beams of driftwood or whale rib.

They used domed snow houses, or igloos, for quick, warm, temporary winter dwellings. They often built these on the ice when hunting

seals. On a polar night, when lit with the flame of an oil lamp, an igloo would glow like an Arctic diamond. The igloo, like the kayak, demonstrated the Inuit's brilliant ability to combine beautiful aesthetics and high functionality with an economy of materials.

In front of each dwelling was a curved impression in the ground, evidence of a tunnel—an ingenious "cold air trap" entry to keep the dwelling's interior warm. An upward crawlway into their dwellings prevented the rising warm air from escaping outside.

Very close by the two sites, ancient hummocks of animal waste nourished a thicket of lush vegetation. This had been their outdoor kitchen, the skinning, butchering, gutting, and cleaning area. The processing of animals—for their meat, hides, blood, feathers, fur, blubber, bones, antlers, ivory, and skins—was primarily women's work.

Apart from food preparation, a woman was judged by her ability to sew and tailor clothing from animal skins and hides. A near-encyclopedic set of skills was required to keep her and her family alive during the hostile winter. Caribou hides were highly prized for their warmth, but it was crucial that they be taken prior to the annual infestation of ticks. Caribou back muscles, carefully split, dried, and twisted, made practically unbreakable sewing thread and twine. Where caribou weren't available, eider duck skins and feathers were used as warm undergarments. Polar bear pants, fur worn outwards, were highly prized—warm and water-resistant although somewhat stiff. Seals were valued for their fur hides, which were light, waterproof, and strong, though not warm enough for winter wear. Dog, wolf, and wolverine fur, being frost-resistant, were commonly used for hood and cuff lining.

A hide that got wet and dried that way became hard as a board. Softening was done by chewing, a laborious task that was part of a woman's job description. Most elderly women had teeth that had been worn down to stubs by a lifetime of chewing. But the end result of a woman's tailoring skills was often spectacular. When the first explorers saw Thule garments, they couldn't believe their eyes. How could such "primitive" people create fur clothing that not only functioned superbly but also looked as good as or better than anything found in the finest furrier shops in London or Paris?

The clash between preconceptions of "primitive" cultures and what explorers actually observed would repeat itself again and again throughout the Age of Exploration. In 1830, having just encountered the High Arctic Inuit, British Royal Navy Captain John Ross wrote in his journal:

Silent Boats #5, etching and chine collé, 15" x 32", 1994

It was for philosophers to interest themselves in speculating on a horde so small and so secluded, occupying so apparently hopeless a country, so barren, so wild and so repulsive; and yet enjoying the most perfect vigour, the most well fed health, and all else that here constitutes, not merely wealth, but opulence of luxury; since they were furnished with provisions, as with every other thing that could be necessary to their wants.

To the south of the dwelling sites were two above-ground tombs enclosed with heavy rocks. Peering inside, we saw that one held three human skulls and skeletons while the other held two sets of human remains. It appeared that other objects had been placed inside as well. On my West Greenland trips I had seen many rock tombs positioned high up on cliff ledges overlooking the sea, like eagles' nests.

Among the Thule and the early Inuit, honouring the dead, human or animal, was of paramount importance. They were animists and believed that everything—rocks, animals, and even grass—has a soul and is endowed with a spirit. They believed that the spirits of the dead moved between hosts and that depending on circumstances, they could become malevolent if certain taboos were not observed.

It has been said that the early Inuit did not believe—they feared. For the East Greenland Inuit, the spirit Ajumaq was a particularly feared pest, with its dog head and black arms and feet. It had three toes and three fingers that caused anything it touched to rot. They believed

that some spirits could kill simply with a look, while others chased you down and ate you just for fun. Others brought diseases that had no cure. Powerful and easily riled, on land, in the sea, or in the wind, spirits ruled the early Inuit world.

To live among the spirits, the Inuit often called upon a shaman or *angakok* to enter a trancelike state in an effort to visit and appease the offended god. Amulets, potions, sacrifices, and ritual killings were also used to mollify the wrath of the all-powerful supernatural and to defend against its wrath. Small pagan carvings of wood, bone, or ivory, called *tupilaks*, are distinctive to East Greenland. These frightening, totem-pole-like depictions of spirits and demons were carved to deliver misfortune and physical harm to others.

⌐⁊ℓ⌐

In that cove where we camped, little had likely changed since the tenure of its last residents, hundreds of years before. It was hard to image anyone surviving off the land I was seeing. Out of a frozen land the evolutionary tree doesn't sprout many branches. There was very little vegetation, and only nine species of terrestrial mammals—and little evidence of them.

The inhabitants of that cove looked to the ocean to survive. Although cold, salty, and oxygen-deprived, the sea was loaded with food, including some huge mammals. A single warm-blooded behemoth like the bowhead whale could provide the Thule with literally tons of food for themselves and their dogs. The same whale carried hundreds of kilograms of blubber that was easily converted into oil, an essential for cooking, heating, and illumination in the winter.

To hunt on the ocean and to move camp, the Thule built two kinds of boats. The umiak was a ten-metre double-ended open boat powered by sail, oars, or paddles. The ribs of its hull were made of driftwood and covered with seal or walrus hides that were stitched together and made reasonably watertight with blood glue. In the Western Arctic, the umiak was both a transport boat and a hunting boat. In the Eastern Arctic and in Greenland, it was strictly a transport boat. According to European explorers, the boat was fast and light; it could also be portaged for short distances and rested on its side for use as a shelter.

Their other boat was the kayak, which was designed to be silent and fast for hunting. The boat's shape varied from region to region and

even from community to community, but it was always built to suit the particular mammals to be hunted, the area's sea ice, and the wind conditions. But no matter the region, like a tailored suit, kayaks were always built to fit the owner, with minute attention given to a hunter's weight, height, reach, and leg length.

Bone was plentiful, but it was too brittle to withstand the stresses placed on ocean-going craft. The only wood available for kayak construction was the driftwood that washed ashore from Norway or Siberia. The Inuit were superb craftsmen who used wedges, knives, adzes, bow drills, and steam to bend and fashion the kayak's frame. Their mortise joinery, notched with peg fittings, was lashed with finely woven sinew and reinforced with blood glue. Their objective was to create a slightly flexible craft, one that would be able to withstand the forces and pressures of ocean water. The kayak's covering was made and applied by women, using the skins of seal or walrus.

Functionally and materially, the boat was an extraordinary accomplishment. But wrapped in the kayak's conception and construction were the Inuit's strong animistic beliefs, which underlined their connection to the animal and spirit worlds. I described it in my book *Wild Places Wild Hearts*:

> The craft's structure had a organic symmetry to it, analogous to that of its maker: skeletal ribbed frame of driftwood and bone, notched and socketed together like body joints, tied with sinew-like ligaments and tendons making it solid yet flexible, and then covered with a layer of skin from walrus and seals, and sealed with blood glue. The spirit of the animal world, indeed. But the human now became the inner being, the new presence in the reconstructed entity. Together, the skin-wrapped skeleton and the hunter became one: half man, half beast; half alive, half dead; part of the terrestrial world, but animated only on water. With its new master it became the hunter, returning to the ocean to betray its brethren.

<p style="text-align:center">⌒�⌒</p>

Tiniteqilaaq was the most remote of the villages in the Ammassilik district. It was at the end of a 50-kilometre channel called Ikaasatsivaq. If there was anything left of a kayak hunting culture in Greenland, I was hoping to find it there, among the village's 150 isolated inhabitants.

We arrived in the late morning, pulling our boats up to some landing docks at the south end of the village. Around the dock was the business end of town: the radio transmitter, coal storage building, salt house, generator, and trading post. By the time we had disembarked, a crowd had gathered. Inuit kids quickly set upon our boats, investigating everything they could get their little hands on. They drummed the hull with their palms, stuck their heads inside the hatches, and climbed into the cockpits. They and the assembled adults were fascinated with the moulded plastic material and with the rudder, which was controlled with interior foot pedals. The kids were uninhibited and fearless, all wanting to take our boats out for a paddle. One person in our group gave a young boy a paddle and pushed the kayak he was sitting in a short distance off the dock, while holding on to the throw rope. The little scoundrel immediately started to churn the water with the paddle, trying to break free of his hold.

As I moved away from the dock, one of the first things I noticed were the dogs, hundreds of them, everywhere. The dogs had a shabby look due to the shedding of their winter coats. They were multicoloured: white, black, grey, yellow, or brown. Their ears were small and round, their eyes brown and almond-shaped. The dogs were heavy-shouldered, with thick legs and wide paws. Their tails were bushy and tightly curled over their backs. When it suited them, a chorus of bone-chilling howls enveloped the village.

These were the famous Greenland sled dogs, considered one of the purest breeds in the world. That purity is maintained by a prohibition on breeding with other dogs. The polar explorers of the eighteenth, nineteenth, and twentieth centuries coveted West Greenland dogs. They would regularly purchase them prior to their expeditions into the Canadian Arctic and to the North Pole. Even expeditions to the South Pole first came north to Greenland to obtain dog teams.

Attacks on people by Greenland dogs are relatively rare in most towns in South and West Greenland, but not in Tiniteqilaaq. I learned that the town had a history of dog attacks, particularly on youngsters. In the Ammassilik area, only recently had people been relocated off the land. Prior to that, people had lived in family groups on the land with their dogs running free. Although they now lived in the village, the dog owners still held to the custom of letting their dogs run loose. Compounding that problem was the sheer number of dogs.

In an anthropological study from the mid-1970s titled *Leadership and Headship—Changing Authority Patterns in an East Greenland Hunting Community*, Gert Nooter writes that the town of Tiniteqilaaq had fewer than a hundred people but about 1,200 dogs, almost all of them running free. According to Nooter, after numerous fatal maulings of children, a law was passed in Denmark declaring that all dogs in Tiniteqilaaq had to be tied. The law, proclaimed in Europe, carried no weight in the East Greenland outpost and was ignored. After more attacks, authorities were sent to Tiniteqilaaq, and in a two-day period 122 dogs were shot and killed. The remaining dogs were tied up by their owners, but, as Nooter states, that lasted only until the dogs bit through their restraints. Several days later, after the authorities had left, all the dogs once again were running free.

As we walked through the town, we saw that most but not all of the hundreds of dogs were tied down. More disturbing than the snarling dogs and the ground cover of canine feces were the mounds and mounds of garbage piled everywhere. Plastic bags, wrappers and containers, spoiling food, cans, bottles, women's sanitary pads, diapers, and every other possible piece of consumer refuse one could imagine were heaped high around doorways and below windows. Years of it, a metre or two deep, all looking and smelling in the warmth of the noon sun every inch a garbage dump. There had been no attempt to bury it, nor had there been any effort to put it in a centralized location. The same conditions had existed in Tiniteqilaaq twenty years earlier, according to Nooter's account.

In their recent past, East Greenlanders had no such thing as garbage. Food scraps would have been thrown outside to the dogs. Hides, furs, guts, bones, worn-out clothing, and old equipment would have been recycled, eaten, or subjected to organic decay.

It was apparent that the town was a town in name only. In reality, it was still a random collection of individual hunters and their families, who had been pressured by modernity to live together. They might be dwelling in a village, but they functioned within the distant order and specific needs of hunter-gatherer families. Within that tradition, they had no familiarity with group hierarchy, no understanding of an elected or imposed leadership. Societal rules and regulations had no currency for them. Maybe the idea of thinking collectively to solve common problems was not in their hunting DNA.

I struggled to understand how people could live in a garbage dump. But garbage was only a surface expression of a more troubling problem: in the hearts and minds of many of these people, life had lost all meaning and purpose. That loss manifested itself in behaviour more alarming than piles of garbage and free-running dogs.

The five settlements in the Ammassilik district of East Greenland have a suicide rate two or three times that of the rest of Greenland. This statistic is even more shocking given that Greenland already has one of the highest suicide rates in the world, particularly among young males. In the past, suicide was unknown among the Inuit, except among the elderly, who in times of food scarcity would sacrifice their lives so as not to be a burden on the family unit.

All Inuit have been having to adjust to vast cultural changes, but nowhere in the Arctic have these shifts been happening so quickly as in Eastern Greenland. The people there are struggling through a seismic transition—from what was effectively a nomadic, sea hunting culture to the postmodern world. And this transition is only two or three generations old. They're being asked to leave behind a thousand-year-old tradition and grab on to a fast-paced world with a radically different economy, technology, and social and spiritual values. It's as if they have been asked to hop a speeding passenger train.

Following European contact, a vast array of social pathologies emerged. It started with a taste of the outside world's products. Then came the erosion and abandonment of traditional skills, which in turn led to a lack of work and an absence of self-worth. Depression, substance abuse, and alcoholism followed. Spousal abuse, child neglect, violence, and suicide weren't far behind.

~

As we strolled through town, I spotted two kayaks along the shore, high on a wooden scaffold, out of reach of the dogs. One of them was bent and collapsed in the middle, showing its skeletal ribbing and shreds of decaying skin. The other looked as though it might be seaworthy, but I wasn't sure. They looked like crucifixes silhouetted against a backdrop of Sermilik Fjord's iceberg maze.

In the centre of the village, the Lutheran Church had just finished its Sunday service and the congregation was strolling home. Some of the churchgoers were dressed in traditional, eye-catching clothing.

Racked Boats, oil on canvas, 20.5" x 34.5", 1992

Men wore their white hooded anoraks over a white shirt and black tie with black trousers. Some women wore red tops, with brightly coloured embroidery and beadwork circling the front and back of the neck. Others had white hooded tops decorated at the neckline, cuffs, and waist. Their pants were made of black fur with bright pieces of flashing sewn in. They wore fur boots, cut high above the knee.

My mind reeled at the incongruities. It was a bizarre scene: a panoramic, breathtaking view of one of the most isolated places on earth—skin kayaks, sled dogs, a glorious sunlit day, people strolling in traditional clothing—in the midst of a garbage dump. In the hot sun, it smelled so bad we often had to cover our mouths and noses.

The startling juxtaposition of sensations continued. As I looped around the town and was returning towards my boat, I came across a gorgeous skin-covered kayak sitting in the sun, ten metres up from the water. It wasn't an artifact from a museum or the result of a kayak-building class. This boat hunted. The kayak was balanced on top of a fifty-gallon oil barrel. It was in perfect condition. It had a frighteningly narrow beam, and its cockpit was similarly minuscule. Even for a small person, getting in or out of that boat would have been an ordeal. Its skin covering was waxy smooth and taut as a drum, coloured in a range of patinated gold, sienna, ochre, umber, and charcoal grey. Its blood-glue sealant, oxidized a blue-black, covered the sutured sealskin. The front

and rear deck tie-downs held tiny, ivory-carved amulets in the shapes of seals, whales, and polar bears. The kayak's slender bow pointed out towards the water. It sat poised, elegant, and balanced—imbued with potential and purpose, like a samurai's sword.

The skin-covered kayak was just one of many technologies the early Inuit had devised to enable them to hunt sea mammals. The paddles were designed specifically to suit each area's sea conditions and prey. They were meant to enter the water silently, creating the least possible wake or splash. The paddle tips were often inset with ivory to reduce wear when paddling in sea ice.

They had also engineered a unique, toggle-tipped harpoon that, upon striking, would veer and dig into the sea mammal's flesh. A line was attached along the harpoon's shaft to the toggle point itself. The rope ran back to a large, inflated bladder float that was carried on the kayak's rear deck. Once an animal was struck, the kayaker would throw the bladder float into the water, freeing himself of the harpoon, the line, and the thrashing sea mammal. The sea mammal would dive, but would soon tire from having to pull the large, air-filled float under water. The hunter would follow the float until the exhausted animal resurfaced, whereupon the hunter would finish it off with a lance.

The Inuit used other ingenious devices to enhance their chances of a successful hunt. Their boats, depending on what they were hunting, carried a selection of throwing boards, drag anchors, tow floats, white camouflage screening, hunting knives, killing lances and spears, bird float darts, bolas, air plugs, wound plugs, deck line racks, and sinew ropes. All the Thule sea-hunting accessories had to be carefully designed and then arranged on the kayak's deck for accessibility, but attached securely enough to ensure that the hunter would not lose the equipment in rough seas or become entangled in it during the hunt, even if the boat was overturned.

The Inuit understood that if they capsized, there was little chance of surviving a wet exit in Arctic Ocean temperatures. A hooded waterproof suit, tied around the kayak's cockpit, joined the hunter with his boat. They used a flip-back technique that was later identified as the "Eskimo roll." If the boat overturned, from an upside-down position, underwater, the kayaker would down-sweep the paddle and twist his hips to resurface. Compared to our modern, wide-beam boats, the narrow Greenland kayaks were extremely tippy but also much easier to flip back up.

The Thule believed there wasn't a problem that a tool or device couldn't solve. Ethnologists credit them with having more gadgetry than any hunter-gatherer society in the world: an amazing recognition, given the scant resources of their barren home. That problem-solving ability is evident to this day among the Inuit. To a large extent, snow-mobiles have replaced dogs and sleds, but given the extremes of the Arctic environment, they often break down. Every Inuit hunter that I've seen has an innate ability to troubleshoot, take apart, and repair a malfunctioning snow machine, even out on the sea ice.

<center>❦</center>

We had planned to camp near the village. I desperately wanted to do some drawings of their kayaks and other objects. But we hadn't reck-oned on the smell, or on the sight of a village buried in garbage. "Soak-ing in" Tiniteqilaaq was more than most of the group could stand. I had to satisfy myself with some photographic documentation of the town and its skin boats.

We left the narrow channel that separated Ammassilik from the mainland and entered the massive, 100-kilometre-long Sermilik Fjord. It was five kilometres across and chock full of icebergs. In the week that followed we made our way east along Ammassilik's coast towards open ocean. As we paddled, the icebergs became more spread out, helped by the full swells of the mighty ocean. In unison, billions of tonnes of sea ice and icebergs, together with our kayaks, were slowly lifted and lowered by the power of the sea. We passed one flat iceberg the size of a couple of tennis courts. Each ocean roller drummed and rumbled below its under-side. Near the middle of its flat surface a hole had been eaten through, and the swells, having been forced and compressed beneath the ice, set off periodic, 12-metre-high geysers that exploded through the open hole. Each eruption roared like a lion, even from half a kilometre away.

The last camp of our circumnavigation was on the very southwest-ern tip of Ammassilik Island. After supper I hiked to a rise of land to paint a scene of our route, looking back into the fjord. As I worked, my thoughts drifted. How was it possible to survive here? To create a boat from what my eyes could see, made from washed-up driftwood and animal skins? How could such a craft be made seaworthy enough to paddle out into the open ocean, to find and then get close enough to stick a harpoon into a sea mammal perhaps five hundred times

Apprenticeship of a Hunter, etching and chine collé, 18" x 24", 1993

your size? You then had to kill it, still sitting in your tippy boat, and safely tow its carcass back home. And you had do it far from land, in often rough, icy water, in an environment deemed one of the most unpredictable and inhospitable on earth. In my experience, paddling close enough to a sea mammal to capture it with a camera fitted with a telephoto lens is an extremely rare event, given that most wild animals are strongly motivated to be where people aren't.

Yet the early Inuit hunted this way for hundreds of years as the primary means of sustaining themselves and their culture. Their existence, let alone their triumph as an Arctic people, was a seemingly impossible achievement. Imagined and written as a story, it would make a fine piece of fiction, too improbable to be real.

Having made the kayak and all its related technologies, how do you then train and prepare someone for the high-risk task of kayak hunting, to go to the very edge of life as a way of life?

The Scandinavians have a long history in Greenland, dating back over a thousand years. Many, such as Knud Rasmussen and Peter Freuchen in the early 1900s, married into Inuit society, spent most of

their lives in Greenland, and wrote extensively about their experiences. They spoke the language, lived as the Inuit did, and regularly and effectively land-hunted with them. But neither they nor any other European was ever able to successfully hunt sea mammals from a kayak.

In early Inuit society enormous status was given to successful kayak hunters. For men, it was the central definition of their worth. In the East Greenlandic dialect, the word for kayak hunter is interchangeable with the word for man. Most young boys would have dreamed of being a kayak hunter.

In preparation for this perilous journey, boys would start emulating their elders at a tender age. Their fathers would sometimes build very small kayaks for them to play with, under their guidance and supervision. Some were built with stabilizing outriggers, like training wheels. Even on land, boys practised their kayaking skills by squatting in small buckets or pots with a tightrope-walker-like balancing pole — a game to see how long they could stay upright.

For men, hunting sea mammals weighing thousands of kilograms on the open ocean with a spear and in a tippy kayak was indeed a high-wire act, at the edge of what was physically and mentally possible — and perhaps beyond the edge.

When anthropologists arrived on the East Greenland coast in the early 1900s they found and documented a condition afflicting kayak hunters that they termed "kayak-angst." The Inuit called it *nangiarneq*. This strange affliction had already been documented among kayak hunters on Greenland's west coast, but oddly nowhere else in the Arctic. Typically it happened while kayaking on calm water, often with mirror-like reflections. The kayaker would become dizzy, shaky, and gripped with intense fear of capsizing. This anxiety and disorientation was so severe as to be immobilizing. The symptoms would generally subside, and a few days later the kayaker might be able to go out hunting again — but usually not for long. If it happened to an individual once, it inevitably happened again and again until eventually it rendered the person incapable of hunting by kayak. It affected an estimated 20 percent of kayak hunters in Greenland. It had no proven causes or known cure. Speculation as to why kayak-angst developed covered a wide range of ideas, from a hereditary defect in the people of Greenland to a form of post-traumatic stress syndrome caused by the constant life-and-death trials of hunting in this manner.

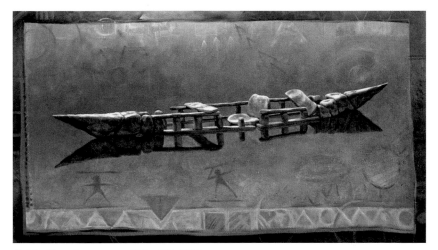

Child's Play, oil on canvas, 20" x 37", 1993

I pushed to finish my little watercolour. The temperature of the late-day air had plummeted and had begun to produce a skim of finely webbed ice crystals on my metal mixing tray, on my paper, and on the sable hairs of my brushes. I packed the paints in my satchel and, swinging my arms to increase circulation, made my way back to my tent.

The air was calm, cold, and damp. Way off to the east, through a vaporous haze, enormous ice bulwarks were paralleling the coast in the Greenland Current. To the south, a flat line of ocean curved out and under the planet—an uninterrupted continuum all the way to the ice chambers of Antarctica. Back to the west, the sea ice and icebergs remained, backlogging the fjord we had left. Everywhere my view was of a silent, brutal outpost: an unforgiving land—a most unlikely place to find signs of habitation, let alone evidence of the apex of human endeavour.

After I returned home, I found an old anthropological account of a tiny Inuit East Greenland village that had long since been deserted. The village had been directly across from Tiniteqilaaq on the west side of the Sermilik Fjord we had paddled. The account included a black-and-white photograph of a stone kayak. It was a life-size replica, made out of large rocks, located in the play area of that tiny settlement. Generations of small boys had sat in its cockpit, sticks in hand, pretending they were paddling and harpooning huge sea mammals, envisioning themselves as great kayak hunters.

That photo prompted me to build a small clay model of a stone kayak, on a sheet of glass. From the model I did a drawing and from the drawing, an oil painting. In the painting, its form reflects onto the sheet of glass, as if the stone kayak is floating on water — defying what is seemingly impossible.

VI

MAUI, 1995

This was my country,
This was my song,
Somewhere in the middle there
Though it started badly
and it's ending wrong.
—Joe Henry

After guiding his caravel through the thread-like strait that would come to bear his name, Ferdinand Magellan gazed upon waters that no European ship captain or seaman had seen. From the deck of the *Trinidad*, Magellan christened what he saw *Mare Pacificum*, the "Peaceful Sea." Perhaps he named it so to reverse the fortunes of a problem-plagued voyage, or perhaps calm waters prevailed off Tierra del Fuego on that November day in 1520. One wonders if the great Portuguese explorer knew how immense a body of water he had just entered. If he had, would the world's largest ocean be called something else, such as *Mare Continuus*, the "Endless Sea"?

Its reach is truly vast, stretching into both icebound polar regions. From east to west, it spans 20,000 kilometres—half our planet's circumference. In square kilometres, it's greater than the Earth's collective land mass. Viewed from outer space, the Pacific Ocean makes a persuasive argument that our planet should be named the Water, not

the Earth. It is also deep: below the surface its undulating and at times fiery floor has canyons and trenches that exceed 10 kilometres in depth.

Dead centre in the Pacific's 160 million square kilometres, exotically distant and remarkably removed from anywhere else, is a broken arc of porous lava — the islands of Hawaii. A map of the Pacific Ocean might suggest that the islands were never meant to be inhabited or even found.

The Hawaiian islands were born 70 million years ago. With the thinning of the massive Pacific Plate, and the welling up of undersea volcanic pressures, eruptions commenced and conception began. For millions of years the area was a tectonic hot spot. The bowels of the earth released a long sequence of cataclysms, spewing, lifting, glowing, flowing, smoking, steaming, cooling, hardening, and then eroding and collapsing into the sea before rising once again. Eventually, this violent union of fire and magma, nurtured by ocean water and time, transformed itself into a vision of beauty.

Blessed by tropical breezes and warm seas, the islands blossomed, displaying all the traits of paradise: endless coasts of ebony or dazzling white sand, offshore coral gardens, turquoise lagoons and bays, cascading waterfalls, underground freshwater reserves, shaded pools of clean, cool water — or, in places, magically salted and warmed. In *Hawaii*, James Michener concluded that "if paradise consists solely of beauty, then these islands were the fairest paradise that man ever invaded."

Of the many invaders that would, in time, arrive, the first came from the south. By 200 BCE, a time when others thought that sailing beyond sight of land risked falling off its edge, the Polynesians had long been long-distance mariners. Given that their homeland consisted of vast scatterings of tiny islands, it's not surprising that their culture developed along the lines of boat building and seafaring. Their longer journeys were in huge, double-hulled canoes, some 30 metres long, that were lashed together with crossbeams like a catamaran. The boats were extremely stable and capable of carrying substantial numbers of people and large quantities of cargo. And they were fast, powered by both woven sail mats and wide-bladed oars. The daring, brown-skinned adventurers navigated by the stars, the sun, the moon, and the wind and by their gods' directives.

Even for the Polynesians, crossing 4,000 kilometres of uncharted open ocean was a severe test of skill and stamina. It's believed that the

first of them to arrive on the Hawaiian Islands came from the Marquesas, but others soon followed, from Tahiti, Bora Bora, and elsewhere in the South Pacific.

At first sighting, they might have looked on Hawaii as a vision of paradise, but a material paradise it was not. The islands had limited resources, concentrated in very few species. They were so isolated that only seabirds capable of long-distance flight could have called its igneous rock home. Terrestrial mammals would have been non-existent. Trees and plants would have been restricted to those whose seeds had hitched a ride in the crevices of driftwood or been deposited in the droppings of seabirds. The Polynesians would have found few insects—only those that had been vacuumed up somewhere else by typhoons.

For the Polynesians, islands as far away as Hawaii would have been one-way journeys, given the distance and the ocean's prevailing north-westerly currents. An assortment of roots, nuts, and seeds, sufficient to start a new settlement, would have been carefully wrapped in palm leaves and stowed in the boat's open hold to survive the long ocean voyage. Between forty and a hundred people would have been on board, including priests, navigators, boat builders, farmers, women, children, and slaves, together with dogs, pigs, and chickens.

My arrival on the Hawaiian Islands came about by way of an invitation and an eleven-hour flight. I went to Maui, Hawaii's second-largest island, to be part of a film. It was an innovative idea—a documentary/narrative about adventure, art, and whales. A friend of mine, Gilles Couët, had suggested to Quebec filmmaker and marine biologist Jean Lemire that he include me in a film he was planning to make. The film's concept was to allow the viewer to see the world of the humpback whale through an artist's eyes. I would be given the same access to whales as a marine biologist. It was hoped that my response might produce some interesting art and make a compelling film.

Jean was familiar with Hawaii. Like many whale researchers, he had come to Hawaiian waters over the years to study whale behaviour, in particular that of humpback whales. Humpbacks winter annually in Hawaii, where they mate, give birth, and nurse their young. At winter's end, when the young are mature enough, the whales return north to their feeding grounds off the Alaskan coast.

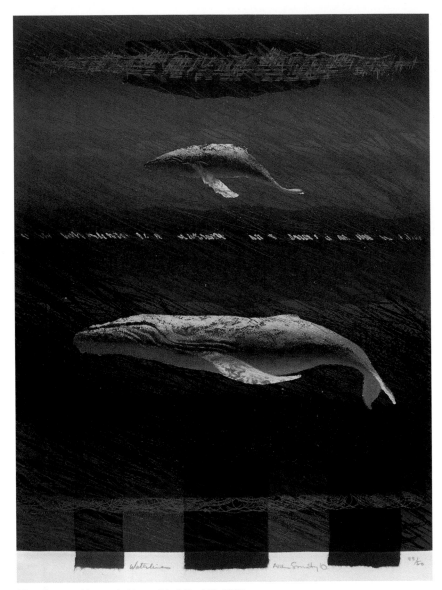

Waterlines, etching and chine collé, 24" x 18", 1997

Jean had obtained a permit from the State of Hawaii that would allow us to enter the water and swim with the humpbacks. In Hawaiian waters, this permission was very rarely granted, even for marine biologists. The one-hour Radio-Canada-sponsored film would be shot

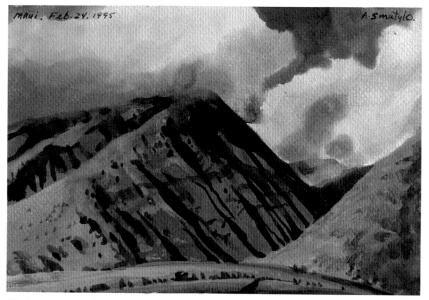

Maui, Feb. 24, 1995, watercolour, 6.5" x 9"

over a two-year period in Maui, Alaska, and Labrador. My artwork aris-
ing from these experiences would be integral to the film. At the time,
however, the film's precise storyline was unknown, for it would depend
on the experiences we had and the artwork I produced.

This was my first trip to Hawaii, and I instantly fell in love with the
climate, at least in winter. The air is succulent—delicately scented,
smooth, and relaxing as velvet. Against the skin its touch soothes the
body like the whisper from a lover's lips. It encourages gentle moods
and seems to hold the promise of a life less complicated.

Maui's balmy on- and offshore breezes warm the water and air-con-
dition the land. High canopies of palm fronds swish and sway, shading
and cooling the ground. At night the ocean dances with the reflection
of a million stars. Evenings and mornings are wonderfully temperate,
and the nights are often cool. During my stay there was an absence of
humidity or stifling heat, day or night. Nor were we bothered by the
swarming or biting insects that one typically expects in the tropics.

The island's fertile hills and plains vibrated in variations of green.
It was a tapestry of moss, jade, viridian, lime, and sage, with added
bits of gold, tan, teal, and umber, all tufted, knotted, and embroidered

onto the red earth. Much of the land that rings the coasts is cultivated, producing tropical fruits and flowers, macadamia nuts, coffee, papaya, sugar cane, and pineapple. In the interior the landscape changes to sensuously rounded mountains that rise rapidly before plunging into crevices. Between the tumbling white clouds in an azure sky and the deep indigo of the sea, the land's earthy textures shimmer and pulsate with energy.

It is a paradise... sort of.

We stayed near Lahaina, on Maui's west coast. Apart from the harbour, its main feature is a huge banyan tree in the town's centre that has set down at least a dozen huge trunks and that shades a quarter of an acre. It was planted in 1873, a time when saloons and brothels lined the streets of Lahaina and when whaling captains, whores, and missionaries competed for the bodies, gold, and souls of sailors. Now a holiday destination, the downtown is lined with storefronts that compete with one another for tourist dollars.

Lahaina is a tourist town with a capital T. An endless variety of merchandise with a "Hawaiian paradise" theme flows from shops and stores, most of it manufactured in China. The tourist multitudes—over two million come yearly come to Maui, 80 percent of them Americans—seem to lack all resistance to paradise-themed products, from cheap Maui mugs and sets of dolphin coasters to Versace sunglasses and Hermes bags. Hundreds of stores are jammed into a few blocks—antique shops, jewellery stores, clothes boutiques, leather merchants, and novelty shops, most of them selling items imprinted with saccharine images. The marketing of souvenir T-shirts is on a scale that my sheltered upbringing could never have imagined. How could there be a thousand different breaching-whales-at-sunset T-shirts? All the same, yet all different?

The marketing didn't end with the material stuff. Every conceivable outdoor activity was readily available with the swipe of a credit card. One could rent various boats, Sea-Doos, bicycles, vintage cars, Harley-Davidsons, dirt bikes, or mopeds. You could sign up for snorkelling, scuba diving, surfing lessons, sunset cruises, helicopter rides, deep-sea fishing, kayaking, whale watching, parasailing, paragliding, volcano tours, and rides on everything from submarines to horses.

Probably because of my occupation, the worst for me were the art galleries, and there were scads of them. There, one might have reasonably expected to find at least a modicum of self-expression and individuality. But with only a few exceptions it was a continuation of the T-shirt theme at higher prices. There were hundreds of scenes, all garishly coloured, of whales and dolphins cavorting in a tropical cove with a distant volcano, rainbow, or sailing ship, against a sunset backdrop. A white stallion prancing along the shore with a distant volcano, rainbow, or sailing ship, against a sunset backdrop. A long-haired Polynesian princess thigh-deep in water with a distant volcano, rainbow, or sailing ship, against a sunset backdrop. Variations of these were produced and reproduced on everything that would hold surface colour, from pillow covers to shower curtains, from dinner plates to backpacks, and from vests on stuffed animals to ashtrays.

Apart from the art, many galleries put enormous effort into selling the artist. Some used billboard-sized posters, others wall-sized plasma screens to portray the artist. It was a full-body embrace of the bigger-than-life ideal of star making. Some artists were depicted as golden-haired surfers riding the waves while communing and "at one" with whale and dolphin. Another artist was depicted playing a guitar, bare-chested in a suggestive Hollywood soft-porn pose. Some claimed acting credits on TV shows and in feature films. If you couldn't afford the paintings there were DVDs, CDs, posters, books, playing cards, calendars, and so on.

Many people would view Lahaina's commerce as simply a good business model—willing sellers and buyers, each getting what they want. I viewed it differently. Viscerally, it gave me a fright: consumerism on amphetamines, a gluttonous consumption of nothingness. It was as vacuous as an elixir's claim for perpetual youth. While offering a piece of paradise, they were destroying it.

Maybe it was simply my take on things, but I viewed Lahaina as something more than just another example of rabid consumerism. I'm not sure why. Perhaps it was because it was happening there, in that particular setting—a small South Sea island in the middle of the Pacific Ocean. To make analogies with John Milton's epic poem might be a stretch; nonetheless, Lahaina kept bringing to mind the words "Paradise Lost."

Jean and the film crew stayed in a rented house in Lahaina. Gilles introduced me to a professional photographer and guide, Mike Beedell, who was part of the film team. The three of us stayed at a campground 10 kilometres south of Lahaina. The film's funding was too limited to book us in a Lahaina hotel for two weeks, but the three of us preferred to camp anyway. There aren't many camping areas in Hawaii. The islands had been overrun by hippies in the 1960s and 1970s, who reportedly camped all over the place and seemed disinclined to leave — not exactly the visitor profile the Hawaiian Department of Tourism was looking for. The state subsequently began removing and restricting campgrounds.

We pitched our tents and set up house in the small private campground. It was a fabulous location, with ocean frontage and the shade of towering palm trees. Because the campsite was entirely on beach sand, the owner had laid down old rugs and carpets everywhere. Over time they had taken on the strange appearance of an earthy-synthetic membrane.

We spent the first few days talking about whales and what the shooting itinerary might look like. We also toured around, getting to know the location. I immediately started doing small, quick watercolours of the surroundings, which is my normal procedure to get the feeling of a new place.

A short walk from our campground towards the interior was a petroglyph site called Olowalu. This was one of a number of similar sites that dot the Hawaiian Islands. The petroglyphs had been carved, often deeply, into the porous rock. Many dated back to the time of the first Polynesians. Before alphabets were invented, this was how many peoples passed on their history — by scratching symbols and depictions into rock. The stick figures at Olowalu conveyed a hierarchical society that represented everyone from high priests to slaves. Births, deaths, sacrifices, their gods, and other aspects of life were documented, sometimes literally and in other instances with baffling symbolism.

The early Polynesians chose these sites for their *mana*, or cosmic power. They believed that within these specific spots were powerful force fields that were so highly auspicious that ordinary people would die if they even looked at them. So specific were these spots that a smooth rock surface a few paces away would be totally devoid of petroglyphs, being outside the *mana* force field.

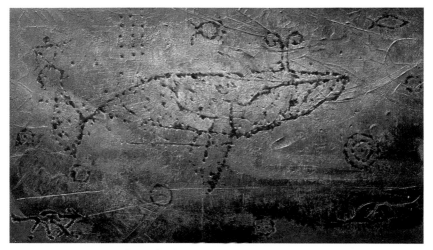

Tail Dance, oil on canvas, 16" x 29", 1996

I did some sketches and took some photographs of the petroglyphs. They were powerful inscriptions and beautifully tactile. I pondered the idea of using paint and canvas to depict my Maui whale adventure as a petroglyph.

Mid-morning on a Saturday, two days after arriving, Gilles, Mike, and I went for a tour of Maui in our rental van. We travelled north to Ho'okipa Beach and sat and watched surfers riding the curls of mountainous waves. When the wind and tides are right, the north coast of Maui is one of the best (and most dangerous) places in the world to surf. Later we turned south along the coastal highway. In the early afternoon we pulled into a little town for lunch. We found a parking lot by a small park that had access to a public beach. We ate our packed lunch on a picnic table, joining other weekend locals who were doing the same. When we finished lunch we went back to the van and got our masks and snorkels to try out. (We would be swimming with the whales without scuba tanks.) We thought it would be wise to test our equipment in a controlled setting before jumping into the ocean with whales. We did a brief swim with our fins, masks, and snorkels that lasted less than thirty minutes. When we returned to the van we found that one of the locked side doors had been pried open. A pile of stuff, valuable stuff, was gone.

After the initial shock and outrage, we took an inventory of what exactly had been stolen. Gilles had lost a very expensive, brand-new

underwater Nikon camera that he had bought for the trip. Mike had lost an entire carrying case of professional camera stuff: lenses and bodies. I had left my wallet with all my money, my passport, credit card, return airline ticket, watch, painting supplies, two completed watercolours, my camera, film, and keys to my house and car in my backpack—it was gone.

We surveyed the people in the park. Even though the van was very close by and in their clear view, everybody we asked, with a shrug of the shoulders, said they had seen nothing. We drove the short distance to the police station in Wailuku to report the crime. It was a warm, cloudless weekend afternoon but the town's streets were semi-deserted. We pulled into the police station's empty visitor parking lot, entered the building up a flight of steps, and went to the reception desk. An officer, sitting behind the counter and a partition of thick glass, glanced up at us standing three abreast, through a small arched opening.

"So, what can I do for you folks?" he said.

"We'd like to report a robbery," Mike responded.

That immediately changed the cop's demeanour. His eyes scanned ours.

"Really?" He stopped what he had been doing and his left hand went reaching for what I assumed was a crime statement report. He grabbed a pen with his right hand. "Okay, who was robbed?"

"We were."

"Really! All three of you?"

As he started feverishly writing, my feeling of utter hopelessness in apprehending the thieves and reacquiring our stuff started to change into something that could be described as approaching faint hope. I was impressed—obviously in paradise, crime simply wasn't tolerated.

"Where did it happen?"

"At the little park in Kahului."

Busily writing, head down, he muttered, "The one down by the beach?"

"Yeah, that's right." We nodded.

He mumbled "really" again. "Okay, so what happened?"

"Well, we went swimming and half an hour later we came back to our van and found that it had been broken into, and a lot of our stuff had been stolen."

At that the cop ceased writing and released the pen from his fingers. It toppled onto the crime report form like a chainsawed sapling.

"You weren't robbed!" he said with animation, dragging out the *r* in robbed. "You were just ripped off!"

As if teaching a kindergarten class, he used weapon-holding hand gestures, explaining that getting robbed meant being held up with a knife or a gun.

He asked no more questions and made no more notes on his crime report form. For the next few minutes he treated us with an air of indifference, as if we had falsified a crime. To try and regain his interest, we estimated the value of the items stolen. We told him we had lost around $20,000 worth of stuff.

At that the cop closed his eyes, exhaled, and muttered something. He shook his head from side to side as he told us to take a seat in the waiting area. He got up and disappeared into the back offices. He brought out new forms for each of us to complete. We were to make a detailed inventory of what we had lost. It took us about half an hour to complete the list, with each item's description and value. When we handed the forms back to him, he perused the list. It totalled over $25,000.

In exasperation he asked why on earth had we left all that stuff in our van. We explained that the van had been locked, that it was in a public place, that it was broad daylight, and that we were gone for only thirty minutes.

Our naïveté astonished him. He blurted out, "Don't you guys have crooks in Canada?"

With his mouth agape and a blank expression, he looked into our eyes one by one, regarding us as total innocents, the Three Stooges, or something akin to adolescents deciding to play poker with underworld crime bosses. But I sensed, beyond his exasperation, that the cop was developing a soft spot for these abused puppies. Our pathetic vulnerability began to worm its way into his heart.

The officer told us that property crime was practically out of control on Maui and in Hawaii as a whole. It was directed at unsuspecting tourists. That particular year, Hawaii's ratio of theft crimes to residents was one to fourteen—among the highest if not *the* highest ratios in the United States for that type of felony.

He asked what were we doing in Maui with so much expensive equipment. We told him we were making a whale documentary and, because we were camping, we had taken all our valuable things with us. We reminded him that there had been lots of people in the park

next to where we parked the van, but added that unfortunately nobody had seen anything.

The officer again shook his head slowly and sighed; he had been doing a lot of that. He said nothing for a while; then, after glancing over his shoulder, he said, "There were only locals in the park, right?"

We nodded.

For the first time it registered with me that the officer was white. Many of the other cops milling around in the office were Hawaiian.

Again, in a low, guarded voice, he leaned forward. "They saw what went down…some of them would have been part of it."

Glancing back and then bending forward again, he added, "Look, Hawaiians hate us. They don't want us here. It doesn't matter if it's on the street, at a park, or in an office like this one. That's the way it is here."

Sensing he might have gone too far, he picked up the Stolen Item Form and swung the talk back to what had got lifted.

⚶

The first Americans in Hawaii were missionaries. They booked passage, Bibles in hand, after reading James Cook's account of his 1778 discovery of the islands and of the natives' pagan rituals and lurid behaviour. The missionaries, most of whom came from New England, set about converting the Hawaiians to Christianity. But they and the others that followed brought more drastic consequences than a new religion. Diseases that the islanders had no immunity to spread like wildfire, reducing the native population almost by half.

At the time of contact, the hundred-year-old Kamehameha Dynasty was coming to an end on the islands. As it waned, the king moved Hawaii from an absolute monarchy to a constitutional monarchy. The combined effects of a more Christian Hawaii and a more representative government conflicted with the interests of many newly arrived Westerners, who had a strong preference for the hedonistic perversions of the past. Other conflicts were emerging as well, such as those over landownership. Private property and its associated rights expanded with the growth of Western commerce, and this became an added irritant for the Hawaiians, who weren't accustomed to the practice of owning land.

Business between Hawaii and the United States expanded rapidly and led to the latter obtaining exclusive trading rights with the former. The islands' agricultural landscape began to change drastically, with

mass plantings of sugar cane and rice. Once a permanent naval presence had bolstered what was already a powerful American influence on Hawaiian agriculture, religion, and trade, grabbing political control of the islands was all that remained. Realizing that, the monarch at the time, Queen Lili'uokalani, tried to promulgate a new constitution that would restore the power of the monarchy and strip foreigners of their suffrage and influence.

The Americans and Europeans on the islands cried foul, and organized and strongly lobbied the US government to intervene. The United States, claiming that American interests and even lives were at stake, sent in military personnel. Queen Lili'uokalani backed down, and abdicated. A provisional government under Sanford Dole, representing American interests, was established.

Subsequently, back in America, the president appointed an investigative commission to look into American conduct in Hawaii. The ensuing report concluded that the "US diplomatic and military representatives had abused their authority and were responsible for the change in government." President Grover Cleveland declared that the forcible intervention had been a "substantial wrong" that should be undone. But the drumbeat of American imperialism could no longer be muffled. The US Department of State's Minister to Hawaii, John L. Stevens, announced that "the Hawaiian pear is now fully ripe and this is the golden hour for the US to pluck it."

A follow-up report cleared the United States of any wrongdoing, adding that the Queen should not be reinstated. In 1894, the Republic of Hawaii was established. Four years later, under President William McKinley, the United States annexed Hawaii in an expression of what the president referred to as America's "Manifest Destiny."

For a hundred years, however, the fruit's bitter taste had lingered in the garden. So much so that in 1993, under the Clinton administration, the US Congress passed the Apology Bill in an attempt to address the misinformation that the United States had spread regarding the island's overthrow. That bill apologized for the "suppression of the inherent sovereignty of the Native Hawaiian people."

⁓

Gilles asked the cop's opinion about where he thought the camera equipment would end up. The cop said it would be sold to a fence—a

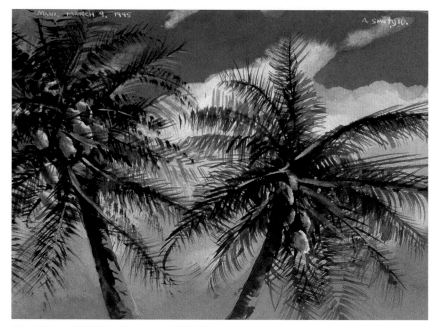

Maui, March 9, 1995, watercolour, 6.5" x 9"

pawnshop in all likelihood—for money to buy drugs. Gilles asked, if the cameras were sold locally, who would be the likely dealer? To our surprise, the cop responded by saying that if we could wait a minute he'd take us to him.

After the van's doors were dusted for fingerprints, we followed the officer's cruiser into the downtown area. We parked along the thoroughfare that ran through the middle of town. It was a late Saturday afternoon, hot and still, with the streets and sidewalks semi-deserted. The cop led us into a tiny storefront called The Paradise Pawn Shop. Its Open/Closed neon sign wasn't on.

Inside, the room was baking hot. My first impression looking around was that for a pawnshop there was a surprising lack of junk. The room was lit by flickering fluorescent tubes and by sunlight that reflected off the sidewalk and came through the front window. The air was dead and thick, choked with the smell of dust and cigarette butts. A bored middle-aged guy was sitting behind a low glass counter. He wore a white tank top that needed washing. He had a cigarette hanging from the edge of his lips and a round porcelain ashtray in front of him. He

was squinting, presumably keeping the cigarette smoke out of his eyes. A woman in a long green loosely flowing dress was leaning against the back wall behind him. She was resting her chin on the palm of one hand, holding her elbow with the other.

I felt as if I had walked into Mickey Spillane novel.

The uniformed cop gave the owner a brief outline of what had happened. Gilles filled in the details of the makes and models of the photographic equipment taken and told the guy we'd like to get the items back.

At that point, the conversation, considering that it was in the presence of the law, got surreal. The guy behind the counter said that if he did get our stuff in, how much would we be willing to pay to get it back? After consulting with Mike and me, Gilles told him fifty cents on the dollar if we got the cameras back within twenty-four hours. Past that, we would be interested but at a further price deduction — twenty-five cents on the dollar. Past two weeks, we wouldn't be interested, as we'd be gone.

The owner took our camp's address and phone number and said he would be in touch if the merchandise surfaced and if the deal was of interest to the thieves. With the cop watching and listening, the owner said that if the cameras showed up, it was understood that the cops wouldn't be involved. We glanced over at our guide to the Hawaiian underworld. The cop shrugged and gave a slight head nod, as if to say, *Of course.*

With that, we thanked the officer for his beyond-the-call-of-duty help and headed up the highway in our rental van towards Lahaina and our campsite. For the moment anyway, the feeling of loss from the heist was replaced with a buzz of excitement: of clandestine meetings, rip-offs and tipoffs, hush-hush deals, and speculations of double-dealing.

A crazy mix of things floated about in my mind: the absurd, the daring, the naive, the intriguing, and the unknown. In some ways I saw the theft as one small part of a multi-chain pileup of divergent worlds crashing into one another. The collision had started way back, two hundred years before: haves and have-nots, Hawaiians and whites, past misdeeds and property rights.

Given our experience that afternoon, some of the things we had observed on our morning cruise along Maui's coastal highway started to make a lot more sense. We'd seen numerous cars abandoned on the side of the road, picked clean of hubcaps, wheels, and even doors and seats — left like carcasses of week-old road kill. We'd also observed

tourists (more experienced and savvier than we) sunbathing literally within two metres of their parked rentals.

Driving back, in the day's dying light, we picked up a strong Honolulu radio station. It was playing Bob Dylan's "Everything Is Broken." We cranked up the volume and joined in singing, switching a few of the words in the song, such as "broken" to "stolen."

> *Stolen cultures, stolen lands,*
> *Stolen cameras out of rental vans.*
> *Stolen places, stolen hearts,*
> *People's lives comin' apart.*
> *Take a deep breath,*
> *Feel like foldin'*
> *Everything's stolen.*

After the pawnshop meeting, the three of us were buoyed by what we saw as a reasonable chance of getting (buying) our cameras back. Personally, my camera was much less of a concern than some of my other stolen stuff. Not having a wallet, passport, return ticket, or ID was a big worry, particularly since I was in another country.

The next morning, after I learned that Canada doesn't have a diplomatic presence in Hawaii, I found a pay phone and called the Australian consulate in Honolulu. In Hawaii, Australia handles Canada's interests. I told the consulate what had happened and mentioned that I needed their help. I went on to explain that the loss was compounded because I was in Maui shooting a documentary and that the filming was on a tight two-week schedule. The woman in the office replied that without a passport, my biggest problem would be getting back into Canada. She said that since I had no personal identification of any kind, I needed to get verification faxed to me from my employer in Canada, confirming that I was who I said I was.

I told her I was self-employed.

"Well then," she advised, "you would need written confirmations regarding your identity from some of your employees."

I said I didn't have employees.

"Well then, from your wife."

I told her I was recently separated and that a phone call from me, from Maui, asking for help likely wouldn't go over too well.

Unsure what to say next, she gave me the number of the Canadian consulate in San Francisco. What I heard from them wasn't good. They said I was in a serious predicament, in that I wouldn't be allowed to even board a plane back to Canada without a passport or other substantial documentation. They suggested I forget about the film, fly to the Australian consulate in Honolulu post-haste, and try to build a convincing paper file regarding my identity.

Given our limited budget and our limited time in Hawaii, going to Honolulu for who-knew-how-long would have severely impacted, if not scuttled, the film. The basis of the film was my reaction to the whales and the resulting artwork. Anyway, I didn't know how I was going to function creatively while my thoughts were consumed with the theft of my identity and its ramifications.

Although it wasn't at the very top of my list of concerns, I lamented the loss of my little watercolour kit. It was a simple fold-out metal box where I kept my paints and mixed my colours. I had had it for thirty-five years, travelled with it all over the world, and used it to mix paint for a thousand watercolours. It was an old, comfortable friend, and I was going to miss it terribly. Like a musician losing a lifelong instrument, I wasn't looking forward to buying and using a replacement.

On a purely sentimental level, I also felt the loss of a small green-and-white thermal plastic coffee mug. I had found it along Caledon Creek, north of Toronto, on my very first watercolour excursion when I was sixteen. I had forgotten to pack something to hold water and had found the mug while searching the riverbank for some sort of container. I had used it ever since to hold water for every watercolour I'd done.

But sentimentality aside, I had to focus on reclaiming my identity. In their typical comic-*noir* fashion, Gilles and Mike mused that with the contents of my backpack I had provided the thief with everything he needed to completely assume my identity. With my passport, wallet, and return ticket, he could fly to Toronto. With my car keys and parking voucher he could get into my car at the airport parking lot and drive to my house (no one else was living in it) in Owen Sound, unlock the door, go to sleep in my bed, and help himself to the clothes in my closet. Mike and Gilles figured that with the keys to a fully equipped studio, and with two unsigned watercolours from Maui in his (my) backpack, the thief had been given an excellent start in his transition from petty thief to artist impersonator.

I would have found the joking funnier if it hadn't sounded so eerily plausible.

They went on to say that I shouldn't worry, though, that I'd be fine spending my remaining days in exile, tenting in the Lahaina campground while painting and selling images of whales frolicking at sunset to tourists. They thought, however, that I'd need to change my professional name so that the certified Smutylo wouldn't sue me for impersonating him.

The following day was dominated with talk about the theft and what to do next. Our misfortune spread beyond our own tents and picnic tables and became the talk of the campground. Most of our fellow campers were continental Americans, and they all expressed barely controlled outrage that innocent types like us, guests to their country, trying to make an educational documentary about whales and being a "good kinda folk," could be treated so badly. It was one thing to steal from streetwise Americans, but ripping off Canadians—hell, that just wasn't right.

A plumber from Baltimore was particularly riled. He said Hawaii was in need of some good old-fashioned law and order. He went on to say that the whole of America was plagued with disrespect for the law. Underlining the point more than he realized, he said that when he got calls to go to certain Baltimore neighbourhoods he always packed his .38 and put his loaded shotgun behind the seat of his van.

After a day and a half there was no word from the guy at the pawnshop or from the cops. However, my call to Visa reporting my stolen credit card had already resulted in a replacement card delivered right to me, as if on the wings of Hermes. You can lack identity in America, but not credit.

The reality of never seeing our stuff again was starting to sink in. What to do about our filming schedule, the loss of film equipment, and my identity problems began to weigh down the entire film crew.

Then, in the late afternoon, forty-eight hours after we'd reported the theft, a police car rolled into the camp area's entrance. I happened to be walking along that trail at the time. The patrol car eased to a stop. The officer lowered his window and asked if I knew of any people staying in the park who were making a movie. I identified myself as part of that group.

He said that someone had turned in a bag that they'd found thrown on the side of the road, north of Lahaina. A feeling of elation started

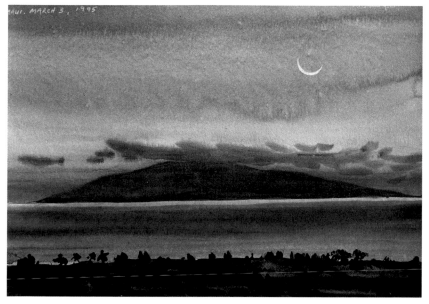

Maui, March 3, 1995, watercolour, 6.5" x 9"

to build. I said that I'd had a black backpack stolen a few days ago. He said it wasn't so much a backpack as a lunch bag, and it was light blue, with a top-loading zipper. He said it contained sandwiches, a book, a black purse, and some sort of paint supplies. Apart from the mention of paint supplies, it didn't sound like any of our stuff. Also, it seemed to have been found in the wrong part of the island. He said we should come down to the station to take a look anyway.

I told Gilles and Mike about the conversation with the cop, and before starting dinner we drove to Lahaina to the police station. As we headed north along the coastal highway, the sun dropped below the horizon, leaving the sea the colour of India ink and the sky blood-orange. The headlights from the oncoming traffic roughly equalled the illumination from the sun's afterglow. Lahaina's streets, as usual, were jammed with slow-moving cars and brightly clothed pedestrians.

At the police station we indicated to a receptionist why we were there. We were led into a very large, brightly lit area with lots of long tables. There were other groups of people in the same room for the same reason as us. After about ten minutes an officer came to our table carrying two items.

In one hand he held a large black circular purse with an over-the-shoulder carrying strap. In the other was a quilted, square, blue-vinyl satchel with side carrying handles. They weren't ours. Expectations, restrained though they were, went crashing.

He put the two items down on the table in front of us and left. Both bags were crammed with crap. I sat and watched as Mike and Gilles started pulling stuff out. The blue case smelled of lunch: peanut butter and jam sandwiches, a clear plastic bag with a bruised apple, an old banana, broken cookies, and a few juice boxes. A book. A child's toy. And then out came my dented, silver-grey watercolour box.

I felt like a kid finding our family's lost cat. Under that was more: my brushes, my sketchbook and fine papers, and even my little green-and-white thermal mug. I was thrilled. Opening up the folder of art papers I found the two watercolours I had done the first day I arrived in Maui. The thieves had tossed them out with all the other stuff. I could have taken that as an artistic insult but concluded it probably wasn't meant as a critique of my painting.

The discovery was fabulous news, but it got even better. Jammed into the bottom of the black circular purse was my small, dark-blue document folder. Inside the sleeves of the plastic cover sat my passport, airline ticket, and some other travel papers. Farther down, at the very bottom of the bag, were my car and house keys.

It felt wonderful, as if the weight of the world had been lifted from my shoulders. There were no cameras, of course, nor were there any wallets. We had all lost cash. In US and Canadian currency I'd had about $1,000 in my wallet. But we'd never held out any hope of getting that back.

The thieves had broken into other cars that day and had stuffed all the things they couldn't easily hawk for cash into those two bags and tossed them out their car window, probably on the way back to Lahaina.

After that, the rough start to the Maui adventure melted away. We commenced an amazing two-week experience out on the clear, warm waters of the Pacific Ocean in a couple of small Zodiacs: observing, documenting, snorkelling with, identifying, discussing, and learning about humpback whales. The experience of swimming with whales in their underwater world evoked emotions that cannot be put into words. From above and below the water, we saw them close up, sometimes only metres away: mothers with their calves, males fighting other males for mating rights to females, and explosive displays of wild pectoral and

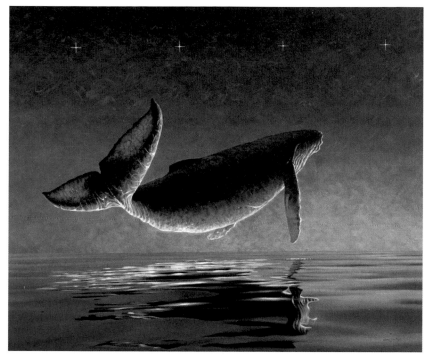

Released, oil on canvas, 35" x 42", 1997

fluke slapping. We saw spectacular breaching, forty tonnes fired right up and out of the water, sometimes repeatedly for twenty minutes, the same whale, over and over again. On occasion the young swam around and under us wanting to play. Another time we were alongside a male the force of whose singing sent a wall of sound resonating through our bodies.

When the two weeks were up, Jean seemed pleased with both the variety and the intimacy of the whale encounters we had had and with the film footage his crew had shot. I was thrilled with what I had seen and felt and spent the following year and a half developing those ideas, and others from experiences in Labrador and Alaska, into whale theme paintings and etchings. A year and a half later, the one-hour documentary premiered throughout Canada to critical acclaim.

I carried back to Canada no ill will towards our Maui thieves. Assuming they were Hawaiian, their south sea island home had been invaded, their land stolen, their culture destroyed. A once proud and

independent people had been left to wait tables, clean hotel rooms, and dance for their conquerors for nickels and dimes at nightly luaus. One could hardly blame them.

Two months after I got back home, a small envelope from Maui came to my house, addressed to me. The return address was in Lahaina. Inside the envelope was my Ontario Health Card, which had been in my wallet. It was heavily toothmarked and chewed. The accompanying note from the senders said that their dog had gone for a run and had come back with my health card in his mouth. With the card, they'd gone to the Lahaina police, who had told them about the theft and given them my address in Canada. The note ended with them apologizing to me on behalf of the people of Hawaii for what had happened. They said they hoped I wouldn't judge all island people too harshly.

VII

BYLOT ISLAND: MIKE BEEDELL, 1999

The sea has never been friendly to man.
At most it has been the accomplice of human restlessness.
—Joseph Conrad, *The Mirror of the Sea*

The portly 20-centimetre doll appears to be a cross between a parakeet and a toucan. Its coloured material has faded with age and its stitching is well worn. It has the look of a doll loved by a child, or by children, for years. Its owner, however, is a man. His name is Mike Beedell. He calls the bird Tookie.

For a stuffed toy, Tookie has had an uncommon existence. For the past twenty years it has accompanied Beedell into places far-flung: from the Amazonian jungles of Peru to see scarlet macaws, to Antarctica to visit nesting colonies of chinstrap penguins. It has been in the solitude of Zanskar's Tibetan Buddhist *gompas*, deep in the Himalaya, and on the Central Asian plateau to witness exhibitions of Mongolian falconry.

Like Beedell, the doll has been in more than a few tough jams, such as the time on the Galapagos when it came close to meeting a grisly end. Beedell had to wrestle Tookie from the jaws of a 100-year-old, five-hundred-pound Galapagos tortoise. It thought Tookie was vegetation.

Like all stuffed dolls, Tookie is immune to fear. As those of us who have tripped with Mike Beedell have come to know, this is a useful trait.

⌐∿⌐

I am well acquainted with Beedell's style of travel—he is a good friend. Over the years we have travelled together in the Amazon, the Arctic, the Himalaya, the South Pacific, and Antarctica. When he told me about his plan to go to the Arctic and kayak around Bylot Island, it sounded like another of his intriguing ideas—ambitious, edgy, and a touch crazy.

Such adjectives have been used to describe much of what he has done. As a young man, Mike sailed the Northwest Passage in a two-man catamaran. Later, he retraced a historic 1870s Inuit journey—2,500 kilometres by dogsled up the Canadian High Arctic coast to Greenland. He is one of Canada's top adventure guides as well as a highly regarded professional wildlife photographer.

As one would expect, Beedell is at home in the wilderness—calm and relaxed in practically any situation. What sets him apart from other extreme adventurers is that he creates and meets these challenges without the obsessive single-mindedness that characterizes the usual goal-oriented expeditionary types. His trips often involve hard going, but never to the exclusion of having fun and finding time for creative diversions.

Beedell is an amazing study in contrasts—mentally and physically tough and tenacious, he also has the playful absent-mindedness of a poet. Ideas, both quirky and inspired, come out of him as unpredictably as popcorn in a pan. But he is also sensitive and dedicated, as demonstrated by his photographs, which have been featured in top adventure and travel magazines and in numerous wildlife books. Such a combination of traits is, in my experience, extraordinarily rare in one person.

Mike was keen to do the Bylot trip with his new wife, Pamela Coulston. I didn't know Pamela as well as Mike, but she too was impressive: a consultant in international development, an accomplished designer of jewellery, a gifted writer, and a skilled equestrian. She was also a beautiful woman and a well-seasoned traveller.

By the time they began planning the Bylot expedition, I had been paddling and trekking for over a dozen years in the Arctic and had accumulated enough experience to have an educated unease about

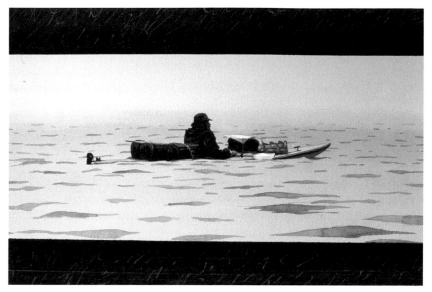

Mike, watercolour, 14" x 21", 2000

Mike's plan. One worry was Pamela's lack of experience kayaking in the Arctic. I wondered if, in the glow of their new relationship, Mike was not seeing her vulnerability as clearly as he should. But that was just one of my concerns.

Bylot Island lies cradled in the waters of Eclipse Sound and Navy Board Inlet, in a huge indentation on Baffin Island's northernmost coast. On a map, Bylot looks like a great goose egg deposited in a snug-fitting nest—an apt description, considering that the island is a renowned bird sanctuary, home to one of the largest bird concentrations in the Arctic. But Bylot Island viewed from the ground or from the seat of a kayak offers a vastly different impression.

Its shores are surrounded by big water of the dark, rough, fearsome variety found in the North Atlantic—just one of the reasons the island had never been circumnavigated by kayak. The island holds hundreds of entangled glaciers, which pour over the spines of rugged mountain ranges. At its centre sits an enormous anvil of ice, testament to Bylot's distinction of receiving more snow than any other location in the Eastern Arctic. In paddling its 600-kilometre shoreline, the unpredictability of sea ice would be a major concern. That ice can be five-metre-thick multi-year stuff that is continually jostled and churned in

pounding surf. At other times it can form and refuse to melt, becoming an impregnable flat expanse stretching off to the horizon. Either way, the island's coast can be churned and trampled or else sealed off from navigable water. Added to that, much of its north coast is straight-walled headlands that make landing a boat, even without sea ice, almost impossible. As well, the island's surrounding waters are heavily influenced by a confusing confluence of sucking tides, powerful ocean currents, ferocious storms, and infamous katabatic winds. Hard to get to, harder to get off, the island, apart from a few Inuit camps, hasn't been inhabited in modern times. These hazards were extra troubling given the logistical difficulty in obtaining help if necessary.

In the view of many, however, trumping all of the above risks was the presence of polar bears. In the summer, Bylot Island is home to one of the densest concentrations of polar bears in the world.

But as significant as these impediments were, so too were the benefits.

To an adventurer and photographer like Beedell, the island was both a treasure trove and a siren's call. Bylot is home to the richest variety of Arctic flora and fauna found anywhere. Three hundred and sixty plant species grow around the bays, inlets, bogs, and coastal lowlands that ring some of the island's extremities. This is also breeding habitat for more than three million birds spanning seventy species, including swans, geese, loons, fulmars, ducks, eiders, ptarmigans, cranes, plovers, sandpipers, jaegers, skuas, larks, terns, murres, puffins, gulls, owls, larks, swallows, redpolls, and ravens. Land mammals are there too: two kinds of lemmings, arctic hares, wolves, red and Arctic foxes, polar bears, ermine, and caribou. In the water, Mike and Pamela could find themselves paddling beside bowhead and killer whales, walruses, harbour, harp, hooded, and bearded seals, and belugas and narwhals.

For 4,000 years this rich congregation of life had drawn Native peoples to Bylot Island. Among the cultures and subcultures that inhabited the land were the Independence, the Dorset, and the Thule. The dwelling sites and artifacts of these ancient Palaeo-Eskimo hunters often lay as they were left, on or just below the ground.

Mike and Pamela would spend the summer of 1999 surrounded by unbelievable wildlife, remains of amazing past cultures, and a spectacularly untamed and remote landscape.

Although Mike had been musing about circumnavigating Bylot Island by kayak for a long time, he chose the year 1999 for a couple of

reasons. It coincided with a Parliamentary proclamation designating Bylot Island as the new Sirmilik National Park. The incredible variety and density of flora and fauna and the scattering of archaeological sites would now come under government protection.

It was also the year that the Inuit of the Eastern Arctic could finally celebrate a measure of self-determination. After many years of negotiations, in 1999, Canada was to proclaim Nunavut a self-governing territory of the Dominion. It was hoped that with their new status, the Eastern Arctic Inuit would be better able to achieve their aspirations, protect their culture, and, to a large extent, control their own destiny.

Mike had long identified himself with the Arctic and its people. He loved the place. He had made dozens and dozens of trips to the Far North, documenting it by way of his vast collection of photographs and illuminating it to others as an adventure guide. Mike wanted to share what he knew of the Arctic with Pamela, of course, but also with as wide an audience as possible. In Mike's mind, a kayaking expedition around Bylot, coupled with the creation of Nunavut and Sirmilik National Park, was a perfect confluence of dreams fulfilled. It would be a great opportunity to help create broader public awareness and to celebrate a new chapter in Canada's relationship with the Arctic.

Mike spent a year planning the trip, and as he did, things got increasingly complex. He added two overlapping ideas that he believed would give the circumnavigation a powerful synergy and generate added publicity.

The first was to send back weekly articles by satellite to the *Ottawa Citizen* and three other major Canadian newspapers. Pamela would do the writing and Mike would send his photographs. The agreement with the newspapers was a wonderful coup that would give a much stronger national voice to their Bylot adventure. But to meet their obligations they would have to take energy converters, extra camera gear, a satellite phone, a laptop, and solar panels to power it all. There would be solar power problems associated with weak sunlight and cloud cover, and a lot of effort and time would be needed to keep all this technology working. And with such a media contract there would be enormous pressure to make publishing deadlines.

I thought it was a lot for Pamela to take on — it would be hard enough to send back periodic updates, let alone weekly full-page feature articles, while handling the rigours of Arctic travel. She was unaccus-

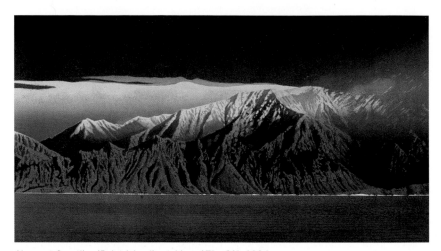

Nunavut Coastline (Bylot Island), etching, 17" x 31", 1994

tomed to paddling in the Arctic to begin with. Now her concentration would be split between the cerebral act of writing and the physical and mental strain of being immersed in an extreme environment. Mike, of course, saw it differently. For him, broadening a wider audience's knowledge of the Arctic overrode any pedestrian worries about taking on too much.

Paralleling that plan was another, even more ambitious. To help welcome Nunavut as a member of Canada's family of provinces and territories, Mike wanted Inuit elders and youth to join the expedition during part of the trip. So he invited a small group of Inuit to paddle a portion of Bylot Island's coast with Pamela and him, for two weeks. As well, he wanted four or five people from the south to join him who were involved in culture, communications, and/or adventure travel. He saw the selected local elders, artists, and youth from Baffin Island engaging in a two-week sharing of ideas that would help facilitate broader cross-cultural awareness. I was one of the southern people asked to join this portion of the expedition.

I accepted Mike's invitation. It was impossible not to be impressed with the heartfelt, bold, and altruistic nature of the plan—although it did sound like something the Ministry of Culture or Parks Canada should be organizing and sponsoring, not a young couple on a shoestring budget.

But setting aside the trip's idealism, I had strong misgivings about the plan—a group of inexperienced people would be paddling kayaks for the first time, in a locale that was well known for its dangers. Although Mike and Pamela assured me we would paddle only when the conditions were good, in the weeks leading up to my going north, my mind was full of troubling what-ifs.

<div align="center">✐</div>

I had first glimpsed Bylot Island six years earlier, in 1993. That summer I had backpacked and kayaked the north Baffin coast, going east from Pond Inlet by myself, then later west with a small group of sea kayakers. Although 12 kilometres off Baffin's north coast, no matter what I was doing Bylot's steep southern ramparts and interior ranges and multitude of glaciers always demanded my attention. The distance did nothing to diminish its impact. I depicted that island fortress in numerous ways: during snowstorms and sunrises, shrouded in fog and clouds, and at twilight. Many of the pieces were smallish, on-site watercolours; some were larger studio works on paper; a few were editioned etchings; and one was a big horizontal canvas portraying the aftermath of a powerful snowstorm on Bylot. Those images often showed the island's barriers to entry, its characteristic foreground of sea ice laced across Eclipse Sound.

In the pantheon of stunning Arctic vistas, few compare to the island's southern face. Like a stockade or battlement from medieval times, it announces itself as impenetrable and not to be trifled with. It has inspired generations of those who have put pencil to paper and brush to canvas: from Sunday sketchers and watercolour dabblers to the likes of A.Y. Jackson and Lawren Harris. (In 2010, *Bylot Island 1*, a 1930 oil painting by Lawren Harris, sold at auction for $2.8 million—a Canadian record at the time.)

<div align="center">✐</div>

Mike's plan was that he and Pamela would depart Pond Inlet by dogsled in the early summer. A *komatik* (a large long sled) would transport them, their gear, kayaks, food, and supplies across a frozen Eclipse Sound. They would be dropped off at Button Point on the southeastern corner of Bylot Island and from there would paddle counterclockwise around the island. Inuit had previously been hired to drop

off a number of bear-proof food caches along the shoreline every 150 kilometres or so. Later in the summer, for the cultural exchange, the Inuit and southern people would rendezvous with Mike and Pamela somewhere on the island's far side. Motorboats would take our kayaks, supplies, and us from Pond Inlet to a location to be determined by their progress.

The account of the trip would be available through Pamela's full-page, weekly dispatches starting in early July and continuing throughout the summer. Everyone involved in the cultural part of the journey would be able to follow the expedition's progress prior to joining it.

Both Mike and Pamela brought an impressive list of skills and experiences to the table. But in the Arctic, expertise, experience, and careful planning can easily be negated by unpredictable weather, bad luck, and circumstances beyond one's control, any or all of which can descend like a bad dream. For Mike and Pamela, their dream trip quickly descended into something more akin to a nightmare.

An early end to winter snow meant that when they arrived in Pond Inlet, dogs were no longer available, as the teams had been dismantled for the summer. Undeterred, they found an Inuit who agreed to take them by snowmobile and *komatik* to Button Point. The Inuit failed to show up at the agreed time, or any time thereafter. Another person with a snowmobile was hired, but he left for his hunting camp without them, leaving them stranded in Pond Inlet. Desperate to get across before too many open leads developed in the sea ice, they purchased a used *komatik*, loaded it with their two kayaks and 250 kilograms of food and gear, and with lead ropes and harnesses started hauling the whole lot across the ocean ice by themselves. The diagonal crossing to Button Point was 130 kilometres.

It would be hard to overstate the drama of what followed — two weeks of snowstorms, shifting ice, open leads, mush ice, hummock ridges, fierce winds, cold, exhausting work, and a dwindling food supply. When I heard their account, it brought to mind illustrations and re-enactments of what is believed to have been the Franklin expedition's final days: men hauling their lifeboat and supplies over snow and ice in a desperate attempt to escape their entrapment.

In one of her dispatches to the newspaper, recounting the crossing, Pamela describes the effort:

These last days have been extremely difficult, arduous beyond what either of us imagined. Poor weather conditions and a late dispersion of the annual ice and our decision to make our way to Button Point under our own steam has made for a gruelling start to the journey. We spent many long days and nights pulling the rig over the ice, as long as 14 hours at a go, and often awake for more than 24 hours. We were making the push on not much sleep, not much food.

When they finally reached land, they assumed that they would stash the sled on shore and continue their journey by kayak up Bylot's opened east coast. But they found themselves on the southeast corner of the island, surrounded and confined by dense multi-year pack ice, stretching out to the open ocean as far as they could see. The ice put their agenda and their dreams on hold: not an uncommon circumstance in Arctic exploration.

With their patience and their food supplies dwindling, they waited. In her weekly articles, Pamela saw the parallels between themselves and other explorers when it came to the Arctic's cold hand of fate.

"You plan, you prepare, you research, you do your math. In the end, in the Arctic, nature will decide where you go and when you go."

Although Pamela described some joyous experiences, to a newspaper reader the overall impression was that of an exceedingly difficult, demoralizing grind. As I read her accounts, I was also pretty sure that the real physical and mental depths of their struggles were never fully conveyed.

Weeks passed and the Arctic's short summer waned as they remained icebound on the southeastern shore. Pamela and Mike realized that even if the ice cleared soon, paddling around Bylot before winter set in would be a race against time. Besides setting back the circumnavigation, the ice had ruined the planned rendezvous with the cultural exchange group. It would not be possible to meet on the island's far side as planned. In fact, no one — including Mike and Pamela — knew where we would meet, or if we would be able to meet at all.

I was anxious even before I had started reading Pamela's newspaper entries. As I digested each weekly article, my anxiety grew. The expedition's uncertainties were becoming too numerous to count.

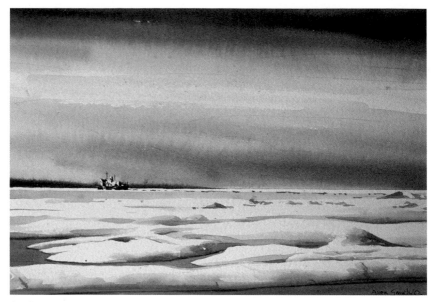

Ice Breaker, watercolour, 10" x 14", 1992

Then, a week before my scheduled flight to join them, the plot further thickened.

Mike called me from Bylot Island and, over the crackling static of the satellite phone, confirmed what I had sensed already regarding their problem-plagued trip. He told me that Pamela had been through a lot, and without elaborating, added that she really didn't want to continue the circumnavigation. She had had enough. She would be remaining with him only until the cultural exchange part of the trip was over.

Mike asked if I would consider taking Pamela's place paddling around the rest of the island. The request didn't entirely surprise me. I told him I would think about it and let him know when I got there. Given the short Arctic summer, I did not believe there was enough time left in the season to make it around the entire island. But that was not my only concern.

During the week that followed I agonized over what to do. Like them, I felt trapped. I wanted to help a friend accomplish his goal, yet it was a goal I had already assessed as high-risk and getting more so.

After the phone call to me, with food running low, and still stuck at Button Point, Mike and Pamela were picked up by a Canadian Coast

Guard icebreaker that was in the area, and brought back to Pond Inlet. That's where I met them a few days later.

It was good to see them both safe and sound, but they looked exhausted. Mike had lost a lot of weight and Pamela had lost her glow. To add to their problems, they had just learned that practically all of the Inuit and many of the southerners had bailed out of the cultural exchange at the last moment. I don't know if it was because of what they had read in Pamela's newspaper articles or for other reasons, but it was a huge letdown for Mike and Pamela. All of their tireless fundraising and months of work to put the logistics, equipment, and supplies in place on behalf of those people had come to nothing.

Yet Beedell refused to let his cultural exchange idea die. He scurried around Pond Inlet desperately looking for people to go kayaking around Bylot Island for two weeks. At the last minute he found the replacements he needed. The Inuit contingent now consisted of four teenagers and a carver. Aside from me, only Avril Benoît, a CBC broadcaster, came from the south. Still, the setbacks persisted. Benoît had been asked to come because she was co-host of an influential national radio program and from that chair would be able to give both the Arctic and our journey substantial exposure. But just before coming north, she had been unexpectedly dismissed from that job.

<center>⁓⁓⁓</center>

Two large outboard boats took the nine of us, our kayaks, food, and a sizable pile of gear through and around 30 kilometres of deteriorating sea ice to Bylot Island. The new plan was to kayak along the coast in a clockwise direction. The same boats would return two weeks later to pick up the people returning to Pond Inlet. The next two weeks were pleasant if somewhat directionless. Mike and Pamela were tapped out, with little energy left to devote to group leadership or even to coordinating food preparation. It was obvious that the early part of the trip had deeply strained their relationship, often leaving an unsettled feeling over the entire camp.

The Inuit adolescents were good kids, but they were like most teenagers—when left to their own devices, they mostly ate, slept, and hung out together. Given their lack of experience with kayaking, I was glad we paddled only moderate distances and only when the weather was good. There were times spent around meals and hikes that were insightful

and I think rewarding for everyone, but there was much less of it than had been planned or expected.

Two weeks later, when the boats came to pick up the cultural exchange group, Pamela went back with them to Pond Inlet and then on home. I decided, as Mike had asked, to continue on with him.

It was a difficult decision. Apart from the risks inherent in paddling the island, the idea of replacing Pamela—someone who had worked for a year to help make the expedition a reality—didn't feel right. But when I asked Mike if he would carry on alone if I didn't go, he told me he would. This wasn't a pressure tactic or a pretense of heroism to get me to come, just a statement of fact. It swayed me to accompany him.

Our immediate worry was food—we didn't have much. The pre-trip food planning hadn't included four teenagers with ravenous appetites. They had mowed through a ton of food during the two weeks—anything that didn't need significant cooking had been eaten. Mike sent one of the boats that had come to pick up the exchange group eastward, back along the Bylot coast, to find and retrieve a food cache barrel for us. (We had paddled past the barrel shortly after our group was dropped off, but at that time we'd had all the food our kayaks could carry.) Unbelievably, the Inuit driver returned a couple of hours later saying he couldn't find the barrel.

Exasperated, Mike said, "Yeah, but you were the one that put it there!"

The Inuit's deadpan reply was, "I know, but the land all looks the same."

Not the response one expects to hear from one's Inuit guide.

Mike's impatience was steadily growing. With every passing hour those boats and their drivers were costing the expedition hundreds of dollars. In frustration, Mike announced that he and I would be fine, and with a wave of his hand, he told the boat drivers and the rest of the people to return to Pond. Wide-eyed, the Inuit teenagers looked at me with utter incredulity, as if this sight of me would be their last. They knew, as did I, that we had a few days', not a few weeks', worth of food.

After the boats left, Mike and I carefully laid out our remaining food provisions. It was a frighteningly small spread. A five-pound bag of rice, a plastic jar of oatmeal, about four pounds of onions, two dehydrated dinner packets, a few carrots, some noodles, three soup mix packets, oil, spices, milk powder, coffee, tea, and that was about it. Over the next few hours I secretly thought and hoped that Pamela and the guides, worrying about our survival, would again search for the food barrel

on the way back to Pond. Finding it, they would certainly bring it back to us. For the next few hours I waited to hear the distant drone of an outboard motor, but off the water there came no such sound — only ice crystals tinkling like hushed harp strings from the drifting ice floes.

Mike was as optimistic as ever. He reckoned that we were only 150 kilometres from another cache of food that had been placed for us earlier, at a spot called Tay Bay. He also mentioned that we might obtain food at an ornithological research station. However, as for its location, he knew only that it was four kilometres inland and about halfway to Tay Bay. It was from that summer camp that biologists studied Bylot's huge population of breeding snow geese. Mike called the place the Goose Camp.

Over the years I had become well acquainted with Mike's proclivity towards positive thinking and selective perception. I thought that the food we had was utterly inadequate for two men to paddle 150 kilometres, given the low temperatures and the inevitable wind delays that are common in the High Arctic autumn. When I asked, Mike dismissed the idea of our retracing the coast for the missing food cache. That decision was disappointing but not surprising. Setbacks, one after another, had left Mike's careful plan to circumnavigate Bylot in shambles. For two months, practically everything that could go wrong did. The summer was almost gone and winter was around the corner, but he had scarcely begun the circumnavigation. Added to that, his new bride, his life companion and co-adventurer, who had shared his dream, had returned home. Pamela's departure also ended the weekly newspaper articles, which meant that most of the circumnavigation would not be chronicled. All of this had to be affecting Mike's judgment. It was clear that he wanted no more delays — he wanted to finish this thing. I didn't argue the point. Given what lay ahead of us and Mike's frame of mind, I saw no benefit to introducing a negative or critical tone between us. I just silently hoped for fair weather and a good dose of luck in finding the Goose Camp.

If our route around Bylot was a wonky-shaped clock, the location of the exchange group drop-off was about 5 o'clock. Moving clockwise, the group was picked up at 6 o'clock. The Goose Camp was somewhere around 8 o'clock, and our food cache at Tay Bay was roughly at 10 o'clock.

We broke camp and departed late that afternoon, hugging the shore and picking our way through melting sea ice. There wasn't a breath of

wind. A grey pall enveloped the air, water, and land. In the dull light of a pewter sky, everything around us seemed to have come to a stilled hush—like the prelude to a theatre's curtain rise.

The terrain to our right gradually flattened, with Bylot's monster ice and mountain interior receding from view. As we continued west the openings between the floes grew wider and there were fewer icebergs. To our left, the Pond Inlet channel separating Baffin Island from Bylot Island had expanded into an irregular 40-kilometre-wide basin called Eclipse Sound. At the back of this sound is a series of finger fjords, an important feeding ground for the elusive tusked whale. It is estimated that in the summer, half of all the world's narwhal travel to Eclipse Sound, under the protective cover of the sea ice in Navy Board Inlet and Pond Inlet. The character of the ice is crucial to their arrival: uniformly solid expanses offer no breathing holes for the narwhal, and water that is too open favours predation from killer whales and Inuit hunters.

On the second day of paddling, our route swung towards the northwest past a massive delta braided with mighty glacier-fed rivers that disgorged muddy-grey water. The silted delta and its many tributaries took a day and a half to paddle past.

Mid-afternoon on the third day we spotted an outboard boat pulled up on shore with its motor's propeller out of the water. To the right of the boat sat a woman. As we paddled near we saw that she was having some tea and appeared to be alone. That was an odd sight, as in two weeks we hadn't seen anyone or heard any boat traffic. We landed and introduced ourselves. She offered us tea from the large silver kettle that sat on her rusty green Coleman stove.

Her name was Rachel. She was slight, with greying hair tied back. She wore a fur-lined parka and looked to be about sixty. She was Inuit, from Pond Inlet, and spoke good English. She said she was waiting for her husband and others to return from the interior, where they were hunting caribou. She had a bag of fresh bannock that she pushed towards us. We both calmly took a piece, attempting to conceal our hunger. She offered a second piece. With just enough hesitation not to appear totally rude, our hands reached for more.

We didn't mention that we were short of food, but when we got up to leave she asked if we wanted a piece of *muktuk*, the raw, fatty, thick skin of a whale, in this case a narwhal. We nodded in the affirmative. This insulating layer of blubber stores concentrated energy and is loaded

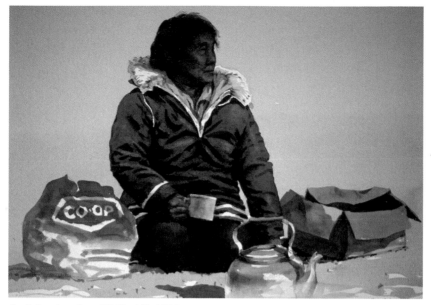

Rachel, watercolour, 10.5" x 14", 1999

with vitamins and minerals. Rachel cut off a dessert-plate-sized piece about one inch thick and dropped it into a plastic bag. We thanked her, and as we got up to leave, to our amazement another outboard came chugging eastward just off the coast. Seeing us, it turned inland, beaching its wooden bow onto the shore sand by our boots.

It was Charlie Inuarek and his family returning to Pond Inlet from a hunt. Mike knew Charlie. His fifteen-year-old son, Niko, had been with us on the cultural exchange. Charlie was regarded as one of the best hunters on North Baffin, and the hold of his boat attested to that. It was piled deep with caribou carcasses and thirteen narwhal tusks, one of which was nearly three metres long, the biggest I'd ever seen.

Narwhal, called *tuugaalik* in Inuktitut, are actively hunted by the Pond Inlet Inuit. The hunting method involves shooting them with high-powered rifles from motorboats as the whales come up to breathe among the ice floes. After shooting one, perhaps multiple times, the hunters try to secure the wounded narwhal with a grappling hook or a harpoon. However, because the hunt almost always takes place in pack ice, the narwhal often can't be retrieved after being shot. The vast majority of those shot either escape, wounded, under the ice or die and

sink to the bottom. Although not abundant, because of their extreme elusiveness the narwhal has so far escaped the endangered species list.

Narwhal tusks always have been an important economic resource for the Inuit. In the Middle Ages the ivory tusk (which is the extended, spiralling front tooth of the male narwhal) was marketed throughout the world as the horn of the unicorn. The Norsemen, from their Greenland base, were the first of many middlemen involved in that trade. With the Europeans and the Asians perpetuating the unicorn myth, narwhal tusks became the most valued commodity on earth, ten times worth their weight in gold. They are still highly sought by collectors in the outside world. The thirteen tusks in Charlie's boat were worth about a thousand dollars each, depending on their length.

Charlie's boat also carried his wife and three young children, a female husky, and a large litter of pups that were scampering all over the place. We exchanged pleasantries and told them about the cultural exchange. Niko had done well, we said, although we mentioned that he once tipped over in his kayak. Fortunately, it had happened close to shore, so we were able to get him out of the water, into a change of clothes, and quickly warmed up. Charlie nodded and grinned as he listened to Mike's account of his son's mishap.

He asked if Mike and I had seen polar bears. We said no. Knowing that southern types like us would be hesitant to kill a bear, he issued a warning to shoot any that came into our camp. Otherwise, he said, the bears would return when we slept.

While Charlie was getting ready to leave, Rachel's family returned from their hunt, boarded their boat, and left.

Too proud, I guess, to mention to that great Baffin hunter that we were out of food, we watched Charlie and his boat stuffed full of wild meat depart. It was so overloaded that its gunwales were barely visible above the waterline. Then, for some wonderful, unexplained reason, as Charlie's boat was in reverse, sliding away from the shore, he looked at us and asked over the noise of the outboard if we wanted some caribou. We nodded in unison and watched Charlie's hand reach over to his wife, who handed him a large knife. He bent down and from under a soiled tarp sliced off a huge hunk of meat. The blood-dripping piece was big and heavy. Its size would have overflowed two outstretched hands. He dropped its weight into a dirty plastic bag, tied the end in a knot, and

tossed it underhand to us across the water. We waved our thanks as the outboard clunked into forward gear and chugged off, leaving a trail of blue exhaust over the water. Through a scattering of ice pans, it wove its way east towards Pond Inlet.

We stood in silence as Charlie's boat disappeared around the point. When it was out of sight, we turned and started walking back towards our boats. A few paces from the kayaks, having said nothing, we glanced at each other and simultaneously broke the desolate silence with shrieks and howls of joy. We clasped each other's shoulders and jumped around in a circle like Kazakh dancers, feet pounding the sand.

That evening, we feasted. While a pot of rice simmered, we fried a few onions with a pile of caribou, thinly sliced. It produced fabulous gravy that we poured over the rice. The fresh caribou tasted like lean beef, and in the circumstances it was immeasurably more delicious to us than it deserved to be. We had no problem finishing what we cooked, and we cooked a ton.

I was amazed by how being without food and then finding it and eating it could bring so much unrestrained pleasure. I thought of the Palaeo-Eskimos, those ancient Arctic hunter-gatherers who as a matter of course lived with the fears and joys that came with the hunt for food. It was living in the extreme. Perhaps the measure of joy experienced during a successful hunt was commensurate with the degree of desperation. I wondered if they were inseparable, linked together like a teeter-totter — the lower you descended, the greater the height that followed.

We debated what to do with the remaining raw meat. We had seen fresh polar bear tracks and knew of their amazing ability to pick up a scent from many kilometres away. If we weren't careful, owning those precious pieces of caribou and the *muktuk* could end up being a tragedy instead of a blessing.

Obviously, keeping it in our tent wasn't on. Neither was storing it in the kayak's hatch, as we didn't want one of our boats to be ripped apart. We also didn't want to put it too far away and have it carried off by an animal. We decided to try to secure the odour inside a few tightly tied plastic bags. We then buried that package with rocks overtop. We also put some pots and pans on the rocks, all within sight of the tent, giving us the option to defend it.

Following the southwestern curve of the Bylot coast, we gradually left the waters of Eclipse Sound and proceeded north into Navy Board Inlet. That long channel, eight to ten kilometres wide, separates Bylot from Baffin Island's Borden Peninsula.

The days were becoming noticeably shorter and were now mostly overcast. The night sky had lost its summer light. The High Arctic's transition, summer into winter, goes from continuous light to continuous darkness in a couple of months. The loss of daylight is startlingly abrupt when first experienced, as if someone in the room were turning down a dimmer switch.

Most days now featured at least one snow shower. On Navy Board Inlet we were no longer sheltered from the prevailing winds. Brisk northwesterlies constantly blocked our advance, to the point where some days we were land-bound.

On off-days and almost every evening after dinner, Mike and I hiked the coast or the interior. Mike usually explored and photographed; I often stopped to paint for a few hours. I worked in watercolour on six-by-nine-inch sheets of paper. All my materials fit into a flat Tupperware box that was easily transported and that kept my paintings dry.

There was no shortage of subject matter. To the west, across the top of the Borden Peninsula, stretched the snow-capped Hartz Mountains. From a thousand-metre summit the mountains slid and then dropped precipitously into Navy Board Inlet. Narrow finger glaciers arced across the dark cliffs like suspended comets. In the foreground, the colours and patterns of the sea ice and the occasional iceberg were constantly changing and rearranging themselves. Inland to the east, Bylot's snow, glaciers, and mountain ranges were becoming more prominent the farther north we went. Winter was almost upon us, yet the lowland tundra still pulsated with thick, warm textures. Here and there a speckling of colour clung to the last of the late-blooming wildflowers.

When I had finished painting, I usually ran into Mike, who inevitably showed me an amazing item he had discovered or described something incredible that he had seen.

During the day we expended huge amounts of energy paddling, hiking, setting up camp, and simply keeping warm. Nights were always cold, usually below freezing, so that even when sleeping the internal furnace was always asking to be stoked. Through trial and error, self-

propelled adventurers in the Arctic have learned how necessary it is to consume vast amounts of food to stay healthy and functioning. Even then, expedition members inevitably lose significant weight. Depending on how strenuous the trip, intake per person is around 6,000 calories per day, which is roughly three times normal intake. I don't know how many calories Mike and I were consuming, but I guessed it was far less than even a sedentary person requires.

Our appetites knew no bounds—we were constantly hungry, even after meals. Within two days the caribou was gone. The *muktuk*, which we ate raw so as not to lose any of its nutrients, ran out shortly after that. It had the texture and taste of an oily pencil eraser. Only rice and a few odds and ends remained. At that point, we weren't yet halfway to our food cache barrel.

Our last hope for food before Tay Bay was the Goose Camp. Mike didn't know its location, only that it was about four kilometres inland, about halfway up the coast of Navy Board Inlet. We debated whether tramping through the vast interior looking for it was worth the time and energy. We discussed whether it might be better just to keep going. We camped on the shore in what Mike believed to be the vicinity of the camp. Our plan was to spend the next morning looking for it; if we couldn't find it, we would paddle on.

In the early morning we woke up to the distant drone of a Twin Otter off to the northeast. We surmised that it was the plane taking the camp's researchers off the island before winter. In a panic, but with soaring optimism, we dressed quickly, grabbed our day packs, and headed off towards the sound. A kilometre inland, from a rise of land, we saw the plane taxiing along a huge valley. There were no buildings in sight. Through binoculars, we saw the Goose Camp staff loading their gear, getting ready to depart. The plane's twin-prop engines continued to run.

We quick-stepped in a straight line towards the plane. I prayed it wouldn't leave. People were starting to board. We had to circle around a large, boggy pond. With only a few hundred metres left, the engines started to rev. There was no one left standing by the plane, its door was shut. Surely they must have seen us? We quickened our pace, the plane started to spin around, we started to jog, the engine's throttle opened, we started to run and wave. Breathing hard, we came to a stop and stood and watched the white-and-orange plane roll and bump across the tundra, lift, climb, bank, and disappear into the clouds.

If meeting Charlie was our teeter-totter's maximum height, its lowest point was right then and there. A kick in the groin couldn't have felt much worse.

For a few minutes we stood there in disbelief, less than 50 metres from where the plane had been loaded. How could it be? Why hadn't they waited a few minutes to see what we wanted? We cursed all ornithologists, researchers, and biologists and their stupid, pointless studies and academic papers that no one reads or cares about. Worrying about snow geese! Shit, there were millions of 'em!

We wandered over to plane's departure point, where a pile of boxes and barrels remained. We talked about our bad luck — close as we were to food, our chance was gone, *poof*, as if it had been a mirage. We checked a few of the old barrels, plastic pails, and storage coolers and found research samples of plants and other unidentifiable things. What were our options now? Would the plane return? Probably. But when? Maybe in a couple of hours. Maybe in a couple of days. Maybe in a couple of weeks. The research station wasn't in sight. Should we continue our search for it? Even if we did find it, it would probably be locked up tight anyway. Would we break in? If we did break in, what kinds of food would still be there, left over to winter? Maybe some pasta and dried goods? Or maybe nothing?

We continued on for a while with more suppositions and scenarios — the normal back and forth heard among would-be thieves.

The sun's arc, low as it was, started to win out over the cloud cover. To the northeast, towards the interior, beyond the flat tundra plains of the landing strip, the land began to glow. Mike suggested we hike up a low rise to see if we could spot the research station. He added that there might still be fruit on the blueberry bushes that we saw on the south-facing mountain slope. The foliage of the fruit-bearing bushes had a distinctive red-wine colour.

Mike got out his map of the area while I wandered around, perusing the boxes scattered on the tarmac. One cooler had a "Fragile" sticker, and words scrawled in felt pen across its white plastic top. There were some dates and what looked like code numbers. Its outer surface was smeared in grime. Inside were plastic containers holding muddy samples of vegetation. I proceeded to another cooler and opened the lid.

There was a moment's pause and then I shrieked. My unblinking eyes opened wider. My heart started thumping. I slammed the lid closed. Mike whipped around.

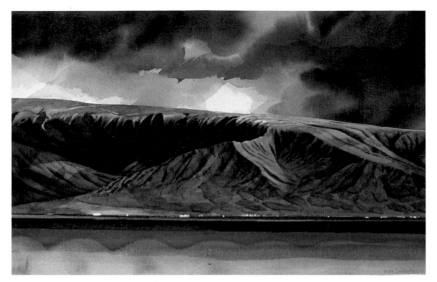

Land of the Snow Geese, watercolour, 14" x 21", 1999

"Mike!" I screamed. "Miiike...!"

I tilted the closed cooler in his direction and, with a slight pause for dramatic effect, flashed open the lid again. The bottom of the cooler was covered with little square, gleaming silver packages of Philadelphia cream cheese... like wee bars of white gold.

Mike scampered over to where I stood. There was no time for embracing or dancing. Frantically, we commenced prying open everything with a top or a lid, as if all the contents needed oxygen.

We discovered a half-bucket of powdered soup mix. Then a dozen oranges. Another cooler of plant samples. More samples. More samples. A box with about two dozen apples. Some plastic tarps. Empty sample bottles. A cooler containing butter—four 1-pound packages—and a huge whack of salami, six inches in diameter and a foot long.

Oh my God! The motherlode!

Lady Luck had found us and was smiling. The teeter-totter had been rebalanced.

We sat on the ground, leaning against the coolers with our faces to the sun, and sliced apples and peeled oranges for breakfast.

A detailed discussion followed about proper etiquette. Should we leave a note? Some money? Or just grab and run, hoping they wouldn't notice or care what was missing? We chose the latter.

We stuffed our two backpacks full of apples, oranges, butter, and packages of cream cheese. We dumped a pile of the mustard-coloured soup mix into a plastic bag. I got the salami positioned to cut and poised my knife blade over a four-inch long chunk. I glanced at Mike. Mike directed my knife inward. I repositioned two more inches in. Mike's finger continued jabbing inward. Another two inches...still not enough. Chuckling, I sliced off 80 percent of its length, returning a baffling little two-inch-thick disc of meat to the cooler. Leaving a trail of apple cores and orange peels, our now heavy day packs on our backs, we hiked the mountain ridge to pick blueberries.

Navy Board Inlet now doglegged west before curving north again. Most days involved paddling into a stiff, cold wind. The water that we plied and pulled with our paddles felt noticeably heavier and thicker. As well, there was little ice around to flatten a crooked sea. Paddling was cold, wet, and slow. Mike began to wear his dry suit while kayaking. I had one but found it too hot and claustrophobic. Instead I wore a heavy fleece and a Gore-Tex paddling jacket. We both used neoprene mitts called Pogies, which encompass both the hands and the paddle.

The view to the right, into the interior, was becoming higher, grander, and whiter. The clouds that hung over Bylot sometimes received light reflected back up from the island's high glaciers. The clouds, lit from below, gave the mountainous interior an unearthly glow, as if a prophecy, long foretold, was at hand.

It was along that part of the coast that we started to see our first polar bears, usually meandering along the shore. One day we came across a very old bear, in poor condition, eating a carcass on an ice floe. Most of the bears regarded us with puzzled curiosity; perhaps they had never seen this odd kayak–human configuration before.

Photographing them from a kayak was a challenge, particularly with an onshore wind. Hands had to be freed from the Pogies and paddle, the paddle secured or balanced, the cockpit skirt opened, a camera retrieved from its closed case and adjusted to shoot. Looking through a camera lens with one eye shut significantly diminishes one's sense of balance. During this procedure, any combination of things could happen: the open cockpit could be swamped; your paddle could be knocked into the water by a wave; you could run aground on shore

rocks, be rammed by floating ice, or capsized or charged by the subject matter. Added to that, the photographer in Beedell was always looking for that extra-dramatic shot, which meant me being positioned as close to the bear as possible.

Polar bears are the most carnivorous of all the world's bears. The calorie requirement for such a large animal (a male can weigh 600 kilograms) in a cold climate is enormous. They roam the circumpolar pack ice, hunting mostly ring and bearded seals, usually within 300 kilometres of the coast. Seals and other sea mammals, such as small whales and walruses, provide the energy-rich meat and fat the bear requires.

The bears Mike and I were seeing had come ashore for the summer because the sea ice had melted. On shore they wander around or snooze, waiting for winter and the return of the ice. In many places, thinning sea ice, caused by a warming climate, is affecting bear and seal populations. Because ice is breaking up earlier in the summer and reforming later in the fall, more bears are being deprived of seals—their main food source—for longer periods of time. During the summer, pregnant females go inland looking for a birthing den. Because there is less sea ice, this results in an extra-long land stay. Midsummer until early spring the following year adds up to seven or eight months without food for these females, while they are nursing one or two cubs.

The fifth day after leaving the Goose Camp we had an especially hard, long paddle into a driving wind. In dim late-afternoon light, we came ashore at Canada Point beside a massive boulder, three and a half metres high and partly buried in the shore rock. Chiselled into that huge rock are the words that officially claimed Bylot Island as part of Canada. Between 1906 and 1909, Captain Joseph Bernier aboard the sailing ship the *Arctic* proclaimed similar status for many of the smaller islands in the Arctic.

I was shuddering with cold when we landed. There was little light left in the sky, and a gale was starting to blow off Navy Board. All I could think about was setting up a tent and getting warm and dry, but Mike thought it important for us to celebrate our Canada Point landing. He got his tripod out of his kayak, mounted it with a video camera, and propped up a Royal Canadian Geological Society flag and Canada's red Maple Leaf beside the landmark. Over the howling wind and crashing waves, with the camera rolling, we sang "O Canada," standing beside Bernier's rock.

From Canada Point, our goal was practically in sight. Thirty kilo-
metres separated us from a barrel stuffed with food. But for the next
two days a furious wind kept us land-bound. While waiting for the
wind to drop, I painted, while Mike did some hiking and photography.
Both days were cold and crystal clear in the disappearing warmth of
the Arctic sun. The piercing blue skies carried small, white lenticular
clouds that looked like double-pointed darts or fat little kayaks. The
pointy-ended shapes seemed to mock us as they glided unencumbered
across the open sky.

After our haul of food at the Goose Camp, I thought our food prob-
lems were behind us. But they weren't. Because of the relentless cold
and the energy required for hiking and paddling, we were rapidly con-
suming our stolen stores. Now almost out of food again, we couldn't
afford to wait very long at Canada Point. If the strong wind prevented
us from paddling to Tay Bay we would have to hike to the food cache.
Given the ups and downs and ins and outs of the coast, it would be 40
or 50 kilometres on foot.

There seemed to be a pattern of high winds during the day, so we
decided to try paddling at night. On the third day at Canada Point we
woke at 2 a.m. to a biting wind. Mike dressed and climbed out into
the cold. As he left, I heard the tent crunch and crackle from the dead
weight of ice and frost on its nylon roof and walls. I stayed in my sleep-
ing bag, holding on to its warmth as long as possible. Returning a few
minutes later, having surveyed the conditions in the pitch-black, Mike
crawled back into bed. He said it was too rough to leave. That was fine
with me. As enticing as our waiting food cache was, I had no appetite
for paddling rough seas, driven by a freezing wind, in the dark.

Two hours later, goaded by the reality of our situation and by the fact
that the wind might blow for a week, we got up, packed, and loaded our
boats. Our kayaks and paddles had thick coverings of ice and hoarfrost
that we chipped off as best we could. On empty stomachs, we departed
into a coal-black night.

Our desperation for food overrode the obvious risks of paddling
an unfamiliar coast in total darkness. But as we paddled, our eyes
gradually became accustomed to the absence of light. And soon, with
the first grey glimmers of dawn, the winds began to drop. Amazingly,
four hours after leaving Canada Point, we were plying calm waters with
sunshine warming our backs.

We paddled side by side, our spirits sky-high. Life had suddenly gotten good again—in fact, it couldn't have been better: kayaking on a clear, warm, windless morning with a good friend, and with a grand spread of food, as much as we could eat, awaiting us.

For the umpteenth time in the past couple of weeks, Mike reviewed the contents of the food cache. As I probed for details, Mike rambled on about the various flavours and smells that accompanied each item, as he recalled personally wrapping and packing the barrel. Our camping pantry would soon be stocked with Camembert, Gouda, mozzarella, and Emmenthal cheeses, smoked herring, dried fruits, jams and biscuits, nuts, dried meats, tins of salmon, gourmet coffee, cookies, and cinnamon-raisin-nut loaf.

And there were copious packages of high-end freeze-dried desserts and dinners: not the usual prepackaged trail crap, but rather a splendid elite line that reached new gastronomic heights in camp food, so the manufacturer had assured Mike. The list included Tomato Basil Pasta with Chipotle, Paella with Saffron Rice & Chicken, Thai Satay and Curried Stir Fry, Blueberry Pancakes, and Peach Cobbler.

All the food items had been individually wrapped in plastic and put inside a heavy bag that was sealed with duct tape. This had been done to prevent the chance release of food odours. The bag filled a large, heavy-gauge, bear-proof plastic barrel that was a metre high and half a metre wide. The lid was secured with a metal clasping ring that was further secured with wire and duct tape.

With no wind to speak of, we made it to Tay Bay with blinding speed. A prominent line of ominous-looking black rocks rose out of the water like sentinels, partly obscuring the bay's entrance. We could have paddled right past the entrance if we hadn't been looking for it. The row of rocks and the bay entrance looked like an empty wall safe with its door ajar. It was early afternoon when we slipped through the narrow passage and entered the glorious oval bay that we had been longing to see. It measured about three kilometres wide by five deep.

Mike didn't know exactly where the barrel was, since an Inuit guide had dropped it off during the summer at Mike's request. Mike believed it had been placed on a stretch of flat rock to the right, just inside the entrance. It had been there for about three months. We paddled along the right shoreline, straining to spot a blue barrel. As we approached

an open area of flat rock and low grasses, Mike arched his body up, presumably seeing something.

His paddle strokes quickened, and then an explosion of profanity erupted.

"Goddamn fuckin' son of a bitch! Fuck! Goddamn it!"

Beedell ran his kayak ashore, jumped out into knee-high water, and ran like a madman for the blue barrel. By then I could see it, lying on its side. It had a sizable hole chewed through its centre. Mike lifted it, checking it for any contents, then threw the barrel down and booted it. His rant continued, broadcast across the bay and beyond, accompanied by the sound of the empty barrel rumbling over the flat-rock terrain.

When I came ashore, there were no exchanges between Mike and me. In silence we commenced to survey every inch of ground within a 50-metre radius of the barrel. We were looking for bits of food that the bear might somehow have missed. At the same time, both of us were deep in our own thoughts, processing a grim new reality.

We retrieved a small tub of peanut butter that had been tightly sealed and miraculously overlooked. We also found two little tins of salmon and two tea bags. There was a gallon can of camp fuel drained by huge puncture bites and another tooth-marked can still full of fuel.

With claws, canines, and incisors, the bear had severely mauled, bitten, and raked the food barrel in an awesome demonstration of determination. However, it was apparent that only after the barrel was on its side had the bear come up with a successful strategy. By jumping up and down, it had made a crease in the middle of the barrel sufficiently pronounced to allow the animal's teeth to grab hold of the thick, tough plastic. From that one spot it had been able to pull, rip, and chew an opening big enough to get at the contents.

In the south, such a barrel is commonly labelled bear-proof; however, there is a big difference between black-bear-proof and polar-bear-proof. A polar bear can fling a 180-kilogram bearded seal around like a rag doll. A male can weigh three-quarters of a ton, which makes the polar bear an entirely different story than his southern relative, which averages one-quarter of that weight.

About half an hour after the barrel's discovery, Mike's positive and inquisitive outlook returned. From across the search area, he shouted to me, "Hey, Al, you should see this!"

He came trotting over, holding something in his hand. It was a strand of soiled, silver packaging, long and twisted. "Look how the old

bugger's sphincter spiralled out this foil packaging after wolfing down one of our succulent dinners!"

The setting of our predicament was a fabulous place. We pitched our tent in the flat, open area where we had found the barrel. Behind us were a few freshwater ponds and lookout rocks. Along the south side, a high, dusty-brown cordillera swept along the bay in scalloped ridges. To the east, across the bay, a three-kilometre-wide block of ice, the Inussualuk Glacier, covered the back of the basin. A steep-sloped mountain wall rose almost vertically to the north, decorated with finger glaciers. Another long, narrow glacier descended almost to the water at the bay's entrance. Most of the floating ice pans were jammed into the back of the bay at the glacier's face.

We got out the satellite telephone, and Mike called our contact in Pond Inlet. Given that it was a return boat trip of about 300 kilometres, there wasn't much chance of getting anyone to bring us food from Pond, but we got the word out that if someone was coming our way, we could use some. Generally speaking, people in the Arctic don't get too excited about someone on the land without food: it happens all the time. That's why everyone has a gun.

We had a shotgun and a fishing rod, but neither of us was much of a hunter or fisher. The next morning I got up early and from my kayak trolled the bay for four hours without a single bite. Mike, taking another tack, mentioned that there was a scheduled flight between Arctic Bay and Pond Inlet every Thursday. It happened to be Thursday. The flight path was almost directly overhead. Mike immediately called the Pond airport and, yes, the plane was there, but the pilot was in town at a restaurant for lunch. We needed to reach him before he got back to his plane so that he could buy us some food in town.

Mike's satellite phone was a fickle mistress. It needed the warmth of the sun to come alive, but even then, one was never sure for how long it would be receptive or if it would respond at all. A number of variables had to line up for that wonder of technology to function: sun, without cloud cover, to solar collector; solar collector to inverter; inverter to phone; phone to a satellite, one of hundreds orbiting outer space; and then from 500 kilometres up, satellite back to telephone in the Pond Inlet diner.

Mike's guess as to where the pilot would be eating lunch was right. The waitress who answered went to get the pilot. The phone

faded in and out as the pilot picked up the receiver. With the phone ready to die:

Mike: We are at Tay Bay and out of food. Could you buy some at the co-op and stop it off on your way to Arctic Bay?

Answer: Nope. Don't have tundra tires. It would be way too dangerous.

Mike: Okay…Well, could you fly low, over us, and throw some boxes of food out the door?

Answer: No way. I've got passengers. I'd lose my licence.

It was exasperating. Being very close to getting food had exactly the same end result as having no chance of obtaining food. We were running out of time and options. The next cache was on the north side of the island, another 150 kilometres away. On my questioning the potential status of that bear-proof barrel, given what we had just discovered, Mike assured me that cache was in a metal barrel and would be secure. Still, it was too far for us to reach.

Undeterred by the pilot's response, Mike came up with another Hail Mary scenario. He began talking about a Russian cruise ship that he said was scheduled to come down Navy Board Inlet into Pond around that time. Mike had a good idea of this ship's itinerary since he was regularly contracted to be a resource person on similar eco-cruise ships.

When we spotted the ship, his plan was to paddle out into Navy Board Inlet to intercept it. They would take us on board, where we would wow the ship's passengers with tales of our adventure. In the particular episode Mike was envisioning, the hundred or so passengers would be clamouring to buy (at exorbitant prices, naturally) my on-site watercolours. Meanwhile, Mike assured me, the ship would be so impressed with us that we would be hosted in the lap of luxury—lavished with food and drink, compliments of the captain.

I head-nodded while listening to the plan, even though I thought it a far-fetched strategy for getting something to eat. I appreciated it more for its creative genius, as I would the plot line in a *Seinfeld* episode. I had no problem envisioning Kramer playing Mike.

That was the part of Beedell's personality that some might, and did, find frustrating, to the point of wanting to strangle him. Our situation was serious and I thought called for practical problem solving, but at the same time I knew Mike to have an uncanny knack for pulling rabbits out of hats. Over the years I'd watched him do it many times. Furthermore, I found Mike's ability to view life as a wonderful adven-

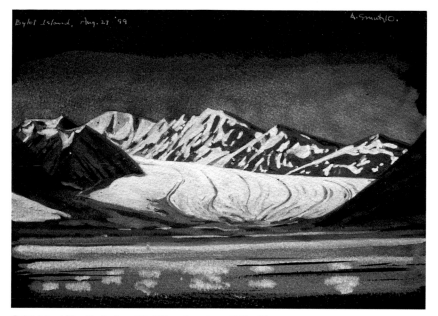

Bylot Island [Tay Bay], *Aug. 27, '99*, watercolour, 6.5" x 9"

ture, no matter how challenging the situation, inspiring and a great gift. Beedell's absence of inhibition and comfort with the unknown set him apart. He played at life with random intent, with flair and fun, it seemed no matter the circumstance.

This trait had been underlined earlier on our trip. With almost no food, winter loudly knocking at the door, polar bears all over the place, and us 100 kilometres from anywhere, Mike had come out of the tent one morning in a getup I hadn't seen before. He had on a kilt, a shoulder-length red wig, and a tam perched at a jaunty angle. He was in his alter ego, by way of Scotty MacTavish.

I was over the stove preparing a morning breakfast of tea. He swaggered into our foodless kitchen and greeted me in a heavy Scottish brogue.

"Aye, Al, me laddie. Bylot, you know, she puts a right tilt in my kilt, she does!"

It was never voiced, but I felt our string of episodic luck: first coming across Rachel, then Charlie, and finally finding the Goose Camp supplies, had been just that—very lucky. Now, besides having run out of

food, we were rapidly running out of time. In a week, two at the most, winter, like a zip-lock bag, would seal off Tay Bay.

With no further prospects in sight for getting resupplied, our remaining option was to hunt. There were lots of waterfowl flying around the bay, but our cartridges weren't loaded with pellets, only slugs for polar bear. But on the water, or rather in the water, there were seals, a lot of them. Consistently curious, they'd been around our boats all the way up the coast.

We practised shooting at a tin can on shore, testing the rifle's sights. We would have to hunt from our kayaks, for the seals were not inclined to surface close to shore. Inexperienced as we were at hunting seals from a kayak, or in any other way, we debated whether the shotgun's kick would cause us to capsize. We decided I would paddle next to Mike and hold his kayak as stationary as possible while he discharged the gun.

Through silver water we paddled towards the middle of the bay. The light was low and there was no wind. Drifting, we watched and waited. Seals began popping their heads out of the water around us. Most were either too far away or too far behind us. From the cockpit there was a front firing angle of less than ninety degrees. And even when the seals that surfaced within that firing angle and were close enough, they always disappeared before the gun could be lifted, aimed, and fired. Seals surface for three or four seconds only, to look around and breathe. To have enough time to aim and fire, Mike needed to constantly keep the heavy shotgun to his shoulder in a firing position. Waiting created severe muscle burn in his arms and shoulders.

After twenty minutes the dark mercury head of a ringed seal popped up ten metres away, slightly to the left of my bow. The dull-grey midnight light glistened off its smooth wet head. Its big black eyes stared at us inquisitively. Mike lined its head up along the sights of the gun barrel. I held my breath and the side of Mike's boat as he squeezed the trigger. The blast thundered and reverberated in my ears, across the water and off the mountainsides and the wall of the distant glacial face. It continued cannonading and echoing within the high walls of the enclosed bay for a number of seconds.

The lead slug punched a hole in the seal's upper neck the size of a quarter. It must have hit the jugular vein, for thick, warm, crimson immediately gushed into the damp Arctic air. Its heart continued

pumping out blood like a pulsating fire hydrant. The blood poured from the seal onto the dark palette of water with the brilliance of a squeezed tube of cadmium red. It didn't seem to dilute in the salty water; on the contrary, fresh with life, it glowed intensely.

I pushed off from Mike's kayak before the blast finished echoing or the smoke had cleared. I knew I had to grab the animal before it sank. The red flow continued to radiate out from its source in an ever-expanding circle. Five metres from the seal, I watched my paddle blade dip and pull through another creature's blood.

As I came up to the seal I put my paddle down across the cockpit and reached with both hands to grab hold of it. At that moment Mike shouted a warning that the seal might still bite. They have sharp, fish-grabbing teeth. I knew the seal was dead, but the warning froze me for a split second and my boat's momentum carried me past. I stopped its forward motion and commenced back-paddling. My head was turned towards the seal as I heard and saw, a metre away, the *blub, blub* of air bubbles escaping from its water-filled lungs. Then the seal's limp body lost buoyancy and sank out of sight. In the dead-calm reflection of glaciers, Mike and I sat in our boats, floating in the bloody aftermath. We said nothing for a while, our paddles and gun at rest. The futility of our actions overwhelmed us. But the self-recrimination was surprisingly brief. Thoughts of self-preservation once again took hold.

Back on shore, we pondered what to do. We were reasonably confident we could shoot seals but not at all certain we could retrieve them before they sank. We thought if we had a gaff hook, it would make for quicker and better securing of the seal after we had shot one. We walked the shore, searching the jetsam for something we could use. Some distance from our camp, we found some pieces of old planking holding a few huge spikes. Like ancient Palaeo-Eskimos using stone-age tools, we set about releasing metal from timber and pounding it with a rock to form a curved hook shape. A piece of driftwood was lashed perpendicular to the head of the spike as a handle.

While we worked on the shore, Mike spotted a polar bear swimming across the bay, coming right towards us. We left our tool making and launched our boats to take a closer look.

He was a huge male in great condition, his back covered in thick fur. His head planed the water, his jet-black eyes looking ahead and his nose

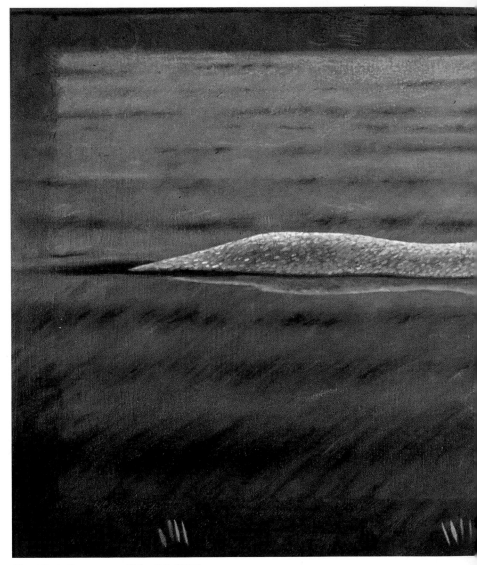

Blood Red, oil on canvas, 28" x 50", 2000

sucking in a loud stream of air at the waterline. He'd probably been wandering the far shore and heard our shotgun blast echoing off the glacier. Thinking that the shot had been fired behind him, he'd have taken to the water—a common response of threatened polar bears. They are strong swimmers, capable of travelling 100-kilometre distances.

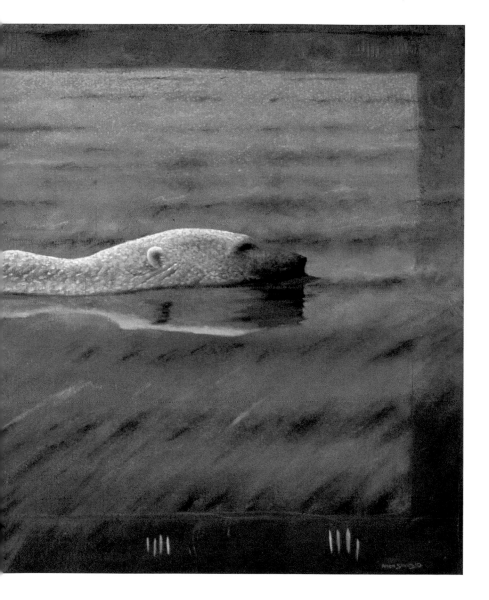

Every minute or so, while swimming, he put his head under water and looked around. Flanking him about three metres away, we managed to steer him away from our camp and over to the bay's north bank. When he got to shore, dripping with water, he wasted no time bolting up the steep slope of the mountain, pushing down a shower of scree

as he went. At the edge of a hanging glacier he stopped, turned, and regarded us for a moment before rambling over the ice and out of sight.

The next day, Mike called Pond Inlet and learned from our contact that there were hunters in the area. They weren't carrying extra food, but they would stop at Tay Bay and pick us up if we wanted. It was my feeling, as well as Mike's, that winter was upon us and that continuing around the island wouldn't be wise, even if we obtained food. We decided to return to Pond with the hunters.

Although we had made a beautiful gaff hook, we abandoned our seal-hunting plans and did a short hike that afternoon, knowing we had a lift out. We climbed the glacier the bear had crossed the night before and followed his tracks inland over the col.

Before returning to camp, I took a photo of Mike and me, using my camera's self-timer. I set up the shot with the glacier rising in the background. As Mike waited for me to focus and set the exposure, I noticed how incredibly thin he was. Slight to begin with, Mike had spent over three months in the Arctic, camping, hiking, paddling, man-hauling, and shivering, almost all of it with an uneven and unpredictable food supply.

When we got back to camp, the two Inuit who had come to pick us up were gillnet fishing in the bay. Beside our tent was a cardboard box containing Inuit boat food—a jumbo can of Spam and Pilot biscuits, which are big, thick squares of rock-hard cardboard that taste exactly the same whether a week or ten years old. We lit into both like they were smoked salmon on rye.

Within an hour we had packed and loaded our stuff and kayaks into the long outboard and departed Tay Bay. Out on Navy Board Inlet the wind had come up, covering the channel in a froth of whitecaps. Even facing a gnarly sea, the Inuit drove the outboard engines at full bore. For five hours the waves slammed and shook the hull so hard I thought its seams would burst. Mike and I held our camera cases tight against our chests the whole way.

We didn't go directly back to Pond. Instead we crossed to the other side of Navy Board Inlet and spent a few days at Low Point, a hunting camp on the eastern shore of the Borden Peninsula. We joined a number of hunters who were staying in a couple of shacks. The camp was littered with bones, skins, meat, hides, discarded junk, and yelping

Low Point, oil on canvas, 19.5" x 34", 2000

dogs. The hunters had just shot a polar bear, and it lay freshly skinned and cut up on a sheet of clear plastic. The parts looked exactly like a very heavily muscled man. The bear had been drawn to the camp by the scent of decaying narwhal. The narwhal were some of what Charlie, who had given us the caribou meat, had killed three weeks before. Three of the narwhal were buried in shallow graves, mounded up with dirt. This fermenting technique ripens the outer skin of the whale. After a month or so, the unearthed fatty tissue is considered an Inuit delicacy.

Before we left for Pond, I did a drawing from behind the camp, looking towards the interior. The scene was austere: some rocks piled one on top of another sitting out on the open tundra. An abandoned propane tank and a piece of rusted metal lay around the cairn. In the background the land lifted — rolling stretches of Indian-red and burnt-umber tussocks with added bands and splotches of white transitioning into a curtain of grey. I lightly flecked the sky with random marks and little symbols — representing what exactly, I didn't know. Later, in my studio, I did a small oil from that study. I painted it as I had drawn it. I didn't change anything.

When I flew out of Pond Inlet that fall, I thought my Bylot Island experience was behind me, a thing of the past. I assumed that I would recall

it fondly from a distance, like any number of expeditions—another adventure, another great memory, albeit indelibly crazier than most.

Yet ten months later I found myself in a kayak back on the Northwest Passage, attempting to finish paddling Bylot Island. Again I had joined Mike and Tookie, to continue, in the words of Stan Rogers's "Northwest Passage," "tracing one warm line through a land so wild and savage."

Our warm line would be drawn into the teeth of its eastern entrance, into its ruthless seas, huge headlands, and an amassing of land-bound polar bears.

VIII

BYLOT ISLAND: THE NORTHWEST PASSAGE, 2000

We will only understand the miracle of life fully when we
allow the unexpected to happen.
—Paulo Coelho, *By the River Piedra I Sat Down and Wept*

It weighs as much as seven men. Moving with a swaying gait and an air of unconcern it saunters the shoreline towards the sun. Its coat's hollow hairs radiate light as if electrically charged. Each stride sends fur rippling with the iridescence of exotic bird plumage. Apart from humans it fears nothing.

The bear's tracks trace the top rise of a gravelly tidal wash from some time ago. Its prints are deep, compressing the coarse sand. Fifty metres from the impressions, higher up on one of the ancient shore beds, is a sequence of flat rocks, half buried. They lie in a curved pattern, well hidden by some sedges, clumps of mountain aven and cotton grass. To the right of the high grasses, thinly buried in soil, leaf decay, and a fine root mesh, rests a palm-sized bear. It is tinged sallow with age. Given its detail, the tiny piece of ivory was carved with reverential care. It, like others that have been found, has been hibernating in the Arctic for a thousand years.

Archaeologists believe that, for their creators, the bear-like representations carried ethereal powers. The Dorset culture believed that the polar bear was a special creature: their equal, perhaps even their superior. The white bear was thought to act as a conduit between themselves and other animals, and between man and the spirit world.

The vast majority of these carvings have been carbon-dated to a time just prior to the Dorset's sudden disappearance from the Arctic. Archaeologists suggest that such a profusion of carvings indicates a time of great threat, catastrophic change, and social upheaval. It's thought that the artist/shaman's carvings were desperate calls to the polar bear to help the Dorset in a world rapidly moving out of their control.

That first summer on Bylot Island, Mike Beedell and I had circumnavigated about half the island. Getting all the way around never really mattered to me—I could have stayed exploring and working out of any number of places. But I thought our Bylot adventure had been amazing—it gave me the gift of the unscripted, a taste of the uncommon, and the good fortune to stay alive and safe.

Beedell saw it differently. Although he too felt it had been an incredible experience, it bothered him that he had not completed the circumnavigation. In fact, he couldn't live with the failure. Not because he was obsessed with the goal or because he wanted to prove he could do it; rather, paddling around the island was a commitment he had made to others.

Mike and Pamela had used their contacts to obtain significant sponsorship for their Bylot adventure. Much of the assistance had been in the form of donated or loaned equipment, services, and other types of support. Corporations involved in communications, computers, photographic equipment, clothes, outdoor gear, sea kayaks, and air travel had contributed to the expedition. When he didn't complete the trip, Mike felt he had let those sponsors down. He was determined to finish kayaking around Bylot the following summer.

That winter, I gently tried to dissuade Mike of the idea, telling him that in all likelihood the sponsors didn't really give a damn if he went right around the island or not. I told him that the trip had received tons of media coverage and had drawn lots of attention and that, in all probability, the sponsors were already more than happy.

Of course, I didn't really know if the sponsors were happy or not. I was trying to discourage Mike because I considered the rest of the trip to be particularly high-risk. Bylot's northern shore presented many dangers and obstacles, with its huge open water, towering headlands, and heavy concentration of polar bears. But Mike's mind was made up. It made me wonder how many adventurers had risked their lives going beyond what was safe because they had made commitments to sponsors.

Although this might not apply directly to Mike and his sponsors, many of whom are his friends, I feel there is an inherent conflict between sponsorship and high-risk adventure. Extreme adventure in remote places is expensive and usually requires sponsorship of some sort. Corporations assess sponsorship proposals (and they get lots of them) often on the proposal's potential to create publicity—a buzz. In extreme adventure travel, if there is little risk generally there is little or no public interest. Ratcheting up the risk—"This has never been done before!"—is something that extreme adventurers have learned to do to get pre-trip publicity and hard news coverage. Sponsorship often follows. But such publicity can backfire. High risk is a short step from tragedy, and corporations generally don't like to see their names or products associated with that.

Mike asked me if I would join him again to finish kayaking the island. Pamela wasn't interested in going—the summer before had been punishment enough. As it turned out, by the end of that second year on Bylot Island, Mike and Pamela would be permanently separated.

For me, Mike's invitation was a dilemma. First off, I have always felt an underlying discomfort with any expedition whose primary goal is a destination. This has more to do with my own philosophy than with any specific physical risks, although those can certainly be a factor. Simply put, my view is that given how humans now dominate the planet's environment, I don't think we need any more of us going to remote places for the sole purpose of conquering "wilderness earth." Perhaps there was a time we needed people to be the first somewhere, or to climb the highest, attempt the most difficult, travel the farthest, or do things no one else had done. Some would say this is a natural part of being human. Maybe so. But I think we've had enough of the adventurer as triumphant hero. Perhaps the planet would be better served if we approached adventure with different values and other purposes: to investigate and interpret, or to look for the spiritual, cultural,

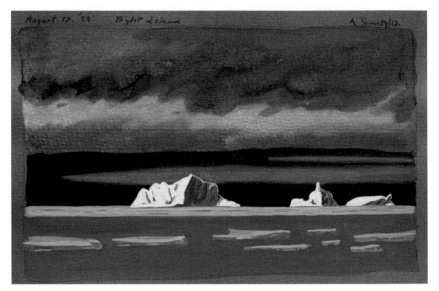

Bylot Island, August 17, '99, watercolour, 6.5" x 9"

ecological, or inspirational relationships between ourselves, the planet, and other life.

I felt an uneasy about Mike's offer for less philosophical reasons as well. The risks inherent in paddling around Bylot are not imaginary. Kayaking the northern route would scare any rational person. I was less concerned about polar bears than about the island's completely exposed coastline. The island is the lower gatepost of the Northwest Passage, where the waterway's 80-kilometre width meets Baffin Bay; essentially, two vast expanses of open ocean meet each other there. But more than that, Bylot's northern coast is utterly without refuge — a 200-kilometre run of mostly high-walled dolomite. Even a casual kayaker glancing at a map of Bylot's north coast can see how incredibly dangerous it is.

Yet the invitation was also hard to resist. I had to admit that I had fallen in love with Bylot: with its abundance and extremes of wildlife, its absence of people, its aloof majesty, and its startling remains of ancient cultures. I also knew that although Mike was firmly committed to a circumnavigation, whatever he did would incorporate a broad range of lateral, non-goal-oriented thinking. And besides, travelling with Mike Beedell anywhere is always fun.

I talked with Mike about my concerns, particularly about travelling the exposed northern coast. After listening carefully, he said we

would travel only in good weather, for there wouldn't be the kind of time pressure we'd faced on the first trip. Mike was well practised at allaying people's fears, and I knew he was telling me what I wanted to hear. I also knew that words used when envisioning Arctic expeditions rarely match the reality. I told Mike I had a commitment late that summer that I couldn't break. He said that wouldn't be a problem, and we allotted a month during the following summer to continue paddling the island.

Mike was already in Pond Inlet when I got there. With his credentials as a wildlife photographer, he had been invited to join a film crew from France. They had been filming birds on Bylot Island as part of a documentary called *Winged Migration*. Shot in forty countries by five film crews over a three-year period, it would become a worldwide, critically acclaimed success. When I met Mike in Pond Inlet, his ripped T-shirt bore witness to the filming. A snowy owl had raked Mike's right shoulder with its talons—it had been protecting its fledglings from cinematic intrusions.

Our plan was to charter a Twin Otter out of Pond to take our kayaks, food, gear, and us to Tay Bay. From there we would resume our clockwise paddle of the island. Chartering Twin Otters in the Arctic isn't cheap—in the Arctic, nothing is. Maintenance and fuel are expensive, the season is short, and the weather is often prickly. Charter airlines in the Arctic mostly transport civil servants, resource personnel, or researchers from educational institutions—most of whom have fat expense accounts, at least compared to ours. Mike asked Ken Borek Airlines, the main regional charter, if they would help sponsor us with a flight from Pond Inlet to Tay Bay. They declined.

Undeterred, Mike thought we might subsidize the cost of the charter to Tay Bay by selling seats on the plane to people from Pond, who would want to get a look at Bylot's interior and the remote north coast. Mike thought $150 was a reasonable fare. I didn't say anything, but I thought it a far-fetched notion—Inuit paying $150 for one or two hours of viewing an island that they see out their windows every day.

I met the Ken Borek plane when it landed on the Pond Inlet runway. Awaiting the plane was a huge pile of our stuff to fit into its small fuselage. On the tarmac sat two hard-shell fibreglass expedition sea kayaks, stove fuel, a tent, food, packs, and other assorted gear, plus two

fifty-gallon metal barrels of extra food that we were hoping to drop off and cache at various spots along the coast. Each barrel weighed about 80 kilograms.

The pilot climbed down from the plane and stared at our pile of gear. "You don't intend to take all this stuff!"

I answered yes, as if he had asked a question.

"How many people are going?"

"Two." I didn't tell him that my partner was currently selling passenger tickets for his plane. I was more worried about the amount of stuff on the tarmac and the pilot's head shaking than I was about Mike's plan to fill the plane with sightseeing Inuit.

Mike was late, and the young pilot was agitated. He had other appointments to keep, a load that he deemed too big for his plane, a missing client, and ever-changeable weather to worry about. Mike and I had been forewarned by the airline: weather over Bylot is notoriously lousy and unpredictable, so unless conditions were clear and calm, the pilot simply would not take us.

Finally I saw Mike walking from town towards the runway, followed by six others. Mike introduced himself to the pilot and then announced that if we could wait a bit longer, in addition to the six passengers present, two more would be coming shortly.

The pilot was incredulous. Unfazed, Mike went to work on him. After about half an hour, with lots of reassuring words, some plane seats removed, and some gear and passengers left behind, the plane was loaded to the hilt and ready to go. There was enough room for five sightseers, Mike and me, and our kayaks, food, and essential stuff. Mike assured the rest of the paying customers left on the runway that they would be able to see Bylot when we got picked up later in the summer.

With that, the plane roared and bounced along the tarmac, slowly skimming over the town and across an ice-choked expanse of Eclipse Sound. Ahead lay the Byam Martin Mountains of central Bylot Island.

The air was clear and icy cold. The plane angled upwards in a rapid 2,000-metre ascent to clear Bylot's interior. From above, the island was a maze of unnamed white glaciers snaking through a hundred unnamed white peaks. Under the weight of a white mantle, a tangle of ice pressed out towards the sea. At its apex stood Mount Thule and Anqilaaq Mountain. The island's peaks reached a comparatively paltry 2,000 metres, but its snow-bound ranges looked as indomitable as the Himalaya's southern wall.

Approaching the north coast, we could see Lancaster Sound—the gateway to the Northwest Passage—and Devon Island beyond that. Lancaster Sound was open and mostly clear of sea ice, which had been a big concern. However, a driving north wind had bunched up a million big chunks of drifting floes in a 100-metre swath along the entire coast. A three-metre sea washed and churned four-metre-thick, multi-year ice in its swells and backwash. The ice crashed and tumbled like ice cubes in a food processor.

With the plane lurching back and forth in the stiff wind, we flew low, west over the coast. Seeing the hostility of the Passage from the Twin Otter's window, I had one overriding question: What the hell was I doing here? I had absolutely no idea how we were going to paddle that water. And if we did, how the hell would we land? I sensed that our Inuit passengers were having similar thoughts, for every once in a while they turned their attention from the window and stared long and blankly into my eyes.

The pilot flew over the high-tide beaches, searching for a landing spot to deposit our food cache. A long, flat stretch of ground was needed, and even then the pilot wasn't sure he could land. The plane constantly drifted, lifted, and torqued in the north wind. Finally he was able to set down on a strip of beach gravel. Mike and I hopped out into the sand-blasting shock of cold wind and rolled one of the steel food barrels into a grass thicket. We did the same with the second barrel another hundred or so kilometres along the shore. At the second drop-off we found one of Mike and Pamela's metal food barrels (the one that had been too far away to reach from Tay Bay the previous year). Bears had mauled its rusty steel surface, but all its food contents were still there, a year older.

When the plane reached our destination, the pilot couldn't find any place to land. He circled around and around, 30 metres above a 10-kilometre stretch of shoreline, for half an hour. Mike sat at the front of the plane near the pilot, talking to him. Finally he got up and squeezed his way down the stuffed fuselage to where I was sitting at the back. He shouted over the droning engines that if we couldn't land, we could perhaps get the pilot to drop us back on the southeastern coast of Bylot, where we would then commence to paddle around the island the other way, in a counter-clockwise direction.

Hnh?

Although I didn't want to lobby for a Tay Bay crash landing, I viewed it as only slightly less desirable than this new plan. There was a previous

year's food cache somewhere on that far side but no guarantee that it hadn't become bear food over the winter.

We assessed our pilot to be a bit on the timid side, as both Mike and I had landed many times on ground a lot rougher than what we were seeing, but the pilot's assessment, of course, was the only one that mattered. Just as I was sure he was ready to give up, he dropped down low, slowed the engines, and bounced down on the gravel beach. We were about four kilometres north of Tay Bay and about 10 kilometres south of where Navy Board Inlet meets Lancaster Sound. From the narrow stone beach a tundra flat of rich, tawny hues stretched for three or four kilometres inland before rolling under the glaciers of the Byam Martin Range.

The pilot, in a hurry to depart, immediately commenced unloading all our stuff onto the beach. There were some quick exchanges of good wishes from the passengers before the Twin Otter was gone. Absent the plane's engine noise, and our young pilot's anxiety, our silent Arctic home felt wonderfully liberating.

It was late afternoon at that point, and we were hungry, having been on the go since our early-morning breakfast. We fired up the little gas stove and made a pot of Chinese noodle soup. All our gear was still in an unsorted pile on the beach, so we were constantly running over and searching for various things we needed to make lunch. Unbelievably, after twenty minutes of looking, we concluded that we had left the utensil bag back at our Pond Inlet campsite. The irony of this was inescapable: previous year, lots of utensils — no food; current year, lots of food — no utensils.

While the soup simmered, Mike and I prowled the windswept shore looking for some sort of beach debris that we could fashion into a bowl-to-mouth device. Mike decided on a scrap piece of red plastic bucket, which he carved into a spoon-shaped scoop. I found a splinter of oak, which I whittled and shaped into an elongated, scooped-out half-moon. When I carved the curved edge sharp, it would also serve as a knife. It took many modifications before our new utensils had any sort of compatibility with our mouths. Observing each other's attempts to eat with these scavenged prototypes precipitated some great bouts of laughter.

In front of us, the channel of Navy Board Inlet was packed with jumbled sea ice. Only out on Lancaster Sound, about 10 kilometres north, could we see open water. We had a good spot to camp with a

great view, and that was fortunate, because until the ice shifted we were trapped there.

Although our camp was surrounded by sea ice, we knew from our flight that our route along the north coast was open. That was both good and bad news. We knew that paddling the coast was theoretically possible. But without any sea ice to flatten the waves, we would be travelling in open and likely big seas. And no ice meant there would be a significant number of polar bears coming to land.

Over the next few days, with binoculars, we watched many bears out on the ice of Navy Board Inlet. One time, we saw a mother walking the ice with two young cubs trailing her. The cubs were about five months old; they would stay with their mother for another two years.

We were able to observe one of her sea hunting techniques. In some unseen way, she told her cubs to stay behind. Then she began to sneak up on a seal resting beside its breathing hole about 50 metres from her. The cubs stayed perfectly still, watching intently. The female polar bear kept her head and front legs close to the ice with her rump in the air as she pushed herself forward with her back feet. She understood that a white, rounded dome (her rear end), as it moved slowly out on drifting packs of sea ice, would look to a seal like another drifting ice clump. The bear kept its easily spotted black snout and black eyes low and out of view. When the female got close enough, she lifted her head up from behind an ice ridge to observe the seal, all the time keeping her head tilted so that her eyes were the only thing above the ridge, and then just barely.

On that particular occasion, the seal sensed danger and slipped down its breathing hole before the bear could get close enough to pounce.

Polar bears hunt from ice floes. Their principal prey is seal, but if the opportunity presents itself, they will go after other mammals, such as young walruses, narwhal, and beluga whales. A polar bear's kitchen is the sea ice; its bedroom is the land. Although they evolved from brown bears many millennia ago, they are no longer land feeders like their cousins.

During the summer, on land, polar bears generally wander and sleep, living off their body fat. That is why climate warming in the Arctic, the melting of the polar sea ice, has put the bears' future in peril. They can't catch the food they require without the hunting platforms of sea ice.

Hunting Grounds, etching, 24" x 18", 1999

Climate change has increased polar bear populations in some areas while decreasing it in others. It is estimated that 22,000 to 25,000 polar bears exist worldwide, about two-thirds of them in Canada. Biologists estimate that in western Hudson Bay there has been a 22 percent decrease over the past twenty-five years. Although their overall numbers are thought to be relatively stable, their average body weight has been dropping steadily. In many places, they have recorded a 25 percent weight decline over the past quarter century.

Bears were moving onto the land around us, but during the first few days they didn't come into our camp. I was always watching for them out on the ice, but Mike cautioned that we had to be careful while wandering the interior as well, since we could literally stumble upon a sleeping clump of bear.

After four days of staring at kilometres of broken ice floes holding us fast to the shore, we started feeling the pressure to move. We had a long way to go and only so much food. Mike didn't want the circumnavigation derailed again by an early winter. Now he started talking about hauling our boats across the jumbled sea ice to the open waters of Lancaster Sound. He had brought plastic sheaths specifically to protect our kayak hulls in case we had to drag them across the ice. His idea was to pack all our supplies in our boats and pull them across the broken ice until we found open water.

I was uncomfortable with the plan. I had pulled kayaks across ice before, but that was either for very short distances over ice pans or for longer distances on expanses of flat, solid ice. The scene before us looked more like vast stretches of broken ice. I thought it was dangerous; one could easily slip and fall into the water or be carried out with the ice, far from shore, if the wind changed direction. If that happened, we could find ourselves on pieces of shifting sea ice that were rapidly separating, making it impossible to either paddle our kayaks or to haul them.

Mike suggested doing a sort of test run. One evening we harnessed ourselves to half-loaded boats out on the ice to try hauling them. It looked to me like certain suicide as I watched Mike start to move on the ice. He was jumping from one slippery, bobbing ice floe to another while tethered to his heavy kayak, which at various moments slid smoothly, got stuck, went off course, nose-dived into the water, or rammed into the back of his legs. All of which threatened to pull or pitch him on his ass or into the ocean.

I tried to follow Mike, but because the ice pans were moving, it was impossible. Jumping any distance across water onto a moving, slippery surface, when you're tied to a heavy, unpredictable trailing object, was unnerving to contemplate and almost impossible to accomplish. I looked out across the sea ice to the open lead, many kilometres in the distance, and wondered if what Mike had in mind was doable.

We weren't far from shore when I shouted to Mike to stop. The sun was low and unfiltered, reflecting off a thousand pieces of jostled sea ice. Mike's knee-high white boots, canvas shoulder straps, and slick, wet kayak sparkled in the strong light.

"Mike, this seems really pretty dangerous to me."

"In what way?"

"Well, cripes, I've almost fallen in twice."

In the calmest voice imaginable: "If you do, don't worry. I'll be here to get you out."

"Uh-huh ... yeah, I'll be soaked and freezing!"

"No you won't. I've brought a towel and a change of clothes."

I sighed and, after a pause, replied, "I don't know, Mike. I'm just not comfortable doing this."

"I know. That's why we're practising."

That was quintessential Beedell: calmly whistling a tune while walking the edge, but surprisingly prepared when doing so.

It soon became apparent that Mike's plan was in fact quite doable. As we moved away from the shore, the ice pans became larger until we were gliding safely across substantial surfaces of flat ice. A few times we came to leads that required us to launch and paddle a short distance before continuing our hauling. The effort to haul on expanses of flat ice was minimal.

Seeing that I'd become fairly comfortable with the procedure, Mike suggested we return to shore. Paddling inside a narrow lead, we surprised a polar bear. I was closest to the bear, just ten metres away, when we came across it. Surrounded by dense pack ice in a kayak is not the way you want to meet a polar bear. A clean escape, either by climbing up onto the ice or by paddling through or around the pans, isn't going to happen unless the bear wants it to. This is an animal that, when motivated, can accelerate to 40 kilometres an hour in an instant.

The bear suddenly bolted towards me, then just as suddenly came to an abrupt halt and regarded me carefully. It could have been right off

a *National Geographic* cover: healthy, young, gleaming white, glowing in the setting sun with the dark cliff backdrop of the Borden Peninsula in the distance. Eyesight is not a strong polar bear attribute. It took a moment for him to realize that I was not the semi-aquatic he normally saw and hunted among ice floes. After recognizing me as human he jumped into the open lead and swam away from us.

As we paddled back through the ice floes towards our camp with a light breeze at our backs, the wind suddenly shifted and came on us from the east. Like a hammer — boom — just like that, half a kilometre from shore, a howling, screeching gale frothed up the sea and separated the ice pans, sending them sailing past us. The wind's force threatened to rip the paddles from our hands. An hour later, exhausted, we reached land. At our campsite we watched the wind continue to rage, and within two hours there was no pack ice to be seen anywhere on Navy Board Inlet.

The following day, we broke camp and paddled north, up the ice-free coast to Lancaster Sound. As we approached the north end of Navy Board Inlet, the winds continued to build from the northeast and the sea surface was tossed with two-metre waves. The sun's rays were broken here and there by low-flying clouds. The whole world was moving over, around, and under us — the clouds, the water, the air, sea spray, sea birds, and pieces of ice. We bobbed and pitched in no man's land, on the heaving plane that separates sea and sky. Only the land to our right, held firm by the mountains' weight and sprawling glaciers, stayed motionless.

The island's northwestern extremity comes to a point like a curved sewing needle. It would have been impossible to land there, given the day, had it not been for a few small islands just off the point. These were the Wollaston Islands. For us, they were a breakwall of black, barnacled, sea-washed rock — for walrus, an important breeding ground. We made a successful albeit somewhat wet landing. A barrier of grounded multi-year ice helped protect us from the crashing surf as we got ashore.

The rough water on Navy Board Inlet was nothing compared to what we now saw. It was something to behold. All the way across to the distant white mass of Devon Island, an 80-kilometre swath of dark phalanxes rolled and howled through Lancaster Sound. The one-and-a-half-storey walls of water were laced with white streamers. The entry-way to the Northwest Passage was a gauntlet of sculpted fury. When I

saw that, I no longer questioned why Bylot hadn't been circumnavigated in modern kayaks—indeed, it made me wonder why anyone would try.

The previous year, while Mike and I were sniffing around for food near the Goose Camp, a large international team of elite sea kayakers, some of whom had paddled Cape Horn, were attempting to become the first to circle the island by sea kayak. The Passage winds and sea had turned them back at the very spot where Mike and I now stood.

⁓

In 1616, Captain Robert Bylot and his navigator William Baffin became the first to accurately map Bylot Island's land masses and surrounding waters. But by then, the name Robert Bylot had already been written into the annals of Arctic exploration, more darkly so. Six years earlier, Bylot had been the first mate on Henry Hudson's tumultuous 1610–11 search for the Northwest Passage—an expedition that had been rife with hardship and dissension. After being trapped in sea ice and having to overwinter on board ship, the crew mutinied, casting Hudson, his son, the sick, and a handful of the captain's loyalists adrift in the Arctic in an open boat. They were never seen again.

Bylot had sided with the mutineers, and on returning to England, he and the others were tried for mutiny. But without Hudson or any of the castaways to contradict their account of what had happened, the accused were acquitted.

Soon after, Bylot was commissioned to explore and map the upper Eastern Arctic. Aboard the *Discovery*—the same 20-metre ship on which the mutiny had been carried out—Bylot and Baffin and their a crew of fourteen men completed what history now regards as one of the most successful expeditions of its time. Although the pair returned with accurate and detailed charts, the naval establishment suppressed their findings. Among those who had backed the voyage, Bylot's reputation and credibility were still tainted by the mutiny against Hudson. It was also felt that if their maps were indeed accurate, rivals might gain an upper hand in finding the northern route to the Orient. So their notes and charts fell into obscurity for two hundred years. The consequences of that neglect would handicap further explorations for generations and exhaust the Admiralty's patience as well as its treasure.

The *Discovery* was just one many ships that for four hundred years had pushed their oak prows into the polar sea ice. Some expeditions

Bylot and Bears #1, etching & watercolour, 10.5" x 14", 1999

were sent off to reach the North Pole; others, simply to discover and map what was there; but the vast majority were commissioned to find the Passage. A northern route, if it could be found, would shorten the Cape Horn or Cape of Good Hope route by a full two years.

While other European nations felt drawn to the Arctic (as were the Americans), for the British it was a national obsession. The Royal Navy sent there some of its best commanders—Cabot, Frobisher, Davis, Hudson, Bylot, Foxe, Rae, Ross, Parry, Franklin, McClintock, Belcher, McClure—and countless more. They came; they searched, took ill, starved, froze, were mutinied against, were killed, went missing, or drowned. The capricious sea ice more than anything else determined whether these commanders and their crews returned home infirm, frustrated, or at all. When expeditions went missing, search parties were sent to find them, and these often spent years seeking their lost compatriots, sometimes getting lost themselves, so that search parties were sent to look for search parties. The most effective communication of the day to relay a ship's distress to the outside world was a note left on a promontory, under a rock cairn.

Ironically, when the Northwest Passage was finally discovered, after centuries of hard and relentless searching, it brought with it no apparent benefit. The channels and passages were all deemed impenetrable owing to sea ice. At least until now.

Although the search for a quicker route to the Orient turned out to be futile, Britain's efforts and sacrifices contributed a great deal to the world's scientific and geographic knowledge. Little by little, British explorers finally solved the complexity of islands, straits, and bays that had confounded ten generations of explorers. By the time a successful route had been found through the Passage, almost all of the Arctic's natural features carried British names. The last great blank space on the world's map had been filled.

<center>✳</center>

The winds on Lancaster Sound raged for days. My mind began to entertain a new worry: perhaps the seas we were witnessing were not abnormal — after all, centuries of seafarers hadn't given the Passage its infamous reputation for nothing.

While we waited, I hiked and painted. The area was spectacular. Everywhere I looked, the views were incredible and varied: snow-topped mountains, winding glaciers, sprawling tundra, roaring seascapes, towering shore cliffs. The coastline going east was high-walled rock that had been carved and cut away by the sea. Colossal caves, grottoes, and catacombs had been fashioned and formed by wind, water, and ice, leaving strange-shaped stand-alone sculptures out in the sea. In one spot a series of rock columns more than 20 metres high were carved in such a way that their massive forms rose from the sea like great bull mastodons confronting one another.

Polar bear sightings were becoming common. We saw at least two or three a day, often as many as half a dozen. One morning we woke to find bear tracks around our tent. During the day they almost always ran from us, particularly when it was a female with cubs. Big males don't like to show fear, though, so they often moved away much more slowly.

Most of the Bylot bears would have had encounters with Inuit hunters, and that probably accounted for their fright when they saw us. However, that isn't a trait one can count on. A bear's disposition, sex, age, and past experiences with hunters can override normal patterns of behaviour. Hunger level is another factor. Most of the bears we were

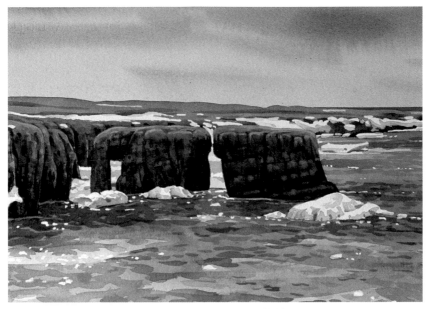

Mastodons on Lancaster Sound, watercolour, 10.5" x 14", 2000

seeing should have been reasonably well fed, having just come off the sea ice.

After three days, the Passage finally quieted enough for us to depart. Even though it was navigable for now, the days we had spent viewing Lancaster Sound's savagery permanently altered my perspective on what we were doing. Skilled paddling alone would be no match for these forces. I was sure we would need the benefit of luck, or the benevolence of Sedna, if we were going to deliver ourselves safely through the Passage's gateway.

Since childhood I've been both drawn to water and frightened by it. My fascination was first cultivated in public school, when I learned that nearly three quarters of the planet is covered with water and that in its saline depths are species so varied, bizarre, and numerous that the job of finding and documenting them all never ends. Some ocean dwellers are hideously fearsome, as if conceived in the laboratory of the depraved. Others glow as if wired electrically, or are as fluid and clear as glass. Some appear imbued with an ethereal presence, as though they hold the secrets of the cosmos, while others expose their inner workings, pulsate with colour, or are delicately laced like a spider's brocaded web.

Some have heads like horses, needle-nose pliers, or ball-peen hammers. There are the heavily armoured, the perfectly camouflaged, the smooth and metallic, the tubular, spiked, horned, winged, tusked, venomous, voltaic, and tentacled and suction-cupped. Some, like phytoplankton, are microscopic, while others are 80-tonne leviathans. Science fiction could hardly dream up an alien world more fantastic.

I learned that many animals are semi-aquatic—that is, dependent on water. Mammals like the polar bear and walrus, reptiles like the turtle and crocodile, amphibians like the salamander and frog, and birds like the penguin, skua, and thick-billed murre live almost all their lives in or on water.

I grew up close to water. Our family's house and acre of land was west of Toronto and only a kilometre from Lake Ontario. That is a significant lake, one of the larger bodies of fresh water in the world, but it inspired my imagination about as much as a sewage lagoon. Actually, at the time, it *was* used as a sewage lagoon. Lake Ontario in the 1950s was a waste depository for the surrounding cities and towns, a foul-smelling mix of domestic effluent, industrial toxins, and floating slicks of scum and refuse, with a shoreline covered in algae, seaweed slime, and dead fish. Our family tended to treat the lake as though it didn't exist.

For recreation we always headed north, to places like Lake Simcoe or Rice Lake. In the back seat of the car, my pulse would quicken with anticipation as I waited impatiently to catch the first glimpse of shimmering blue water. If we happened upon water without people around, that was even better.

Sometimes we travelled farther north to Georgian Bay. There, at last, was *big* water—big in the sense of expanding one's imagination and big in the sense that it wasn't corralled by shorelines but stretched off beyond the horizon. Its size and its lack of surrounding urbanization freed it from the human misuse that I was used to seeing.

My imagination must have made Georgian Bay more spectacular than it was; yet there was no denying that it was unbridled, mysterious, and unpredictable. Summer days among its thousands of islands took on the allure of a South Sea adventure. And no matter how serene the bay seemed, sailing, paddling, and fishing all carried risks. Storms and shipwrecks were always part of the bay's lore.

I learned to swim in Georgian Bay, but with trepidation. I imagined creatures with bulging eyes, guillotine beaks, and rows of needle teeth

looking up from deep below, assessing the white flesh of my spindly arms and legs. When I went fishing, dropping a baited line into its depths felt like sending an intergalactic probe for alien life.

Travelling eastward through the roller-coaster swells of the Passage, Mike and I skirted the feet of some monumental headlands. From a kayak's cockpit, I felt unsettled by the vertical cliffs that towered out of the sea. Vertigo mixed with foreboding, as if we were entering a sacred, out-of-bounds place where people in little boats simply should never go.

The most spectacular section was a three-kilometre promontory called Cape Hay, a vertical face of Precambrian rock soaring 300 metres out of the deep, dark ocean. It is truly a bird kingdom—hundreds of thousands of nests cover its walls on tiny ledges. There were guillemots and kittiwakes but mostly thick-billed murres. The escarpment's wall was alive with black-and-white blotches of vibrating life with a sound so dense that no single call could be distinguished. When I looked up, the sky was a grey haze, with tens of thousands of birds coming and going continually.

Thick-billed murres are 45 centimetres in height with a black head and body and a white breast. Though somewhat penguin-like, they are actually close cousins of the extinct great auk. They travel great distances to find food, but they are better swimmers than flyers. Their wings are small and thick, which makes taking off from water difficult for them. But that same trait gives them the ability to dive deep and swim underwater. They regularly pursue fish to 100 metres below the surface and sometimes as deep as 200 metres—deeper than any other bird will go.

The female lays a single egg, which is pointed at one end like a cone. This helps prevent the egg from rolling off its high, narrow cliff ledge, as such a shape naturally rolls in an arc. In the Arctic, the summer window for successfully reproducing and raising young is frightfully small. Like all seabirds, murres need open water to feed, so they can't arrive to nest too early. But if the adult birds nest too late, the fledglings may not have enough time to mature before winter.

After the chicks have fledged (or have apparently fledged), the parents fly down to the water and, while swimming below, call to their young still up on the ledge. The young can't fly yet, so they join their

beckoning parents by falling off the cliff. Some hit the water directly while others flap and flutter, bouncing off the rock ledges, other birds, and other nests before hitting the ground more than 100 metres below.

Amazingly, most survive this fall, even if they don't hit the water. Often congregating below the cliff are Arctic foxes, glaucous gulls, and even polar bears capitalizing on the raining, furry-winged balls of food. When the early Arctic explorers discovered the murre colonies, in their journals they often credited this easy food source as a supplement to their rations and indeed at times as a means to ward off starvation.

The parents continue to call their young in the water, and somehow the surviving offspring are able to distinguish, among the thousands of adult cries, which ones belong to their parents. Reunited in the water, they then begin an 800-kilometre journey south to the warmer climes of Greenland, entirely by swimming.

Cape Hay was mesmerizing. The wind had died and the long roller-coaster swells of the Northwest Passage rocked us up and down as we sat looking up at the winged empire of rock. Among the hundreds of thousands of birds around us that were swimming, flying, and nesting, we watched two Arctic foxes at the top of the cliff work the precarious, narrow ledges for murres' eggs and murre young. For the foxes it was hunting in the extreme—high risk and easy pickings, all at the same time.

Mike called to me that we should go. I had lost all track of time, but Mike had noticed dark clouds building to the northeast. We would be extremely vulnerable if the wind came up in front of that long, per-pendicular cape.

As we paddled on, I wondered when the first murre came to call that lacerated rock face home, and why. Perhaps it predated the Dorsets; perhaps it was even before the arrival of humans in the Arctic. What kind of cruel joke had evolution played on the thick-billed murre? Encouraging them to nest on the most exposed spot the Arctic could devise, subject to the pounding of snow, rain, sleet, waves, and wind. Then to lay eggs high on tiny, sheer rock ledges, to hatch into fledglings that couldn't fly but instead, obeying their parents' commands, took their first step to maturity by plummeting onto jagged rocks or into a rough, ice-cold ocean.

When the wind blew, we stayed put; when it dropped, we paddled. The ocean swells coming from Baffin Bay, combined with the topography, made departing and landing the most challenging aspects of our journey, whether there was wind or not. When breakers over a metre high were hitting the shore, it was too difficult and potentially dangerous to depart. Similarly, when it was time to disembark, the crashing surf threatened to slam the kayaks sideways against our legs with enough force to break bone.

And once we were on the water, the large waves breaking on the coast sometimes required us to paddle long distances to find a landing place. Extra-long periods between bathroom breaks were a problem, particularly for Mike. He had a plastic pee bottle that he kept in his cockpit. Even for a guy, this is a tricky procedure in a bobbing kayak in a big sea. Sometimes I had to paddle over and help him when it was rough, so that he didn't lose his balance and tip over.

From our map, we knew that possible landing spots along the north coast were very few and far between. When we were able to land, we often set up camp amidst the evidence of others: scattered bones and ancient artifacts. Beyond the whale, walrus, caribou, and seal bone litter we would see placed stones and mounded earth, indicating dwelling hearths and tent footings.

Some of the sites would have dated back to the Inuit's ancestors, the Thule people, who arrived in the Arctic from Siberia a thousand years ago. The old encampments Mike and I saw were certainly used by the Thule, but they were not likely the original occupants. Many of the Thule encampments on Bylot and across the Arctic had once belonged to an entirely different culture, the Dorset.

Archaeological interest in the Dorset culture developed in the early 1960s, sparked by several discoveries, chief among them a series of Dorset wooden masks found on Bylot Island in 1962 by the missionary and amateur archaeologist Father Guy Mary-Rousselière. Since then, more than a thousand artifacts attributed to the Dorset people have been unearthed across the Arctic. They reveal a fascinatingly mystical culture, unlike that of any other polar people.

Of the various Dorset finds, the largest and the most impressive have been their longhouses. These are made of large boulders and rock slabs and are 6 or 7 metres wide and up to 45 metres long—clearly, building them took considerable time and effort. The longhouses were not

Way Down Deep, etching, 24" x 18", 1994

roofed over, for the walls of these foundations are only one metre high. They have been found across the Arctic, from Victoria Island to northern Quebec, and north to Ellesmere Island—yet apart from being meeting places of some sort, we can only conjecture why the Dorset built them.

From their artifacts, we know that the Dorset travelled along the same general shamanistic road as the Thule. However, unlike the Thule, whose products were utterly utilitarian, the Dorset left behind artifacts, such as the longhouse, that can only mystify us. Assessing their possessions using the normal parameters of logic and functionality has yielded few insights. Archaeologists only began to understand the Dorset better when they examined their artifacts in the context of magic and the supernatural.

Dorset artifacts are distinguished primarily by their size. All the tools and carvings the Dorset left behind are extremely small, light, and highly portable—miniatures by intention. So small are they, in fact, that the renowned archaeologist Robert McGhee states that, using the normal proportion of tool size to human height, the corresponding "normal" person for a Dorset tool would stand only 30 centimetres high. McGhee adds that the traditional Inuit stories about a race of tiny people who live underground likely arose from their repeated findings of Dorset artifacts. (Early Inuit stories refer to the Dorset, the people their ancestors replaced, as the *Tunit*. Their oral history describes these people as large and strong but with a gentle disposition.)

Dorset culture was also distinguished from all others by the absence of drilled holes in their tools and carvings—indeed, in anything they left behind. For some reason, they would painstakingly notch out holes when required, instead of drilling them. A more efficient method for making small holes—namely, with a bow drill—would have been within their technological reach, given that bow drills were used by the polar people who predated them and by almost all other hunter-gatherers of that time. So, why didn't they use it?

Researchers have various theories, most of which revolve around the Dorset's shamanistic beliefs. They had an animistic view of the world, so perhaps they viewed the motion of a bow drill—swirling around and around, creating its own air motion—as an offending gesture to the wind and storm gods.

Also, the Dorset made an unusually wide variety of cutting burins and micro-blades, and each tool had a unique purpose and was made from a specific and often rare material, such as jade, crystalline quartz, or a found metal such as copper or iron. Other hunter-gatherer societies tended to use a single multi-purpose tool made with local materials. Thus, instead of one tool to kill, skin, and butcher, the Dorset designed

a precise tool for each step in the process. The fact that their materials were often unavailable locally suggests a highly developed trading system, a cohesive culture, and a belief that distinct and innate spiritual powers dwelt inside the inanimate.

The most fascinating of their artifacts are their carvings. These too are small. Although they must have served many purposes, from adornments to children's toys, the religious practices of the Dorset were always tied into these works, which would have had highly symbolic meanings for them. Researchers believe that the individuals who made these carvings, the artists or shamans, had an exalted status in Dorset society. From their art, it is apparent that they made few distinctions between themselves and animals; often, they carved an animal combined with a human, or one animal fused with another, such as a bear's head on a falcon's body. It is believed that such depictions were attempts to summon the power of both and thereby compound their abilities. As with their tools, each carving was designed for a specific use: to induce fertility; to protect a person, family, or tribe; to bring hunting success; to elicit favourable weather; or to punish an enemy. Their art points to a world ruled by magic and overseen by spirits, animals, and the power of the Earth.

<center>～✶～</center>

Everywhere we stopped on that coast we stumbled upon wildlife. Walking inland one day we found a peregrine falcon nest with two big fledglings home alone. Presumably, their parents were away hunting. The nest was a square cave about 10 metres up a vertical rock face. It looked like a giant wall of Lego with a few blocks omitted. The ground around the rock face was barren scree, void of vegetation except directly beneath the nest. There, in a small radius, lush grasses and ferns grew out of generations of falcon waste and remnants of prey.

Peregrines are crow-sized bird-eating raptors. They are found from the Arctic to the rainforest, with their physical markings correspondingly varied. The Arctic peregrine is grey, with a white-barred chest and a pure white throat. Black markings extend down from the eyes to the lower neck. If thick-billed murres are the deepwater, hunter-submarines of the ornithological world, peregrine falcons are the supersonic jet fighters. They hunt in the air, dive-bombing other birds from above. In flight they can reach speeds of 320 kilometres per hour, faster than any other animal on earth.

For the Dorset, birds of prey occupied a special place. This is evident in the prominence and particular characterization of these birds in the carvings they left behind. In the same way that the polar bear ruled the land and the ice, the falcon's power and swiftness had no equal in the air—a pure hunter.

The two fluffy young adolescents with their brownish down gave little indication that they would soon grow into high-velocity missiles. They peered down at us and then out to sea, repeatedly calling "*Maaaa...Maaa...Maaa...*" Mike said that Arctic skuas and gulls go after young falcons in their nests when the parents are away hunting. He added that peregrines have made a dramatic comeback since pesticides nearly wiped them out in the 1960s.

Because of the dangerous coast and big seas, visits by humans were extremely rare along Bylot's north coast. The results were startling: an island-zoo, without people, fences, or barriers, chock full of Arctic animals. I began to wonder if such a profusion of wildlife would be commonplace everywhere if humans were permanently absent.

One day, under thick, low sea clouds and a drizzly fog, we hiked inland across an open field of soft umber tundra. We came across a snowy owl's nest with six young. The chicks were spread out on the ground over a 50-metre radius. They were big enough to wander away from their open nest but not to fly. The vicinity was littered with compacted regurgitated pellets, consisting of tiny pieces of bones, fur, teeth, and feather bits. The young owls were big, and covered in billowy, greyish-brown down that perfectly matched the ground cover. They were impossible to spot and easily stepped on unless they moved.

Although their feathers gave no hint of what they were, their talons did. They lacked foot feathers, but they possessed the same huge, powerful meathooks as their parents. One of the parents sat on a flat rock, its golden eyes watching us from a safe distance. Its plumage glowed like a spotlight against the day's dreary dampness. At that stage, the parents must find and drop off food to each of their dispersed offspring. Snowy owls often need to defend their vulnerable young from jaegers and Arctic foxes. They eat mainly lemmings, but they are known to feed on other small mammals, birds, eggs, and fish. They are perfectly adapted to living in the Arctic but become nomadic southbound travellers in winter if prey is scarce. The males are pure white; the females and

Air Traffic, etching, 18" x 24", 1999

immature birds are flecked in dark-brown. Adults have a wingspan of a metre and a half, with feathers that have a unique muffling quality, making their flight utterly silent.

Later, back in camp, I was still pondering our snowy owl experience while listening to Mike call in our position by satellite phone. His voice signal was transmitted through the phone out into Arctic air, to a satellite positioned somewhere over Brazil, then to a telephone in Pond Inlet, with the reply coming back the same way. It was one of a billion similar transmissions, invisible chatter sent and received, that now continually circle the globe and perhaps beyond. Listening to the short back-and-forth on the phone, I conjured up images of transparent words flying around us—coded clutter, filling the air, invisibly moving at the speed of light.

In Inuit mythology the snowy owl is the foreseer of good fortune and a protector, widely depicted in their art. I wondered if its hushed, feathered wingtips were sensitive enough to pick up our teleported messages—nano-pulses riffling through its air space: a cacophony of silent noise.

Stress is a subjective thing: what one person is at ease with can make another panic and become sick with worry. An individual's temperament plays a role in this, but one's past experiences, or lack thereof, also can do much to determine a person's comfort level. For me, at some level, stress circumnavigated Bylot with us. Usually it hovered in the distance, out of sight and out of my thoughts. At other times, however, like Edgar Allan Poe's raven, it came knocking at the door. With the exhilaration of discovery, my artwork to focus on, my years of Arctic travel, and Mike's self-confidence and lightheartedness, I was able to keep anxieties about towering seas, shortening rations, and wandering polar bears on the other side of the door—at least, I could until halfway down Bylot's north coast.

It happened while we were kayaking late one evening, looking for a place to land. That day we had started paddling the deep swells of the Passage in early afternoon. By evening the strong winds had dropped, but huge ocean rollers from Baffin Bay continued to thunder and pound the high-walled coast, making it impossible to go ashore. The sun was doing its low, diagonal sweep across the sea's surface as we paddled east against a powerful current, looking for some kind of coastal irregularity where we could get off the water. Hour after hour, working extremely hard, we inched our way eastward. When we stopped to take a breather, or simply ceased paddling for a few minutes, the current carried us back to where we had been ten or fifteen minutes before. To our right the crashing waves that slammed the rocks generated a highly agitated backwash. We were paddling about 100 metres off the coast to stay clear of the turbulence.

The low sun had grown big and amber in a cloudless sky. It carried blinding light without warmth. The ocean stretched off to our left all the way to the horizon. The angle of the orange light threw long, hard-edged shadows across land and heaving water. Mike was about 75 metres ahead of me. For prolonged moments he and his heavily loaded yellow kayak would completely disappear in the elongated troughs of the two-metre swells.

It appeared out of the water, 10 metres directly in front of my bow: a round, bald, humongous head. Frozen in place, I stopped paddling. I held my breath. Together, my boat and the object of my attention were lifted and lowered by the sea. Its hulking head and shoulders were visible half a metre above the water. Its head was another half metre wide.

What the hell was it? My mouth went bone dry, my pulse quickened, and I could feel the hair on the back of my neck stand on end. Childhood fears of bogeymen and monsters, of things that go bump in the night or lurk in the deep, in that split second returned.

It was staring dead ahead at Mike, not realizing I was right behind it. The creature's skin was rough and indented, like elephant hide or tree bark, coloured a ghoulish white-grey with bits of dark mottling. It was so incredibly big that it took me a few seconds to comprehend that it wasn't an alien creature or a sea monster but rather a huge walrus.

Its gaze stayed fixed on Mike, head and shoulders high out of the water. I was drifting closer and closer, but it still didn't realize I was right behind it. I slowly and quietly back-paddled a half-dozen strokes. Mike was merrily paddling on, totally unaware that a leviathan's eyes were assessing him.

Time stopped. For the moment I was semi-paralyzed, overtaken by terror of what was to come.

The beast dove back underwater with purpose, heading towards Mike. I shouted to him. He couldn't hear me. In a panic I cried out as loud as I could again and again.

Mike often listened to music with earbuds while paddling, but I couldn't tell if he had them on. Anyway, the sound of the waves crashing on land was loud enough to drown out my cries. I blew my whistle and shouted over and over and over without getting his attention. I was madly paddling, trying to catch up with him, but against the powerful shore current I didn't know if I would reach him in time. As I paddled, fear welled inside me. I was sure I would see Mike attacked any second. As well, since I might be paddling over the creature, if it attacked me, neither Mike nor anyone else would know.

This, then, would be my fate? To be attacked by some huge sea creature? To disappear into the waters of the Northwest Passage with no one to bear witness, leaving only an upturned kayak? Or else watch a friend's grisly demise, knowing full well it was coming yet unable to prevent it? That image, I already anticipated, would be burned into my memory and remain there to forever haunt me.

Mike knew that feeling too. A few weeks before, soon after we'd been dropped off, I had left him at the campsite to go into the interior to do some painting, telling him roughly where I was headed. He followed a few hours later in that general direction. After walking for about half

an hour, he saw a polar bear hunched over and eating something along a riverbank. Totally panic-stricken, Mike ran back to camp to get the shotgun, thinking the bear had nailed me. When he got to camp I was in the tent finishing my watercolour, having returned to get away from the torment of blackflies. Looking up from my work, I saw the flushed terror on Mike's face dissolve into huge relief when he saw me happily painting in the tent.

Now, practically exhausted, I got close enough to him to get his attention at last. He ceased paddling as I drew near.

"Mike! There's a big... really huge walrus! It's right behind you! It was really focused on you! We need to stay together... right together, and as close as possible to shore."

Mike listened to my frightened, breathless account and, in an infuriatingly relaxed manner, responded with, "Oh, it was probably just a bit curious."

I was in no mood for Mike's "everything is fine" pacifications and angrily told him so. I reminded him of an encounter I had had two summers before. A large rogue walrus had attacked me while I was paddling Buchanan Bay on the northeast coast of Ellesmere Island. The pre-attack behaviour of that walrus was remarkably similar to what I had just witnessed. That walrus had followed us, from behind, watching, huffing, and projecting himself high out of the water before the strike. I had also observed lots of normal walrus behaviour—and it was nothing like that.

Fortunately, the attack at Buchanan Bay had happened while I was in a stable, heavily loaded, foldable tandem. But that had been a soft-covered boat. Although it didn't flip or rip, it easily could have. And when it rammed our boat, we were close to shore, where we could scramble to safety—an escape option that currently was unavailable.

Walruses are formidable. They can weigh more than 1,000 kilograms. Their tusks can grow to a metre in length and the width of a person's wrist. For some reason their normal, docile behaviour is absent in an estimated 15 percent of males, who become aggressive rogues. Since that incident on Buchanan Bay I had done some homework on rogue walrus attacks. I'd talked with an Ottawa sea kayaker who'd had his soft-covered tandem ripped down the middle by a rogue's tusks. Inuit fear them, and even in a steel motorboat they will avoid travelling in walrus-infested waters.

Rogue, etching and chine collé, 24" x 18", 1998

Walruses are normally bottom-feeders, existing on a diet of mussels and clams. With their powerful lungs and their ability to create a partial vacuum in their throat, they suck out the soft innards of mussels and other crustaceans. Rogue walruses, however, develop a taste

for sea mammals, mainly seals, eating their meat, or rather sucking their flesh from their bodies. Rogues are a threat to young polar bears and smaller whales and will even cannibalize young walrus.

I had read many accounts of modern-day kayakers in Greenland who had been attacked by rogue walruses. In one case the rogue had lunged out of the water, grabbed the paddler's head, and pulled him under the water, where he was eaten or sucked to death.

Again, I forcefully impressed on Mike the need to stay much closer together and to travel as near to the shore as possible. We continued on for about an hour with no sign of the walrus.

The midnight sun hung like a Christmas ornament just above the water. The ocean swells had lessened somewhat, but the seas were still too large, and the shore too vertical, for us to land, so we rafted up on the undulating surface to have something to eat. From his kayak's wet cockpit, Mike pulled out some cheese and crackers, two apples, and a little plastic bag of nuts and dried fruit. Drifting backwards in the current, our paddles at rest and Pogies removed, we used our spray skirt covers as a tabletop for our snacks.

While we were eating, and looking out on the open ocean, six metres ahead of us, silhouetted by the sun, positioned for perfect horror-film effect, our stalker's head rose slowly from the other side of the mirror. It came up with its red eyes glaring at us. Through the blazing sunlight it raised its body as high out of the water as it could. It immediately huffed a series of loud, deep-lung exhales, *"HAAAHH…HAAAHH… HAAAAHH…."* The bellowing rumble resonated into my chest.

The contrast at that moment between him and us was staggering. We were nibbling crumbs of damp food with our prune-wrinkled, white-frozen fingers, sitting wet-assed and shivering, wrapped in thermal polyester, polar fleece, Gore-Tex, and assorted vinyl and rubber inside fibreglass tubes.

He, on the other hand, was self-contained and at home. Every aspect of the pinniped's strange-looking form, no matter how uncommon or how unfamiliar to our eyes, was designed to be there where it was. Its leathery skin, three centimetres thick, is regarded as the hardest membrane to penetrate of any creature on earth. Early explorers had watched their musket balls bounce right off walrus hide. Modern hunters use full-metal-jacket bullets to penetrate its skin. Beneath the hide is a layer of blubber more than seven centimetres thick that protects the

inner core from cold, along with a circulatory system that, if necessary, can withdraw heat from the creature's surface without harm. When this happens the normal cinnamon-brown colour of the walrus turns ghostly white.

Each taunting huff sent puffs of vapour out from the sides of the stalker's head. Its warm breath caught the cold air and, backlit by the setting sun, formed circular plumes that floated and glowed above and around the rogue's head. Partway out of the water, its ivory tusks glistened like unsheathed sabres. What was going on behind its small red eyes? Encased somewhere inside the beast's nearly eight-centimetre-thick skull, deep in the recesses of its cranium, neurons were firing off electrical charges, a plethora of aroused chemicals, formulating a plan for God only knew what. Like accused shackled in a prisoner's box, Mike and I awaited our fate.

Then, one final huff, and with its eyes continuing to glare, it reached a decision. It dove, coming straight at us under the water like a one-tonne meat torpedo. I was absolutely certain we were about to be hit. Mike felt the same as he quietly said, "Hold on." We braced the two boats tightly together by cross-lacing our paddles and leaned in toward each other. But nothing happened. We waited for three or four minutes, then quickly packed away our food and continued on, staying as close to shore as we could.

I saw the rogue half an hour later, from a 30-metre distance, once again huffing and projecting itself high out of the water. It was to one side of and slightly behind Mike, glaring at him, as it had done before.

It dove towards Mike as I shouted a warning. We veered our boats even closer to the crashing agitation on shore. That was our last sighting of the rogue.

⁓ψ⁓

We had been granted a reprieve on the water, barely, but reaching land didn't liberate us from danger at all. Polar bears were now appearing in increasing numbers. Biologists estimate that 150 to 200 bears congregate on Bylot's north coast during summer. There was little sea ice left on the Passage, so the island's bear population was at its height. We were averaging ten sightings a day. One day, while we were on a short trek inland, both our kayaks were raked and mauled. The boat's sealed hatches were full of food, but after clawing and chewing assorted stuff

on the kayak's deck and cockpit, the bear or bears decided to move on.

Where to keep our food while sleeping was a big concern. Some experts say that in bear territory you should cook and store food hundreds of metres from where you sleep. Such a precaution might or might not have kept us safer, but it would certainly have produced a recipe for polar bear dinner. Having already gone through the trials of no food, neither one of us liked that option.

We ended up storing the food in the kayaks' hatches at night, with pots and pans piled on top as an alarm system. This was done close enough to our tents to give us a chance to defend our food and prevent our boats from being mauled. During the day, we could no longer hike together inland, as someone needed to stay in camp with the food and boats. We ended up both staying close to camp, since we had only one gun.

Mike hadn't been sleeping well the whole trip, as he was trying to keep semi-alert for bears. A larger group could have deployed rotating guards at night that would have enabled everyone to get at least some sound sleep. With only two of us, that wasn't possible.

The effects were starting to catch up with Mike. One evening, desperate to get a good night's sleep, we jerry-rigged an alarm system of ski poles, paddles and pieces of driftwood stuck in the ground, topped with drinking cups and pots and pans, connected together with rope, in a tight perimeter around our tent. We figured that if a bear came into camp and tripped the rope, it would give us at least a few seconds' warning. The one night that we set up the system, our sleep was forever interrupted by the noise of toppling poles and pots, blown over by strong wind gusts. Before night's end we abandoned our bear alarm system so that we could get some sleep.

For some reason, even though I knew polar bears were wandering around outside, I slept reasonably well. Maybe I was subconsciously relying on Mike to be my alarm clock. But I also felt that trying to stay half awake didn't really accomplish much. Unless you continually got up and looked around outside the tent, you could have no idea if a bear was nearby or not. Inside the tent there was usually too much noise from breaking waves and the sound of the fly or tent ropes flapping in the wind to detect the arrival of a bear. I theorized that whatever came our way, I would deal with it when I awoke. That theory was soon to be tested.

A day after the walrus incident, we landed and camped along a cutaway of a huge escarpment called Maud Bight. It was a wide delta of gravel wash, carved and transported there by a massive glacial river. Above high tide, in the middle of the delta, rested the remains of a 12-metre ship. With its double-hull, oak-planked construction, the wreck looked like an old whaling boat. Sandblasted, splintered, and bleached off-white, its bow sat on a tilt, deep into the shore gravel.

After supper we went for a short hike, climbing a rise of land that still gave us a view of our tent and boats. It was a clear evening with a light wind blowing off the water. The sun was huge and doubly bright, reflecting and shimmering off the sea.

I was walking alone, taking a lower elevation than Mike. Staring across Lancaster Sound through the glare of the sun, I saw what appeared to be a big, dark, square-shaped object one or two kilometres from shore. I had binoculars but still couldn't identify it. I thought at first it might be a bowhead whale, its form distorted by the glare of the setting sun. But the object wasn't moving, and it was too big, the wrong shape, and too high out of the water to be a whale. It remained stationary for ten minutes, then suddenly disappeared.

When I met up with Mike sometime later, he too had seen it and agreed it wasn't a whale. With no other logical explanation, we concluded that we'd seen a nuclear submarine — specifically, the sub's bridge. Since Canada at that time didn't have any operational submarines, we figured it was most likely Americans or Russians invading our sovereign waters.

At night the sun was dropping below the horizon but there was still enough light to read, paint, or do whatever we wanted. That evening, though, we were both dead tired, so we cut short our walk and went to bed early. Uncharacteristically, Mike joined me that night in falling immediately into a deep sleep.

The sound that broke our sleep was loud and very, very close. It was a "WHAM!" — something like an open hand hitting a tabletop really hard. And it was more than sound — it had a vibration that could be felt. Mike and I immediately awoke. I went from totally unconscious to totally aware in a millisecond. The sound didn't linger — it was gone. It was a memory, recalled only through the haze of my last moments of cozy sleep.

My heart was thumping, but what had actually happened? It was perfectly quiet, no wind, no noise, no nothing. The tent was well lit.

We glanced at each other but didn't talk. I didn't dare speak, whisper, or even breathe. I was afraid that anything but silence might unleash the unthinkable.

Maybe it was…My mind, like a Rolodex, started flipping desperately through possibilities, but I couldn't find anything that fit, at least nothing that I liked. Being awoken from a peaceful sleep quite aware that there was a pretty good chance a magnificently huge beast—a three-metre, 700-kilogram carnivore, the most powerful predator that walks the earth—could be moments away from ripping me apart, was an odd sensation. It was something slightly less than full-bore terror, though, since there was no tangible auditory or visual evidence that any threat actually existed. I prayed that the eerie silence would stretch on, but I felt certain that something to the contrary was coming.

Polar bears commonly search out sleeping seals in their winter snow dens. The den might be covered in a roof of snow and ice a metre thick, but the acute sensitivity of the polar bear's olfactory bulb can pick up a seal's scent inside a den from a kilometre away. When the bear senses the precise location of the seal hidden under the snow, it will attempt to break through the roof by clobbering it with a blow from its powerful front paw. If that doesn't work, on all fours and with the force of its weight, the bear will jump up and down on the roof to collapse it and get at the seal.

We weren't seals in a snow den, but the parallels were hard to ignore.

Mike and I were sitting upright, still in our sleeping bags. The loaded shotgun lay where we always placed it, between us, its polished wooden stock and nickel-plated barrel resting on top of the gun's faded canvas case. We were in a yellow two-person North Face dome tent with double door openings. For some reason I had a strong sense that the bear was standing on my side of the tent. There was lots of light outside even though it was 1 a.m., but because of the tent's translucent fly the light was too diffuse to offer silhouettes or shadows.

Mike picked up the shotgun, switched off the safety, and pumped a shell into the firing chamber. On this trip we always had a prearranged cartridge sequence in the magazine with three different shells. The first was a plastic bullet, the second a spray of shot, and the third a lead slug.

Still sitting, half in his sleeping bag, with the rifle in his hands, Mike let out a couple of deep-throated growls. I presumed that was to

indicate to our intruder that we weren't seals. Regardless, the trailing bit of Mike's growl was met with *"KAAWHAAMMM!"*—a deafening, colossal wallop on my side of the tent. The whole tent bounced like a slapped basketball. From the force of the blow, the bear's claws came ripping through, shredding both layers of the tent's nylon wall and fly, just over my knees. The tent stayed upright but the blow had snapped two of its four arching poles.

Mike had the gun at his shoulder aimed over my outstretched legs, but we still couldn't see the polar bear through the sagging, ripped nylon layers. He asked me to unzip the door on my side, to see where he was. It was a worn zipper that I knew needed two hands, one to hold, one to pull. I undid the first zipper but still couldn't see out because the vestibule's zipper was closed.

Sensing that I wasn't keen on prostrating myself at the feet of an annoyed polar bear, Mike told me to forget it. I backed off. He aimed the shotgun above my sleeping bag and pulled the trigger.

"KABAMMM!"

The blast was deafening inside the tiny confines of the dome. The plastic bullet went through both layers of drooping nylon. With my head and ears buzzing from the blast, through a veil of gun smoke I opened the zipper of the vestibule door and saw the bear standing on two legs, three steps away. He looked down at me with his small black eyes, seemingly weighing what happened and what to do next.

Mike pumped the second cartridge into the firing chamber and asked if the bear was hit. I said I couldn't tell. He asked about blood. I reported there wasn't any.

The bear very slowly backed up, clearly in no hurry. He kept his head and his eyes turned back to me, trying to decide whether to stay or go. We climbed out of the tent shouting, puffing out our chests and swinging our arms, giving our best caveman impression, trying to encourage his departure. He was large—a big adolescent male. While regarding us, he regularly opened and stretched his lower jaw as if yawning—a typical display of stress.

Then he turned his back to us and slowly walked west along the shore. He started crossing the delta, but every few minutes he would stop and look back. With binoculars, we watched him climb up the high cliff at the far end of the river basin. He then lay down to sleep on a knoll of grass about three-quarters of a kilometre away.

Ursa Major & the String Theory, oil on canvas, 23" x 34", 2001

Considering that polar bears are large, fearsome, and highly curious meat-eating machines, surprisingly few fatal attacks on humans have been documented. The reasons for this are several. Very few people dwell in their immense habitat; also, their normal food source is plentiful and far removed from where humans go. Also, travellers in the Arctic inevitably carry guns, and polar bears have come to associate humans with them. Over the years, thousands of polar bears have been killed preemptively, shot when they wander into hunting and research camps.

Thinking back on it, it's quite likely that if we hadn't had a gun we would have both been killed. And if we hadn't had rubber bullets the bear would probably have died.

The sky had turned a sunless grey, with a bone-chilling wind starting to build off the water. We got out some needles and thread and huddled outside for the next few hours, sewing up the multiple rips in the tent and fly. We felt no hurry to get back to sleep.

Mike had brought extra tent pole lengths, which we lashed like splints to the broken ones. When he brought out the two extra pole sections, he lamented that there were now only two more spare poles

left. I didn't respond, but his words kept playing in my mind: "Only two extra poles...*left*?" I slowly came to realize that such a statement could only be made by someone who anticipated not only being attacked, but being repeatedly attacked.

The following morning Mike made one of his regular satellite calls to Pond. He gave the support person our location and a quick account of what had happened, saying that we were both fine and, despite the risks, were continuing on. Undoubtedly, word of the attack spread quickly through the town. I figured the incident would neatly dovetail into what the people of Pond were already thinking regarding our circumnavigation: hand-hauling a loaded *komatik* 130 kilometres across deteriorating sea ice, a coastguard rescue, a wife abandoning the expedition, running out of food, and now a polar bear attack. I doubted that anyone in Pond would have been the least bit surprised if Mike and I were never heard from again.

<center>~</center>

People die in all manner of ways. Some are foreseen; some are unexpected; some are tragic, violent, prolonged, or peaceful. The precise ways people die affect us in very different ways. Death by wild animal attack is probably the most gripping and shocking. In normal life, the chances of this happening are statistically as close to zero as you can get. Yet it remains a universally held dread. When it does happen, when bears, tigers, cougars, sharks, or crocodiles prey on humans, it is often deemed internationally newsworthy. The reason, I think, is not just because it is so rare. It is an occurrence so terrifying, and so full of visceral horror, that it must be part of our primeval past. Even though it is now an extreme rarity, we still need to hear, tell, and retell these stories just as we did when we were huddled around an open fire on the Serengeti, 50,000 years ago. Somewhere in our DNA, we still carry the memory of that knife-edged existence, when humans were part of the food chain—commonly the predator, commonly the prey.

My experiences on Bylot gave me a small taste of how that anxiety must have preoccupied our ancestors. Today, people are all but exempt from being killed and eaten by animals. Having spent a lifetime accustomed to that status, I wasn't about to volunteer to give it up. Yet here I was.

Perhaps now it is only in war that humans know what it's like to be routinely hunted. At times, travelling the north coast of Bylot, I felt

I had enlisted myself to fight in a guerilla insurgency and was now outnumbered, ill-trained, and carrying inadequate weaponry. I was in unfamiliar territory, the enemy's home field. Awake or asleep, on land or water, day or night, you could be attacked. Your living flesh could be gnawed off your bones while on land or sucked from your body on water. Between the two, I was more fearful on water. Perhaps it was the unknown, the inability to see or tell if or when it was coming. From a kayak there is absolutely no defence. And quite apart from what designs the walrus has on you, humans once dunked don't fare well in ice-cold water. On land, at least you have the ability to see danger coming (except when asleep) and a gun to defend yourself.

Of course, I felt a high degree of unease with either scenario.

Among the Dorset artifacts that have been found, the polar bear is the most commonly depicted animal. Even within their mystical, animistic culture, the Dorset's relationship with the bear was unique. It is clear that the bear occupied a special place of respect and honour above and beyond all other animals. Perhaps, for them, it was a deity.

Some of the reasons for the bear's high regard are obvious. It is the most powerful predator in the Arctic or anywhere else, at the very top of the terrestrial food chain. Both the polar bear and the Dorset were hunters of meat, with almost no other predators except each other. And visually, skinned, a polar bear looks remarkably human. Once killed, the Dorset fashioned the hide into pant coverings, fur side out—merging themselves with the bear.

The Dorset saw the bear as bestowed with a variety of powers and abilities. Sometimes in their carvings it was depicted flying, as if the bear had been granted passage to come and go freely into other worlds. Many times they carved only the head, to be worn as an amulet—a defence against evil or harm.

The demise of the Dorset culture 1,000 years ago coincided with a rapidly warming climate. That same temperature shift enabled the Thule, who had technologies better suited to a warmer climate, to enter the eastern polar region and spread west, replacing the Dorset people from Alaska to Greenland. The era leading up to the decline of the Dorset people is referred to as the Late Dorset period. During this period there was a sharp increase in the number of carvings; also,

the polar bear came to predominate as their subject matter. When the Dorset found their world buffeted by a changing climate and threatened by invading groups, it was the Arctic bear they turned to for help.

The polar bear was able to adapt to the rapid warming, but it couldn't save the Dorset people, who quickly dispersed in the wake of the Thule advance and vanished from the Arctic.

Like the Dorset, we too have built a mythological aura around the polar bear. They are viewed in an assortment of ways—as unpredictable, as cute and friendly, as dangerous and powerful. People the world over now see the bear as more than a motif on a coat of arms or as a cute cartoon pitchman for soft-drink companies. Perhaps nothing else conveys our world's warming climate and its ramifications better than this single image: a polar bear standing on an isolated piece of melting sea ice. The bear has come to represent our own instability on this planet—a bellwether for an uncertain future. The underlying corollary seems to be that if the polar bear is in trouble, so are we.

My earliest Arctic work hadn't really depicted polar bears at all. I simply hadn't had encounters with them. That changed after the two Bylot Island trips. The way the Dorset viewed the bear, and how that view was reflected in their art, combined with my own encounters, offered me references to the polar bear that veered my work away from depictions of wildlife and towards a more personal cultural mythology.

〜

Mike had brought a small Canadian flag, which he planted in the ground by our kayaks wherever we camped. It was his personal contribution to Canada's claim to sovereignty over the waters of the Northwest Passage. Now that the Arctic is warming rapidly, the issue of who owns the Passage has been coming to a head in Ottawa. The possibility of navigable Arctic sea lanes and of access to undersea reserves of oil, gas, and minerals has spurred other nations to question Canada's sovereignty over the Passage and its surrounding waters. After we sighted the foreign sub, Mike's little flag took on a little added measure of significance.

At one campsite, I made a drawing of Mike's flag plunked to the left of my kayak with the Passage in the background and a large iceberg that had grounded offshore. While I was drawing, a magnificent male polar bear sauntered along the shore towards the boat. I called Mike and, as per usual, we scrambled to uncase both rifle and cameras. The

bear came up to my kayak, then paused and calmly sat down on the shore directly behind the cockpit. It sat there for a few minutes, taking in the kayak's odours and perusing the vicinity, seemingly unconcerned about us. I took a photograph of the bear in profile, looking as if it was sitting right in the boat ready to paddle.

Back in my studio I did a large canvas of that scene. *Northwest Passage* would be the last oil I painted of the Arctic.

Because of the ice and wind delays, time had run out for me on Bylot. I had an exhibition opening in the south that I had to get back for. Mike had notified his brother by phone, and he flew into our camp from Pond Inlet by Twin Otter to be my replacement. He and Mike continued, successfully completing the circumnavigation of Bylot Island two weeks later.

I was sad to leave. Not because I had any need or desire to complete the circumnavigation, but because I was going to miss sharing with Mike the discoveries and adventures that we encountered on every kilometre of that coast. But as remarkable and amazing as the trip had been, I was exhausted—physically, but mentally even more so. I was tired of worrying about our safety. When I look back and assess the trip, particularly during the last few weeks, I can't help but conclude that sleep deprivation and mental exhaustion greatly compounded all the other dangers.

Remarkably, my return flight carried six more paying sightseers, people from Pond Inlet who wanted to see the northern coast of Bylot. One of the passengers was the wife of an RCMP officer stationed in Pond. She had brought her eleven-year-old daughter, Raven. We talked together on the flight back to Pond about the expedition, the bears, murres, owls, walruses, falcons, and so on. The officer's wife asked if I would like to stay with them in Pond instead of in the hotel. I thanked her and said yes, I would.

At their home in Pond Inlet, the town water truck had just filled their holding tank, so I was able to shower as a load of my laundry washed. After I'd showered, she lent me some of her husband's clean clothes and presented me with a cold beer and a heaping plate of food. I dined by their picture window, which looked out over Eclipse Sound. Its icy surface was slashed with the reflective glare from the hundred melting ponds, pools, leads, and channels of late summer. Beyond the ribbons of ice, Bylot loomed out of the water, its glaciers draped around its peaks and bulwarks like a pile of white scarves. The island sat alone,

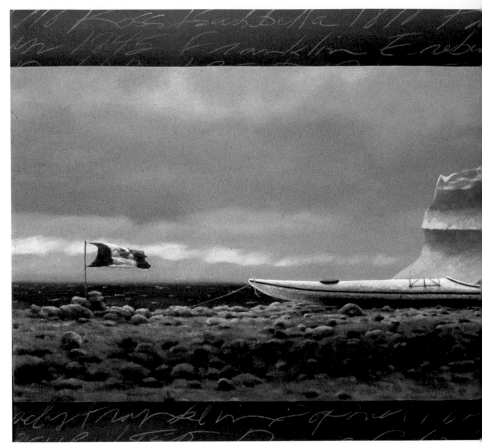

Northwest Passage, oil on canvas, 24" x 54", 2001

unmoved and undisturbed by the comings and goings of the world, a defiant place in a perpetual state of wild.

While I was relaxing in the living room, the phone rang. I overheard my host's side of the conversation in the next room.

"Hello."

"Just got in a little while ago."

"Yeah, it was…a really fantastic flight. Raven enjoyed it too."

"One of the guys came back on the flight, and he's staying with us tonight."

"Yeah…One of the crazy guys."

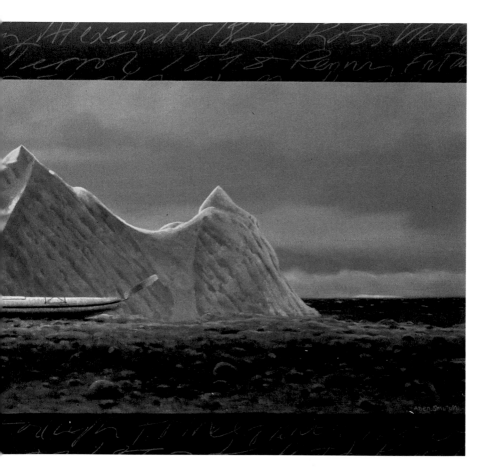

I couldn't really disagree with that assessment, which undoubtedly reflected the thinking of the entire town. I'd thought the trip was dangerous too, but my perspective had conveniently shifted so as to place the perils under the rubric of what is commonly referred to as "manageable risk." Looking back, the Bylot trips were among the most memorable of my fifteen years travelling in the Arctic. Yet it's not something I would do again, nor would I recommend it to anyone.

From my experience on the island, and from what I know of Canada's national park system, it is hard to imagine how Bylot will actually function as a national park. How will park officials ensure visitors' safety? The protection of wilderness and of the animals therein is of

course an appropriate goal for a national park. The maintenance of a healthy and vital summer population of walruses and polar bears naturally fits that mandate. I assume that a diet of tourists isn't part of Parks Canada's polar bear and rogue walrus food supplement plan.

Going online to check the status of the park and to see what kind of use and access was being recommended for visitors, I found the following:

IMPORTANT NOTICE

Parks Canada / Federal Government rules and regulations limit our ability to provide adequate safety precautions and measures. Entry into, use of, and travel within Sirmilik National Park have been officially designated, by Parks Canada, as hazardous activities.

IX

VARANASI, 2010

The man who stole the water
Will swim for evermore
But he'll never reach the land
On that golden shore
That faint white light
Will haunt his heart
'Till he's only a memory
Lost in the dark
—Danny O'Keefe and Bob Dylan,
"Well, Well, Well"

The dim light of predawn hadn't yet stirred the city, its pilgrims, or its car horns. The eye-catching *sadhus*, the lime-coloured parrots, the swirling kites, the clothes washers, and the langur monkeys had yet to appear. Across the river, the sun, like a quiet ember, squinted through a grey horizon.

The only sign of movement was along the riverfront: three men, silhouetted against the river's dull sheen, carried a body wrapped in white linen. Awaiting the cargo was a man in a small wooden boat. At the mooring, the men entered the water and lifted and carefully laid the body across the bow. Stiff with rigor mortis, the corpse's head and legs extended out over the sides. With the three men aboard, the

boatman leaned forward and pulled back on the oars. Against the river's low illumination and the double-ended boat, the white shroud glowed as if internally lit.

Bamboo oars rubbing against heavy twine stirrups, the lapping of water against a wooden hull, and the distant cries of seagulls were the only sounds to be heard. If the four men were talking, it was in whispers.

One hundred metres out, less than a quarter of the way across the river, the rowing ceased and the oars were swung onto the boat. As the vessel drifted slowly in the current, the men stood and turned their attention to their cargo. Together they lifted and pushed the remains, feet first, off the bow. The body entered diagonally with a loud splash. Within a second it had lost buoyancy and disappeared. The surrounding water quickly flattened and resumed its reflective nature.

Along a large city's waterway anywhere else, an offence would have just been committed and the authorities would have been called. A list of charges would likely have been filed, prosecutors assigned, court dates set, perhaps requests for psychiatric tests issued, and a community duly horrified. But not here.

This was Varanasi, where the eternal light of Shiva intersects the earth. And this was the Ganges, the daughter of Vedas, where salvation of the soul is granted.

<center>⌇</center>

The past forty years—all of my professional life—I've gone to remote places for my work. Inevitably, all of the locales have had two things in common: large doses of wilderness and small numbers of people. I'm not sure why I have repeatedly sought out those places. Perhaps I have been looking for a place of balance, where natural forces act as governors over human ambition. Or maybe I have been looking for an escape from normality.

Wilderness milieux have long seemed to suit me, yet over the past few years I have begun to consider another path. What if I went the other way, to the other extreme, towards what I had avoided—an environment dominated, if not overwhelmed, by people?

The prospect of working on the Ganges, in one of the most populous countries on Earth, was for me as unnerving as camping among hungry polar bears. Yet somehow Varanasi had attracted me long before I came. It was a car-wreck kind of fascination. Among other things, I

Bathing, watercolour, 16" x 8.5", 2011

wondered how a waterway could in one particular place be sanctified, pure and godlike, in the eyes of a billion people, yet at the same time visually and analytically be the filthiest place on earth.

The Ganges — or Mother Ganga, as it's called in India — flows from its Himalayan headwaters southeastward to the Bay of Bengal. Along its winding route, it supports 430 million people, roughly the same population of the entire North American continent. Halfway along its 2,500 kilometres is Varanasi, a city of three million people. It lies in the southeastern corner of Uttar Pradesh, the most populous state in India. This one state holds two-thirds the population of the United States but is only 2.5 percent of its size.

To get to Varanasi from Delhi, I hired a taxi and embarked on a 1,000-kilometre journey through Madhya Pradesh, Bihar, and Uttar Pradesh, which are the three poorest states in India. I had planned for a four-day drive, but referring to it as a "drive" is a bit of a misnomer — like referring to Russian roulette as target practice. Nine years of being taxied through the streets of Delhi — with similar annual trips covering 1,000 kilometres of hairpin, Himalayan switchback roads — hadn't remotely prepared me for the vehicular terror of those four days.

Imagine diverting an expressway's traffic — all the eighteen-wheelers, all the buses, vans, cars, jeeps, trucks, and motorcycles — onto a single-lane road. Then add a similar heap of congestion coming the other way. Into any bits of open and surrounding space, densely jam auto-rickshaws (called *tuk-tuks*), pedestrians, dogs, pigs, herds of sheep and goats, tractors, camels, bicycles, rickshaws, donkeys, horses, oxen, and water buffalo. Then here and there remove huge hunks of road, along with stop signs, streetlights, stoplights, and all other traffic safety devices. Now, in the middle of the road add the occasional broken-down truck and lots of very relaxed, stationary cows. Then combine all of that with alignment-destroying speed bumps that are unmarked and placed randomly where no one expects. Finally, have half of the drivers on the road vying for an opening on a Formula One racing team. That was the vehicular landscape, the obstacle course, the real-life video game played out on the roads east of Delhi — and undoubtedly on similar Indian roadways — every day.

My driver's name was Rajeev, a turbanless Sikh in his mid-twenties who had been raised in the Punjab. As a driver, he was both aggressive and amazing. Amazing in that he was still alive. He proudly claimed

to have had only one major accident in four years of driving a taxi. He took great pride in the multitude of scrape marks on his car's dented white panels—a complete paint-coloured near-collision diary of his professional career.

In India, "rules of the road" have been replaced with what I would call the "code of the road." For example, the centre white line (when there is one) serves no real purpose. Passing occurs anytime, anywhere, on either side of slower-moving vehicles, whether there is room to pass or not. The expectation is that oncoming traffic will slow down or move off the road in time to avoid a head-on collision. This road-claiming authority is tempered only by the size of the oncoming vehicle, so big trucks go where they want and when they want—little cars, not so much. The horn and flashing headlights communicate each driver's intent to the others.

The notable exception to "here I come, get out of the way" arises when cows, pigs, sheep, and goats are on the road. Hitting one of these results in the driver having to pay compensation to the animal's owner, which can amount to tens of thousands of rupees (forty-five rupees equals one dollar). Although pigs, sheep, and goats gradually scurry off the road at the blast of a horn, cows feel no such compulsion. Somehow they have all totally grasped their deity status. Unfortunately, dogs seem to have patterned their road behaviour on that of cows, not understanding that being four-legged with a tail in India doesn't automatically qualify you as a god. No owner compensation needs be paid for hitting dogs. Their bloody carcasses litter the road.

In the villages, towns, and cities, all of this chaotic terror spilled onto the road shoulders with an added level of anarchy. This ten-metre no man's land was used as a roadway when drivers were not deterred by parked cars and motorcycles, broken-down trucks, and abandoned *tuk-tuks*, and by women balancing pots of water on their heads, wandering children in school uniforms, food stalls, little tykes crapping at the road edge, vegetable selling, furniture making, tailoring, barbering, welding, clothes washing, tire repairing, or simply crowds and crowds of people.

The visual cacophony was accompanied by constant noise: horns honking, engines revving, buses rattling, and the metal-on-metal screech of truck brakes. In urban areas, the burning of eyes and throats got worse as the concentration of spewed diesel exhaust grew higher. (Allowable car emissions in India are two hundred times those of

Europe.) And since this wasn't the monsoon season, there was usually a blizzard of wind- and truck-whipped dust.

Rajeev smoked unfiltered cigarettes while driving. That didn't help the car's air quality, but I didn't say anything. I figured I'd be smoking too if I drove on those roads. Rajeev's driving and our numerous near-death experiences had left me a nervous wreck. I found myself constantly clench-jawed and squeezing the overhead handrail with white-knuckled intent. On the third day the tension started to manifest itself in the cramping and knotting of my shoulders and back muscles. A couple of times I broached the subject of his driving style. In broken English, Rajeev told me he was a good driver and denied being too aggressive. I countered, saying that we'd passed a thousand cars for every one that had passed us. Rajeev took that as a compliment. It became obvious that attempts to modify his driving would be like trying to teach a whippet to run slow.

But even Rajeev had his limits. He admitted that he was afraid to drive at night because the roads were simply too dangerous. Given the multitude of things on the road and the lack of visibility, nighttime driving would have been autocide. But Rajeev was referring to something else. Among the taxi drivers, it was common knowledge that after dark, on the rural roads in the northeastern states, you could be stopped and killed for a hundred rupees.

We came across numerous pileups along the way, many of which involved transport trucks. Rajeev was quick to point out that truck drivers were notorious for driving drunk and falling asleep, something he assured me he wouldn't do. The implied corollary: *Be thankful I'm your driver*.

Statistically, Indian roads are among the most dangerous in the world. Every three and a half minutes, someone dies in a vehicle collision. Regardless, I had little choice but to count down the kilometres to Varanasi, where I would be released from my car-passenger nightmare. I tried to remember that, apart from a witnessed handful of accidents, everyone seemed to get be getting where they were going. On the other hand, I really couldn't see how anyone could drive those roads on a daily basis and live past the age of thirty-five.

But it wasn't just the traffic mayhem, the close calls, and the choking air that assaulted me—so did the view from the road. In many areas, the land had been utterly degraded. Where there was water, it had

been fouled with fecal matter and garbage. Along our route, the towns especially generated garbage. With no garbage containers anywhere, all refuse sat where it had been dropped or blown. Sometimes it had been swept into small piles that sometimes, somehow, joined bigger piles. The larger piles then morphed into giant, sprawling mounds that got grander towards the edge of each town.

Everywhere we travelled, masses of people were standing and waiting near the roadside. Of India's prowess in information technology—the much-touted success stories of Gurgaon, Bangalore, and Mumbai—and of India's blossoming middle class, there were no traces. Where was the economic engine of the Subcontinent that everyone talked about? What I saw instead were people who were being used when needed and forgotten when they weren't—the compost of a rising state. When there was work, they could expect to be paid less than a dollar a day. For many, home was under a blanket. Three-quarters of a nation's people had been left hobbled at the starting gate. India's caste system—a societal stratification with each layer having its defined boundaries—has been officially declared both antiquated and illegal; but in reality it remains ubiquitous throughout much of the country. What I was seeing along those roads was changing me. Its weight was pulling me down.

During the final day of the drive to Varanasi, Rajeev had stopped in a town to buy some smokes at a truck stop. I had gotten out to stretch against the car's passenger door when a huge truck came rolling up. At that moment a very young puppy scampered out from under our car and aimlessly wobbled towards the path of the truck's front tire. The driver was too high up and too close to see the puppy. The truck appeared to be stopping, but the rig's metre-high wheels kept very slowly rolling forward. The puppy, barely old enough to walk, sat down in the tire's path and looked up at me. I couldn't tell if or where the truck would halt—would it stop in time? Also, I wasn't sure if the wheel's path would run directly over the whole puppy, or part of the puppy, or just miss it. This all happened in two or three seconds, so I didn't have time to grab the dog without risking getting hit myself, and I didn't want to shoo it away and risk scaring the dog back into the tire's path. I watched the front tire roll, in slow motion, just brushing the fuzzy little hairs on the side of the puppy's belly, sending whiffs of dust around the little dog. The double wheels at the rear of the cab were next, but they stopped before reaching the dog. The puppy wobbled

backwards and relaxed near the underside of a tire, as if it were its mother. I tried to grab the dog, but it scampered under the truck's undercarriage.

Exhaling long, I got back in the car and closed my eyes; I'd seen enough. I was in need of a primal scream or a stiff drink, or both. The puppy, of course, had no idea what had almost happened. The incident had taught it nothing.

If I needed a stiff drink after the puppy incident, I needed the whole bottle a few hours later when we entered the unrelenting mayhem of Varanasi. The roads there were essentially moving parking lots, with the addition of the pre-mentioned camels, horses, donkeys, dogs, pedestrians, rickshaws, bicycles, and vendors, and, of course, the ever-present blissed-out cattle.

The moving theatre surrounding me was well beyond bizarre. I counted twenty people piled into and onto and hanging off one three-wheeled *tuk-tuk*. Some people pedalled bicycles without hands, some moved on trolleys without legs. The road was so full that its surface couldn't be seen. Most everybody seemed to have great quantities of stuff that they were hauling, carting, peddling, carrying, pushing, or pulling somewhere. It was the apotheosis of saturated humanity. Yet incredibly, the congregate never stood still. Everything, in fits and starts and tiny increments, kept jostling onward.

The streets were a molten flow—melding, separating, and re-forming as if part of one great tentacled matrix of bone and muscle, alloyed steel, glass, rubber, and polymer fibre. When the moving mass intersected other lanes, it was often without benefit of traffic authorities, stoplights, or stop signs. No inch was given, and no inch was not taken. Actually, inch is too generous–centimetre would be more accurate. I could read the second hand on the wristwatch of a motorcyclist's throttle hand through my side window.

As we jostled for position, a rickshaw scraped our side mirror just as our bumper pushed against a pedestrian's leg. Rajeev hit the brakes and cursed the rickshaw driver and the pedestrian. Road peddlers and beggars saw their chance. Cheap stuff jammed the window glass, while others with hollowed eyes pleaded with empty palms. Through it all, Rajeev, like every other driver, kept his hand on the horn non-stop.

In the heat of late afternoon, we pulled over in front of Varanasi's bus station and waited for a local guide, who was scheduled to meet

us there. I had a room booked in a hotel on the Ganges, but we didn't know where it was. Finding it was complicated because there was no street or car access to the hotels, guest houses, or anything else along the river.

After fifteen minutes a guy looking to be in his mid-twenties, with wrap-around sunglasses and a surplus of hair gel, fishtailed his Honda Hero motorcycle to a halt beside us. He revved its engine and shouted over the cacophony for us to follow him. With that, he did an abrupt U-turn across six lanes of cheek-to-jowl traffic and disappeared in the other direction.

My driver, completely unflustered, followed suit, to the sound of slamming brakes, screeching tires, and an added blaring of horns. With dilated eyes, I looked over at Rajeev. He was in a zone—at last, unshackled, he could finally use his considerable skills. He followed the bike as it zigzagged through the clogged city. Most of the time, when we could see him, the driver rode with one hand on the throttle and the other holding a cellphone to his ear, darting in and out of traffic and glancing back to see where we were. He and we almost hit so many things I simply had to give up caring. The whole thing had a sort of surreal familiarity. Yes, I had seen this before, multiple times—those movie chase sequences that don't end well.

At last the motorcycle led us to a dead-end street, where we parked the taxi and proceeded on foot with all my stuff, following the motorcycle through a skein of dark and winding alleyways called *galis*. The passageways were one to three metres wide: broad enough for motorcycles, pedestrians, processions of mourners bearing corpses, bicycles, rickshaws, and scores of pigs and dogs. This labyrinth was the old city's underbelly, occupying a half-kilometre belt along the river.

I sidestepped dozens of stocky pigs rooting through food waste (often raining down from the windows and balconies overhead) and other refuse that lay everywhere on the damp, uneven cobblestones. I felt as if I had entered fifteenth-century London, or a scene from *Blade Runner* or *Mad Max: Beyond Thunderdome*. Slicks of pungent urine, fresh cow-pies the size of double-layer cakes, and more moderately sized animal droppings implored us to keep our eyes on the ground and jump from one dry spot to another. In the stampede of feet, hooves, and rolling wheels, however, the ground's surface was mostly fouled with tar-like muck. Keeping one's shoes unsoiled was ultimately a futile

Morning Tea, mixed media, 14" x 16.5", 2010

notion. It brought to mind what the British writer Geoff Dyer wrote about Varanasi when he first arrived. In his book *Jeff in Venice, Death in Varanasi*, he describes the dirtiness as "concentrated filth, pure filth, filth with no impurities."

Fronting most of these ancient-looking lanes were tiny stores offering a consumer buffet of sit-down food, silk and cashmere garments, sitar lessons, tailored clothing (little sweatshops), hand-rolled cigarettes, marigold garlands, souvenirs, perfumes and essences, quick-fried foods, and small shrines for those in need of prayer. Most of the shines depicted an indistinguishable, orange, blob-like presence that turned out to be, more often than not, Hanuman, the monkey god, one of the more important of many thousands of Hindu divinities.

We proceeded into a secondary alleyway, up a couple of steps, and through a dark stone tunnel, where three enormous grey-white cows plugged the width. As I stepped over and around those bovine beasts,

I puzzled over how, in the middle of a city, they could attain such massive girth on a diet of garbage and plastic.

My hotel's actual layout, like most things in Varanasi, was hard to fully grasp. In its centre grew a huge banyan tree, which seemed to have directed where the rooms, balconies, and hallways were placed. I was ushered to my room down a narrow, twisting corridor painted a dirty turquoise. Given the entryway of cows, garbage, shit, and a banyan tree, I was in a state of trepidation and second-guessing, having booked my room, sight unseen, for a week-long stay. That feeling vanished instantly the second my room door opened.

The room was the upper portion of a three-and-a-half-metre-wide turret that was a perfect octagon shape. It was seven metres above, and right on, the Ganges. It had a four-metre-high domed ceiling with a windowed door leading to a narrow balcony that wrapped around the front half of the tower. Flanking the door were two windows, which gave a panoramic and unobstructed 180-degree view of the river. The windows, and the walls' peeling palimpsest of cream-coloured paints with an arched ceiling, bathed the room in warm, beautiful light.

That room was as fabulous and dream-like as the previous four days had been nightmarish. Held high in the palm of that Mughal-looking construct, in the glow of the Ganges, mixed with the ambient sounds of birds, monkeys, and children, I could feel the stresses and anxieties of the road trip evaporate, as if a sedative had just hit my bloodstream. I joyously bade farewell to my taxi driver and my motorcycle guide, but not before the guide told me he had arranged an early-morning boat ride for me. He said I needed to pay him 450 rupees for the one-hour ride. The price sounded high to me, but I handed him a 500-rupee bill, which he didn't have change for. (I later found out that the normal hourly rate was 150 rupees, easily bargained down to 100.)

The ambience of Varanasi, there along the Ganges, was, as advertised, truly amazing. While standing in my room, in some unexplainable way, I saw the reason for the ascendancy of this city. I felt oddly at home there—perhaps the room set the tone (even though it had a large resident reptile in the bathroom, rat-like rodents in the hallway, a door that didn't lock from the inside, and large, romping monkeys sharing my balcony). From that minaret-like room, I spent the following week

observing the most bizarre and captivating amalgam of water-based activities and rituals imaginable.

Varanasi, known at various times as Benares and Kashi, claims to be one of the world's oldest cities. Its history amounts to a repetitive cycle of conquerors looting and destroying, then rebuilding. Although its buildings ooze with antiquity, few of them are more than a couple of hundred years old.

One of the city's great oddities is that all of its buildings and its residents are jammed along the west bank of the Ganges. The east bank, only 600 metres away, is a huge gravel-spit of utter emptiness. It is as if the city had been ripped in half, like a piece of paper, along the river, and half of it thrown away. Symbolically, Hindus view the empty shore of this sacred city as a destination, where the release from the painful cycle of life and death is to be found. To me, it did look otherworldly—but in a post-nuclear kind of way.

The focal point of Varanasi is a four-kilometre stretch of continuous steps, or *ghats*, on the Ganges's west bank. Each of the eighty or so *ghats* has its own name, which is sometimes painted on the buildings it fronts. Each *ghat* is distinctive with respect to width, length, orientation, and use.

Exactly how and when the city became the Ganges's, if not all of India's, most auspicious place is hard to ascertain, but it goes way back. From time immemorial, pilgrims—most of them Hindus—have journeyed or been carried there to die, to be cremated, or to wash a lifetime of sins away. Hindu cosmology sees Varanasi as the centre of the Earth. Other faiths, too, regard Varanasi as auspicious. It is where Parshvanatha, the ninth-century BCE Janis leader, gained "enlightenment." And Buddhists say it is where Lord Buddha gave his first sermon.

The best-known *ghats* are the two that burn bodies: Manikarnika, the larger site, and Harishchandra, two kilometres to the south. These *ghats* burn twenty-four-seven, with the bigger site having a dozen or more pyres going at a time. Dawn and dusk are the most favoured times for the curious to view the open-air cremations. One can do that either from the water, by hiring a boatman and his rowboat, or from land, simply by walking to one of the sites.

At night from the water, the dim lights of the ancient-looking skyline backdrop the leaping flames and rising smoke of multiple fires and veil the city in an archaic narrative. Surrounding the fires, workers and watchers, mourners and hustlers trample ground covered with ash,

pools of water, charcoal, discarded shrouds and bamboo stretchers, wood bits and shushed marigolds. Here and there, pigeons, chickens, and cows pick through the debris while dogs sleep near the warmth of the pyres. Contrasting with the fervid activity on shore, dozens of lit candles cupped in flower corsages twinkle like stars as they float on the river's darkness. The little candles come from the hands of pilgrims; they have been released to gain extra karma.

The open-air burnings are wood-fired; it is said that the natural fuel source gives a better send-off for the cremated. A small flotilla of boats is kept busy hauling hardwood timber from 300 kilometres away. It takes 20 kilograms of wood to burn a body, so men are constantly off-loading and shouldering it and stacking it in huge piles.

Backdropping the fires and the woodpiles at the Manikarnika *ghat* is a haunting skyline. At its centre are two buildings with glass-less windows, the tallest of which has a smashed, British-looking, roman-numeral clock set in its top gable. I was told that the buildings were hospices, where the dying come and wait. First-time tourists to the site inevitably get approached for a personal tour. The guides claim to be caring for the dying and ask for donations in aid of the hospice. That is just one of a host of approaches used by touts to get money from trusting people — to be used for who knows what.

The burning ceremony starts with the mourners carrying the body, wrapped in an iridescent gold and red material, on a stretcher to the water, where it is briefly immersed in the river. After drying on the shore for a while, the garlanded corpse is placed on top of a couple of rows of cross-stacked wood, feet facing the river. More rows of wood are then placed on top of the body. All of the cremators are from the lowest caste. Only untouchables handle the body and tend the fire. Usually a loved one ignites the pyre, and within minutes the corpse is engulfed in four-metre-high flames. The burners claim that nothing but fine ash and a few bones are left of the bodies after cremation, and to me that seemed to be mostly the case. After the burning, most of the ashes are released into the river, by the family. Bringing a person's ashes to Varanasi to be released in the Ganges, even if it wasn't cremated there, is also a common practice. That was the case with Beatle George Harrison's ashes.

Some Indian families can't afford the 6,000 rupees that a cremation costs but desperately want their loved one to attain eternal life. Twice

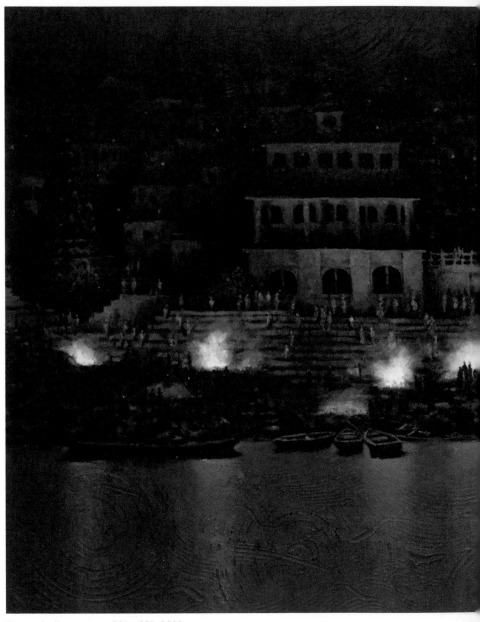

Varanasi, oil on canvas, 30" x 60", 2011

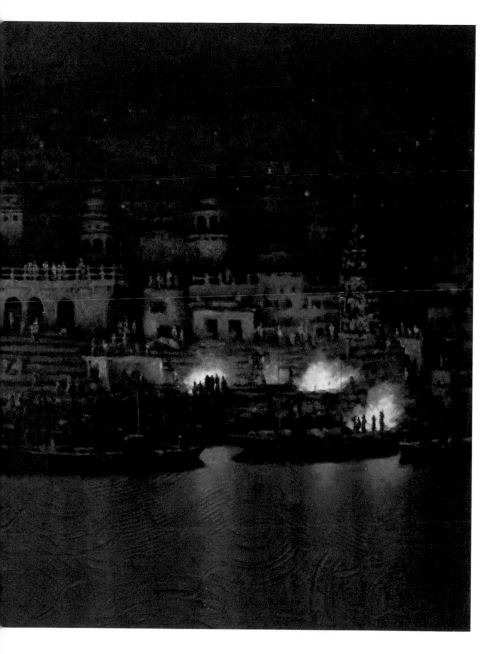

I saw a corpse released directly into the river, without cremation. The number of corpses released annually into the Ganges at Varanasi is estimated in the thousands.

No photography is allowed, either of the corpses or of the burnings. That is an unwritten rule enforced by the burners, wood haulers, and boatmen. But after being around the burning *ghats* for a few days, I was approached by a number of those same people, who told me that for a few hundred rupees, permission to take a photo could be granted (along with anything else I desired).

<center>⁓</center>

My room was midway between the two burning *ghats*, each about a kilometre away. I concentrated on getting to know that two-kilometre stretch of the Ganges.

The rooms and flats that flanked mine, and that were on the water, were not rented out to tourists, as one would expect. More often than not they were home to the working poor, with their unclothed tykes running around among lines of balcony-hanging laundry.

At the Dhobi *ghat*, a short distance to the south, every morning saw a dozen or more launderers knee-deep in the river, walloping clothes and sheets against flat, partly submerged rocks. The washing and rinsing went on until mid-afternoon, by which time a colourful land-quilt of sheets and garments lay drying on the ground along a 60-metre swath of the *ghats*.

The dried laundry was picked up in the late afternoon before herds of big jet-black water buffalo came to the same *ghats* to swim, drink, and be washed. The huge quantities of dung left behind (that weren't released into the river) were gathered as marketable fuel by a few older people, helped by children. They formed the soft dung into hamburger-sized shapes that slowly dried in neat rows just south of the clothes-drying area. At first, I scoffed at the practice of washing clothes in filthy water and then drying them on dirty steps until I realized that the sheets I was sleeping between had undoubtedly been serviced that way.

Each morning I was greeted with the sun's rays coming across the river directly through my balcony door and windows. Each day started with the same rhythm—a quiet and smoky dawn gradually giving way to the sounds and energy of light and life along the river. By late morning the sun and the updrafts off the water had only partly diminished

the thick haze. As the day progressed, scores of insect-feeding swallows and hundreds and hundreds of small, colourful square kites danced and darted high over the Ganges and the city. Mostly the kites mimicked the swallows until, like kamikaze pilots, they plunged to their end or floated helplessly down into the river or the cityscape. Tangled fishing lines and snared kites were draped and wrapped around every pole, electric wire, and building protrusion.

Apart from flying kites, playing cricket seemed to be the chief passion of Varanasi kids and young men. With no flat, open areas anywhere, the *ghat* steps sufficed as the cricket grounds. Strolling tourists and pilgrims, the river, moored boats, and wandering cows and water buffalo were all within the field of play.

The Varanasi *ghats* drew large, international crowds. Most of the pilgrims were Indian, but some were from Africa, the Middle East, the Caribbean, and South Asia. Tourists, although outnumbered by the pilgrims, were there too: from North America, Europe, Japan, and Oceania.

The site's reputation had caught the attention of others. Four days before I arrived, an Islamist group called the Indian Mujahideen had planted a bomb at the crowded Sheetla *ghat*, 100 metres from my room. The blast killed one and injured twenty. In the five previous years, fifty people had been killed and hundreds injured in a similar manner in Varanasi.

An important part of every visitor's itinerary was a boat ride. Dozens and dozens of boatmen "worked" the *ghats*, coaxing pilgrims and tourists to board their boats. Boatmen and beggars were just two of many groups that hustled their wares and services on the *ghats*. The shaving of heads and beards was always on offer, this being a Hindu mourning ritual. Postcards, other souvenirs, and shoeshines were constantly being offered. The touts' come-ons usually started with, "Sir, where are you from?" or "Hello, sir, what is your name?" One quickly learned never to acknowledge such questions.

Knowing that, some touts worked with more cunning. A direct, head-on approach with the arm extended for a handshake, together with a "Hello sir, good to meet you" was harder to ignore. If you extended your arm for a handshake, you might not get it back. These touts would immediately start a rubbing and kneading action, which would eventually grow into a massage and end in a demand for payment.

One day I watched an unsuspecting young Brit as the hand manipulation started. The young bloke asked for the tout to stop. The tout responded, "No money sir, just massage." The massage went up the arm as the chuckling Brit said, "Okay, okay...but no money...remember, no money." Another masseur quickly latched on to the Brit's other hand and started rubbing the fingers and palm, working his way up the arm.

Again, "Okay, sure, if you want...but remember, I'm not paying."

Then a third and four tout entered the picture and started working on the legs. The young traveller was trying to suppress his laughter, with his arms and legs spread-eagled as if being frisked by cops. All the time he kept reminding them that he wasn't going to pay—which of course didn't deter the touts in the least. They kept hold on the guy's limbs, like lions on a gazelle. Of course, in the end, he had to pay, to get them to stop.

Another common sight along the *ghats* were "professional" beggars, often teenaged or even younger girls, with babies in their arms, asking for money to buy food. These poor souls were "employed" by gangs—men who controlled all aspects of their lives. The newborn babies they held had been rented, for effect. The girls' families lived on the street, and their survival often depended entirely on the young girls' ability to solicit money. The girls' family members would spend the day huddled in the corners of the *ghats*, actively begging only when approached. Most of time they napped or picked lice out of one another's hair.

Among the multitudes that gathered at the *ghats*, the most attention-grabbing for me were the *sadhus*—the Hindu holy men. A few wandered around dazed, naked, and ash-smeared, looking like Borneo headhunters, but most were the more familiar-looking mystics, with their golden robes, long hair, and painted foreheads. Many carried a metal trident and other sacred objects. Although the details vary with each individual's circumstances, and also from sect to sect, *sadhus* live lives of extreme renunciation, regularly consume cannabis, and follow an austere, ascetic path. All of those whom I met in Varanasi were good-natured and enjoyed exchanging pleasantries. Most were bone-thin and hung around the *ghat* terraces looking to soak up the midday sun, hoping for offerings of food or money from pilgrims, locals, or tourists. *Sadhus* are respected throughout India and are usually allowed to travel by train without paying. They aren't pushy—not

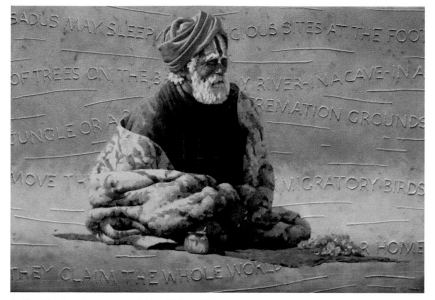

Indian Mystic, oil on canvas, 19" x 27.5", 2011

like the touts and boatmen—but taking pictures of them always results in a request for rupees.

One morning I watched one of the larger tour boats unload a dozen Japanese tourists (most of whom were wearing air-filtering masks) at one of the *ghats* frequented by *sadhus*. One couple asked if they could take a photo of a *sadhu* who was standing nearby. While one spouse stood beside the holy man, the other took the picture. Another photo was requested, with the spouses exchanging places. While that was happening, others in the tour group came by, wanting in on the *sadhu* photo taking. That immediately alerted the four or five other *sadhus* in the vicinity, who had been watching. Like aroused yellow-jacket wasps, they glided into photo-capturing position among the tourists. It was a windfall. Five minutes of constant posing and clicking was followed by another five minutes of Japanese wallets and purses being dug into.

Along a few of the *ghats*, large, mushroom-shaped umbrellas served as mini-ashrams. Under these, *sadhus* and apprentices often sat talking, and perhaps smoking up. These "students" were, more often than not, backpacking youth looking for a taste of Indian mysticism. The sight of that cross-legged, cross-cultural, cross-generational convergence took

me back to my youth, to "His Holiness" Maharishi Mahesh Yogi, the Beatles, and the promise of spiritual enlightenment.

While travelling in exotic places, youth "going local" is common and innocent enough—if it doesn't go too far. One afternoon, walking down the dark catacomb alleys of the old city, my eye was diverted to an unusually large group of flies, a hundred or so, sitting on grey-coloured fabric that was on top of a fresh-looking pile of garbage. A small brown dog was rooting through the pile. I had just walked past the smelly mess when I stopped and looked back. Something was odd about it and not what it seemed. The coat moved. Under it, a young Caucasian kid, perhaps twenty years old, it was hard to tell, was half buried and flopped over in refuse. His face was pallid. He looked like death.

There were, undoubtedly, a host of scenarios to explain how he'd ended up in Varanasi. Had he come, like thousands of other kids, for a quick look-see? Maybe to meet someone? Perhaps to get away from something, or to find enlightenment under *sadhu* guidance? Or to score some hash or to dip a foot into ascetic exotica? Whatever the reason for coming, he had gone too far, and it didn't look as if he was coming back.

The kid did not look at me, nor did he reach up for a handout (which I would have seen as a sign of hope). He and the dog remained with their heads down, pawing the garbage for food.

⁓

While the burning of bodies is the main focus, most pilgrims come to Varanasi to bathe. Doing so in the Ganges, especially at Varanasi, is believed to cleanse the soul and wash away all sins. The bathers were a cross-section of Hindu society, from the manicured and bejewelled with their entourages, to those just off the train, garbage-bag-suitcase and bagged lunch in hand. Water is integral to many Hindu rituals, and Ganges water is particularly auspicious. Coming to Varanasi to bathe, at least once in one's life, is central to the Hindu faith.

Throughout the day, at most of the *ghats*, I saw babies, toddlers, teenagers, newlyweds, the middle-aged, and grandparents swimming and bathing. Some dipped in and out; some waded in up to their shoulders and prayed; others immersed themselves repeatedly. A few eagerly swam out to the middle of the river, and I watched a couple of lads enter with hoots, hollers, and flying backflips.

The public bathing was done with no self-consciousness or awkwardness. What I observed could only be described as genuine inner

joy. And that took some getting used to, because the water was filthy. According to the World Health Organization, to be safe for swimming, water must have a fecal coliform bacteria count of less than 500 per litre. Varanasi's water was 1.5 *million* per litre. That the city uses the Ganges as a dumping ground for human corpses and cattle carcasses, as a laundry tub, and as a watering hole for buffalo is only part of the problem. The pollution comes mainly from two other sources. Industrial waste—a witches' brew of pesticides, mercury, bleaches, dyes, fertilizers, hydrochloric acid, and polychlorinated biphenyls—flows into the Ganges from thousands of manufacturing plants upstream. That is coupled with Varanasi's raw sewage (and sewer waste from a hundred other large cities), which is dumped, untreated, directly into the Ganges. The act of bathing was meant to wash away one's sins, but at Varanasi, one did so in the effluent of millions of people.

Bathing and swimming was one thing; drinking it was something else again. I constantly saw people doing that, and not just token sips but sometimes full gulps, like cold beer on a hot day. Most Hindus believe Ganges water to be an elixir, a cure-all for any ailment. Those who couldn't get enough of it at Varanasi, bottled it and took it home. And for those who couldn't come to Mother Ganga, a litre ran anywhere from 20 to 200 dollars on eBay.

The desire to wash in the Ganges and drink its waters runs deep through Hindu society and history. Many maharajas were never far from their gold or silver vessels of "holy water." An extreme example was the late-nineteenth-century maharaja of Jaipur, Sawai Madho Singh II. Although he lived in the capital city of Rajasthan, a long way from the Ganges, he had made for him the two largest pure-silver vessels ever created and had them filled with Ganges water. When he attended Edward VII's coronation in London in 1902, he brought them with him for his personal use. Each of the huge metal chalices held 4,100 litres and, when filled, weighed 25 tonnes.

It was hard to watch people drink and bathe in this defiled water. I told myself that only the prospect of eternal life could motivate people to do this. All religions have doctrines that can seem very odd and require a suspension of reason. To follow those doctrines is an expression of faith.

I saw a demonstration of that a week after I left Varanasi. At the Karni Mata Temple in northern Rajasthan, one must remove one's shoes before walking on its marble floors—hardly an extraordinary request at a sacred site. In Hinduism, deities often take the form of

animals—again, not an exceptional concept in matters of faith. But at Karni Mata, the holy deities were rats, 20,000 of them, running on and over everything. Cooks were steadily employed at the temple preparing a daily cauldron of food for the rats. While the food was being served, I watched, dumbfounded, as dozens of pilgrims elbowed one another to get the extra blessing that came from eating rat food and sharing it with the rats. The faithful believed that in doing so, they were attaining special karma from the rodents. What I attained, apart from the shock, was socks stained with rat piss and rat shit.

Of course, the Hindu religion is not the only one that asks its followers to suspend logic. More that 100 million North Americans adhere to Creationism—the idea that men and women were put on this earth much as they are today—conveniently ignoring two hundred years of scientific research and thousands of unearthed and analyzed pre-*Homo sapiens* fossils. And the Roman Catholic Church took more than three hundred years to admit that it erred in persecuting Galileo for his accurate astrological observations, which proved that the Earth revolved around the sun.

A couple of weeks after my experience at the temple of rats, I was at Chaumukha Mandir, a thirteenth-century Jain temple, in Ranapur in southern Rajasthan. There, nearly fifteen hundred white-marble pillars support the most important, and most finely carved, Jain temple in India. While circling the fabulous temple, waiting for it to open, I saw maintenance staff emptying bathroom rubbish and other garbage onto a huge smelly trash pile that sprawled over a corner of the complex.

When the temple opened, I walked to the entrance, where a large sign outlined temple protocol. Item number four stated that, because of the temple's purity, menstruating women were not allowed.

Looking around, I asked myself, "Really? Are we kidding?"

I had seen one hundred or so people walk past the sign to enter the temple. Rule number four had stopped none of them in their tracks, had caused no heads to be scratched, had fostered no puzzled looks or requests for clarification from the temple staff. Instead there was blind acceptance.

In silent protest, I left without entering the temple.

Central to most faiths are ancient precepts rooted in curses, sacrifices, and superstitions. Today, what other lens but a religious one could you look through to accept those precepts? Some liberal theologians

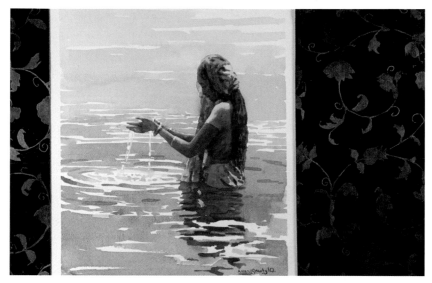

River Blessing, mixed media, 11.5" x 16.5", 2010

attempt to frame them allegorically or as matters of freedom of choice and individual rights. How can you argue against the right of individuals to believe what they want?

What makes drinking and bathing in Varanasi water different, and moves it out of a rights issue, is that doing so could kill you and your children or at least cause serious illness.

There is plenty of anecdotal evidence—indeed, some scientific evidence as well—that Ganges water has an amazing capacity to purify itself (or that it used to). The Ganges has been unusually rich in bacteriophages—microorganisms that destroy cholera- and dysentery-causing bacteria. The river has also had a unique ability to hold oxygen well beyond the point at which stagnation normally occurs. If these are properties it has lost, the river's current state is all the more tragic.

The great "Mother Ganga" may indeed once have been able to justify its sacred status, but her vibrancy and healing powers seem to be things of the past. Her resource has been ravaged, exploited, and abused, her functioning pitifully compromised. Her vulgar appearance and her atrocious hygiene are clear signs of advanced senility. Current medical evidence indicates that contact with her, at least at Varanasi, is leading to increased child mortality, birth defects, skin eruptions, and other

serious illnesses. The Ganges at Varanasi, perhaps more than any other place on Earth, illustrates how hope and blind faith can trump common sense.

Hindu people have developed an incredibly broad and open belief system, one that embraces all gods. They believe that everything is a deity or a potential deity. So it's perhaps not surprising that they apply the same principle of inclusiveness to Ganges water—they use it as a toilet, a bathtub, a laundromat, a toxic dump, and a cemetery as well as a divine goddess.

<div align="center">⌢⁄⌣</div>

Varanasi is a place of contradictions, contrasts, and extremes. Essentially, it is an upside-down world where white is black and black is white.

Unlike any other famous, world-attracting waterfront that I'd heard of, this one neither serviced the elite nor was controlled by it. There were no high-rise condos to take up the best views or waterfront penthouses for the wealthy, no five-star hotels (or four, or three) or restaurants with leather-bound menus and linen and silver place settings. Anything smacking of privilege was absent, pushed back into the city, away from the water. Similarly, there was an utter lack of high-end retailing along the river. No parkettes, no interlocking brick sidewalks or potted flower arrangements, no decorative, heritage-theme lighting, no standardized signage or anything of the sort. There were no off-limits areas, no restrictions of entry. There was nothing to intimidate the commoner or any member of the lowest caste—in fact, the entire waterfront was run by the lowest caste. Rules were few: no photographs of cremations and no alcohol consumption in the presence of Mother Ganga.

If nothing else, Varanasi at its core was about the common people. If there was intimidation, it was felt by the indulged. Their equilibrium must have been whiplashed as they wandered about, soaking in the sights, sounds, and smells of the *galis* and *ghats*.

The activities along the river were timeless, almost biblical: a complete high-tech void, where apps, Gs, tweets, and even the combustion engine were absent, sucked away into some distant black hole. In its place were kites flown by kids and bouncing balls hit with sticks; men whacking wet garments against river stones; and callused hands rowing handmade boats with bamboo oars. Like an ancient warrior caste, strange-looking, golden-robed men with painted faces drifted about,

giving audience to those in need of guidance. Other men unloaded wood, tended fires, cremated the dead, shined shoes, cut hair, and shaved heads. Worshipping occurred at the same place mongrel dogs slept and water buffalo swam—a temple of common ground, without walls or roofs or golden spires.

Was Varanasi stuck in a pre-industrial past? Or was I glimpsing something else?—the future perhaps, a post-apocalyptic world with a new order and a new culture. A city that had adapted and survived, after half of it had been annihilated and left uninhabitable across a dying river. For those who had been spared, everything changed. The "event" had become the Rubicon, where thereafter, the obsession with newness and growth was seen as dangerous and was shunned. Central governance, intellectualizing, the seeking of status, and technological advancement and secularism with its institutions, bureaucracies, regulations, and corporate structures were no longer trusted or allowed. Instead, from the alleyways and the *ghats* rose an ethos with other values—those of the raw earth—not just of the organic, but of the feral and the primal. Truth was found in wood, fire, and blazing pyres, in asceticism, painted skin, and garland flowers, in monkey gods, and in handwork and the handmade, in prayer beads, incense, and mantras—and in blessed water, there to be used as you wish.

<div align="center">⌒⁄⌒</div>

While in Varanasi I made one or two sketches a day. They were quick studies, mostly of people, boats, and building details. I also made some drawings at the two cremation sites, having received a decision, somewhat grudgingly, from the pyre-tending untouchables that on-site representations of the burnings, being non-mechanical, would be allowed.

On my last afternoon in the city, I positioned myself on a lower step of a *ghat* near my hotel and began a drawing of two moored boats, with the river and desolate far shore as background. I was in a good location, somewhat removed from the main flow of passersby and far enough away from the stench of the common urinating wall. It occurred to me while drawing that I had started my career depicting this sort of thing, the boat-and-water combination. Of course, that portrayal is really about the relationship between man and water, and in that regard, a lot has changed over those forty years.

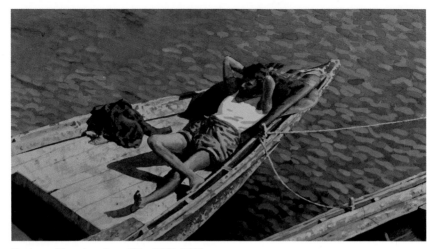

Boatman #1, watercolour, 11" x 19.5", 2011

All over our planet, marine life has declined precipitously. Where I live on Georgian Bay and in much of the Great Lakes, overfishing has wiped out almost all commercial fish stocks. The wide, dense rivers of cod that once flowed on the Grand Banks are no more. The oceans have been vacuumed clean of salmon, hake, sea bass, haddock, halibut, and many other species.

The mountain glaciers that feed the great rivers of the Asian subcontinent, and that sustain two billion people, are now retreating rapidly. Fresh water is getting scarcer; lake temperatures are warming; ocean levels are rising. With regard to pollution, our track record is uneven at best.

When I was a young artist on Georgian Bay and later in the Newfoundland outports, I saw water as unbridled, indomitable, and pure, with a dangerous disposition. Now in Varanasi, four decades later, it spoke to me only of danger, a different danger.

Across my plane of reference, rowboats plied the shoreline carrying pilgrims and tourists in sunhats, who captured the riverfront with palm-sized cameras. The surface reflected the golden light of the late afternoon, but below the mirror and beneath the boats, the water was a reflection of something else.

It isn't easy to transform a major river from a perpetual flow of crystal water into brown sludge saturated with contaminants and filth. The misuse has to be constant, uncompromising, and massive. In that

regard, mankind has a unique ability. Evidence of our folly, although usually less extreme than at Varanasi, can be found everywhere people are concentrated. So consistently does it happen that it is reasonable to conclude that it's a natural by-product of human alchemy—directly linked to our numbers, our behaviour, and our ambition.

Observing the utter filth of the Ganges without becoming totally depressed required some mental gymnastics. I tried to comfort myself with the Tibetan Buddhist thought process that I had gotten to know quite well while travelling in the Himalayas in recent years.

Their most revered prayer, *Om mani padme hum*, is a touchstone of Tibetan Buddhist philosophy. The mantra is inscribed everywhere, on multitudes of stone carvings, prayer flags, and prayer wheels. It literally means, "Hail the jewel in the lotus." Although those words have nearly as many meanings as Hindus have gods, one of the core lessons the mantra teaches is that sullied muck is required in order for the beautiful lotus flower to spring forth—or, that all life should be seen as non-contradictory. Somehow I hoped this wisdom applied to the Ganges.

<center>～※～</center>

After half an hour of drawing, a young lad came up beside me to watch what I was doing. He had on a soiled T-shirt and pants that didn't fit, and he was barefoot. He looked to be ten or eleven. Under his arm was a small kite made from little sticks and purple tissue paper. His hand held a ball of fine kite line.

He told me his name was Samir. His English was good enough to ask me questions, beyond my name and where I was from. He wanted to know if I was an artist, how long I'd been drawing, and how long I intended to stay in Varanasi. I answered his questions and showed him some of my previous sketches.

He asked if I sold my drawings. I said sometimes but not too often. He immediately offered his services as a salesman.

"Who would you sell them to?" I asked.

"Tourists."

I said no thanks, that I'd probably just keep the drawings.

"I get a good price for you. Why not sell?"

"I don't know. I just want to sit and draw, that's all."

Having not really answered him and seeing his blank look, I added,

"I'm drawing, you know, just because I enjoy doing it—sort of like you, flying your kite."

After Samir departed, a man fishing from the stern of one of the boats in my drawing caught a fish, his second one. It was about 30 centimetres long. Even to me, an agnostic, a miracle seemed to have occurred—not because he'd caught a fish, but because there *were* fish.

The sun had tucked down behind the city's serrated skyline by the time I completed my work. As I made my way towards my room, overhead hundreds of parrots, pigeons, and swallows homed back to their cornice, clerestorey, and banyan tree roosts. Now cooled by evening shadows, the *ghats* disappeared into an atmospheric haze of humidity and smoke, following the curve of the river.

On a moored rowboat, one tied farthest from the shore, I spotted Samir, standing, looking up, with one arm moving back and forth. His was one of a hundred kites that were high above the river—weaving and hovering like nervous spirits between this life and the next.

I called, but Samir's attention was skyward. From his hand, I followed the thin line up into the air until it disappeared from my sight. Finally I picked out his kite fluttering high in the topaz sky. It arced and swirled, climbed and dove, as if wanting to be freed from human control and Earth's pull.

X

MUSKOX WAY

He whispers to their spirits
It is now and it was then.
The animals came.
And now you are coming
Right here to us.
Come here to us.
—Inuit song

They followed in the shadow of the great herds, as they must—even to the top of the world.

Four thousand years later the cold polar barrens are still home for those prehistoric mammals, but not so for their human cohabitants. The lives of those first Arctic people are now only found in the land's memory. To those who know how to listen, their voices can be heard in the sunken stone hearths and mounded middens, in the imprint of ancient tent rings and from a scattering of carvings and chipped-stone tools that dot the high tundra. Archaeologists call this place Muskox Way.

North of Resolute, August 1994

The calendar said midsummer but the view out the window of the plane did not. The occasional patches and strips of snow seen near Resolute became more frequent the farther north we flew. Increasingly, the landscape took on the appearance of a zebra's flank, with additional snow powdering the highest elevations. The colour of the ponds and lakes that freckled the terrain transitioned from blue to light grey and then, farther on, to a consistent opaque white.

We flew low, a hundred or so metres above what at times resembled a rock quarry or a gravel pit. Evidence of Ice Age brutality was everywhere. In some places vast stretches were carved into fluted ridges like corrugated cardboard. Occasionally, long eskers—huge, gravelly mounds of sediment—wormed across the topography. Gargantuan rivers that once rumbled under a continent of melting ice sheets had deposited them.

In other places, a hundred centuries of freezing and thawing had rearranged the thin, active layer of soil above the permafrost into alien message boards or sedimentary crop circles. Imperceptible but endless jostling had produced an extraordinary display of tattoo-like, repetitive motifs formed from rocks, stones, and pebbles that had somehow been tilled and sorted by size and shape into ovals, squares, and stripes.

On some of the mountain slopes, the melting permafrost had released strange solifluction lobes, which oozed down the scoured uplands, halting like cooled wax before the washed-out lower plains.

Devon Island, the largest uninhabited island in the world, was coming into view. A thick batter of ice was poured over half of it. Farther in the distance sat South Ellesmere's white, torn-edged ramparts. Our route sliced across the centre of the Arctic Archipelago's land masses, which included Graham, Eglinton, Vanier, Bathurst, Cornwall, Brock, and Cameron islands.

Separating and indenting the islands was a labyrinth of channels, straits, and bays. Wellington Channel and Jones Sound lay below to the east; Penny Strait and Belcher Channel were directly to the west. The place names were derived from those who had come from a world away, a century or two before. Arriving on wooden ships with wide wings of canvas, they proclaimed themselves the lands' discoverers. But what they "discovered" was already inhabited, and had been for 4,000 years.

If having one's name on a map, and the immortality that implied,

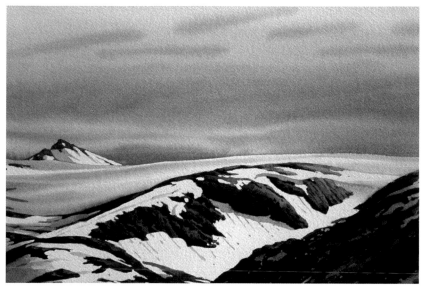

The Other Side, watercolour, 10.5" x 14", 1994

inspired these admirals, commanders, and patrons to probe frozen unknowns, there was no such promise for those who crewed their ships. The loftiest goal for those poor souls was surviving. Common to all early High Arctic expeditions was their unintended duration and their savage brutality.

Below, in the broader sea passages, the ice had broken and tightly repacked itself in millions of bits that filled most of the channels. Random icebergs were frozen in place like chess pieces on a fractured board. Pristine expanses of white lay in the dead-end fjords, with just a blue thread of meltwater outlining the shore. Glacial rivers etched the land with heavily eroded gorges. Where they met the frozen ocean, the rivers gnawed and chewed the edge of the frozen white sea.

To the east were mountains and the ice cap of Greenland. They were separated from Ellesmere by a narrow sea channel. Mauve tongues of low cloud connected the two land masses. To the northwest an overcast sky blocked the sun, and the land turned decidedly ominous. The view from the cockpit was of a solid expanse of glacier-covered ranges with dark, multiple peaks or *nunataks* piercing through the ice.

Twelve of us had signed up with the wilderness adventure outfitter Black Feather, which had chartered the Twin Otter to take us to

northern Ellesmere Island. There we would commence a two-week backpacking trek from Lake Hazen to Tanquary Fjord. None of us had been this far north before.

The plane's co-pilot was a young Inuit. He was dressed in unofficial bush pilot attire: leather flight jacket with fur collar, dark baseball cap, and sunglasses. He was pleasant but not chatty. Viewing the immensity of Canada's (and the world's) northernmost national park ahead, one of our group shouted to him over the engine noise, asking if that was an area he had hiked.

Looking straight ahead, he answered, "No, never hiked."

"Really, why not?"

There was a slight pause.

"No reason to."

We flew over the northern ranges of Ellesmere Island, collectively called the Grant Mountains. Gradually they were blanketed by a monster ice sheet. The light reflected off the sheet and bathed the underwings and the cabin in an unearthly glow. Below, we saw emptiness swept clean of human history. It was a place beyond the limits of all but a tenacious few of the planet's life forms. It appeared to be as much akin to the frozen moons of Jupiter as to terrestrial Earth.

Twenty thousand years ago, when the Late Wisconsinan glaciations reached their zenith, ice thousands of metres thick covered Canada and the northern United States. The only remaining large portion of that glacial mass now lay beneath us, on the northern edge of Ellesmere Island and, to the east, on Greenland. However greatly diminished, it still looked overwhelming.

⌒⁊⌒

After eighteen hours of constant flying—two scheduled flights and a charter—we disembarked beside a cluster of wind-reinforced metal buildings at the far end of Lake Hazen's short gravel airstrip. It was 2 a.m. and the entire staff of Ellesmere Island National Park—all three of them—were there to greet us. Some years, apart from researchers and government personnel, they get as few as forty park visitors. Our group represented about a quarter of its yearly visitors. Access to the park involves flying from Resolute, a four-hour charter. And then it's another four-hour charter to return. If you are lucky, another group is scheduled to come or return on the same day, enabling two groups to

split the flight costs. Even so, it's a bank-account-draining park to visit.

After a very brief sleep in the brightness of a polar-summer night, we did a walkabout with the young park rangers. They seemed anxious to talk to someone and display their underused interpretive skills. We learned that the 38,000-square-kilometre park had been established in 1988. The Grant Mountains dominate the park, with Mount Barbeau at 2,600 metres the highest peak. One third of the park is covered in glaciers. That was not evident from the land surrounding Lake Hazen.

The 800-square-kilometre lake is contained by a wide, shallow basin encircled by distant mountains. Its topography, and the effects of four months of daylight, has created a temperate thermal pocket only 750 kilometres from the North Pole. This microclimate produces a relative profusion of vegetation, which in turn attracts most of the thirty bird species that inhabit the park in the summer. The park's land mammals include muskox, Peary caribou, polar bear, wolf, Arctic fox, Arctic hare, ermine, and lemmings. The ranger said they had just discovered an Arctic wolf's den, but its location wasn't divulged to us.

We got a briefing on the risks of trekking in the park. Because of the park's size and remoteness, coupled with its small staff, the rangers underscored the need to be very careful and self-sufficient. In other words, if you get in trouble you'll have to get out of it yourself. They also warned us about a very long, unpleasant, and potentially dangerous glacial river crossing that was unavoidably on our route.

The rangers encouraged us to stay longer at Hazen, but we were anxious to get started. After lunch, with the ranger's wishes for a safe journey and a dive-bombing by some long tailed jaegers, we started our two-week trek, heading southwest.

We followed the north side of the lake, which was still covered with a layer of grey ice. The summer's heat had melted a three-metre span of water along the shore. The lake rarely sheds its blanket of ice. Refreezing would begin in another two weeks. The lake's only sizable fish was Arctic char.

As we crossed some of the many glacial streams that fed Lake Hazen, our route gradually swung to the west, away from the lake. Most of the time we made the stream crossings by boulder hopping; however, for a few of the wider and deeper tributaries, we had to remove our boots and socks, roll up our pant legs, and wade across. The intense pain of the ice-cold water felt like a thousand needles jabbing through skin

tissue into bone. Some of our group made wet crossings with great reluctance and only after every possible rock-hopping option up and down the stream had been thoroughly investigated.

It was often a tough call. To ford the rushing ice water was torture on one's feet and legs, but you were soon across, dry and safe and on your way. The other option was great if successful, but if you misjudged a boulder jump or slipped on a wet rock, you risked a total dunking of yourself and your backpack, or at least a soaked boot. Which option people chose was an early indicator of who in the group were the risk takers.

Eight kilometres south of Lake Hazen we came upon the Henrietta Nesmith Glacier. Its face was 75 metres high and spanned four kilometres. From that mountain of ice a great flow of silt water cut an endless series of tributaries through the tilled delta and on to Lake Hazen. From atop the high lateral moraine, the twelve of us scanned the crossing that the park rangers had warned us about. It looked daunting. I felt that the rangers had understated their warnings. But we had no other option, as climbing the glacier and crossing its top would have been too dangerous. In the collective silence, no one expressed any interest in getting started. We postponed the inevitable and made camp on the moraine on the north side of the glacier overlooking the delta.

The next day broke clear and warm. Again we deferred our crossing, electing to use the day to explore the surrounding area, camping in the same location for another night. There was some justification for delaying—the sun's warmth that day would produce a faster and greater flow of water off the glacier, making the long crossing considerably more difficult.

Following their own interests, people broke into small groups or went off individually. On off days, I mostly hiked by myself so that I could stop and paint as I wished. I decided to hike inland, along the side of the glacier, following the lateral moraine.

As I climbed alongside the glacier, the noise was deafening. Hundreds of sculpted chutes and culverts of ice, each polished clean in a multitude of widths and depths, delivered gushing torrents of meltwater down the glacier's side. Somewhere down below they joined together, creating the deep, reverberating rumble of a giant subterranean river, which resonated through the ground and into my boots. Having been gouged from the sides of mountains during the glacier's descent, boulders the size of Buicks sat embedded in the frozen car-

rier. The power and even the movement of the glacial mass were easily felt—similar perhaps to the sensation of standing on a dock below a huge ocean freighter that is readying to depart.

At the crest of the moraine the view of the glacier's top changed completely. It was now only one of several sweeping highways of ice originating in a large glacial sheet, which blended into the low cloud striations that stretched and disappeared into the horizon.

This glacier was part of the ice sheet that had covered most of the northern hemisphere 15,000 years ago. So much mass required huge quantities of water, which were drawn from the world's oceans, lowering them a hundred metres or more. Coastlines around the world were drastically lowered. In northwestern North America a land bridge emerged across the Bering Sea, connecting Asia to Alaska. For the first time, so it is believed, people journeyed to North America.

A few thousand years after their arrival, a shift to warmer temperatures began melting the ice sheet. This allowed people further access to the southern part of the continent. Through ingenuity and improved mobility, and crafting fluted spear points from basalt, jasper, chert, and quartz, the ancestors of the North American Indians, the Clovis people, made a home in the New World.

The animals the Clovis people saw and hunted would have been profuse and varied. Some would have been familiar to our eyes. But many would have been strange. The short-faced bear was 50 percent larger than a modern grizzly. The woolly mammoth (one of many mammoth species), at eight tonnes, had survived for almost two million years. The sabre-toothed tiger (one of three North American species), with its 18-centimetre canine teeth, had been millions of years in the making. The teratorn, one of many huge vultures, had a four-metre wingspan and weighed 23 kilograms. The huge mastodon can be traced back almost four million years. There was the giant ground sloth (one of four sloth species), a number of giant beaver species, the woodland muskox, the short-faced skunk, the dire wolf, the American lion, the giant jaguar, the long-horned buffalo, the stag moose, and camels, horses, cheetahs, llamas, tapirs, and many others.

Within a short period of time, however, the variety and number of species collapsed. During the Late Pleistocene era, one of the largest known mass extinctions in history occurred, and it happened rapidly, within as little as a few decades. It happened throughout the world, but

most extensively in North America. That extinction wiped out more than a hundred species of mammals, including most of the largest.

There has been much scientific debate as to how that mass extinction happened so quickly. The environmental upheaval caused by a rapidly changing climate is one theory; perhaps it released deadly allergens that triggered new diseases. Another theory points directly towards the emergence of man, the new and highly effective predator.

One of the latest hypotheses to gain scientific traction suggests that the extinction was a result of the Earth's surface being pummelled by an enormous meteor shower in 9900 BCE that wrapped the planet in a cloud of dust.

Four and a half thousand years ago, the last vacant, habitable territory in North America, if not the world—the Arctic—became occupied. Those occupiers, like the others already in North America, came from Asia. Crossing the frozen expanse of the Bering Strait, they spread east and found a land similar to their native Siberia.

Independence was the name given to these people by the Danish explorer Eigil Knuth, who, at Independence Fjord in northern Greenland in 1948, first identified this culture. Radiocarbon dating of charcoal remains put the age of that site at 4,000 years. This and further archaeological discoveries indicated that these were not ancient Inuit or tundra Indians but very different people.

Independence sites have been found from Alaska to Greenland. Though not numerous, they have many common characteristics. At all of them are found razor-edged blades, burins, and chipped-tool artifacts, indicating a culture that relied heavily on hunting and whose toolmakers were highly skilled. Also, the Independence people dwelled in oval tents with a centre passage of flat stone and with a hearth of two or more upturned rocks in the centre. The tent walls would have been made of animal skins with a central driftwood pole as support.

Evidence points to these people being migratory land hunters who moved their dwellings in search of food. In the High Arctic, all the middens surrounding their sites tell of a reliance on muskox for food. Besides scallop-pointed spears, they possessed bows and arrows. They also kept dogs, though they did not use sleds.

The vast herds of muskoxen would have been easy prey for the Independence people. The instinctive defensive posture of the mus-

Lowlanders, oil on canvas, 26" x 49", 1993

kox—adults circling the young, with their massive heads and horns pointed outward—works perhaps when wolves are the predator. But against sharp lances and honed-edged arrows, such a posture would have been a death sentence.

Had the muskoxen run, they would have overheated quickly, and with their dogs the Independence hunters would have separated the young, the weak, and the old from the herd. Whether they ran or held their ground, these animals would have been easy to kill.

For the Independence people, survival in the Arctic depended on many things, including warm fur and skin clothing, cutting tools, and portable dwellings. All of these things pointed to a need to hunt animals relentlessly during the summer in order to cache enough food for the dark winter months.

For archeologists, the most puzzling aspect of the Independence people, and what distinguished them from any other polar culture, was their lack of a heat source during the winter. They had a firepit for cooking with a centre hole in the tent to chimney out the smoke, but this would not have worked as a heating device, for the tent's heat would have been pulled out the top opening along with the smoke. For winter warmth, all other Arctic peoples utilized some sort of oil lamp fuelled by sea mammal blubber. If the Independence people didn't use a heat source, it is astonishing that they were able to survive the High Arctic winters for centuries.

In *Ancient People of the Arctic*, archaeologist Robert McGhee describes what a winter's night for an Independence family might have been like:

Imagine hunters returning from an unsuccessful expedition in the months-long polar night, carrying a few chunks of frozen meat and fish chopped from a cache made the previous summer. The silent camp, a single tent in an immense Arctic landscape, wakes as a woman strikes sparks from flint and a small ball of pyrites kept in her sewing kit. Dried moss eventually catches fire; a tiny flame flickers around the twigs of willow and shavings of driftwood collected with such pains during the summer before. The tent is filled with smoke and frozen breath and shadows that jump against the frost crystals condensed on the walls since the last fire. Bones smashed at the last meal crackle and spit in the stone hearth. Chunks of meat placed close to the fire begin to thaw; sharp stone-bladed knives quickly shave off the half-frozen food, and it is eaten as soon as human teeth are capable of chewing it. The smoke hole in the roof is plugged with skins as the cold, briefly banished by the tiny fire, creeps back into the tent. The families retreat beneath their muskox hide blankets. The camp will sleep for another day, or perhaps until hunger goads them once again to face the waking world.

As unimaginable as that scene is, even today there are people living and enduring very similar conditions. Between 2003 and 2010 I visited and stayed with several nomad tribes in the Changthang region of Ladakh, in the central Himalayas. Many of the families of one large tribe, the Korzokpa, cook over an open-pit fire, using animal dung, inside their woven yak-hair tents. Those tents have a large opening at the top to vent the interior smoke, but the hole also draws out the heat. An open fire and the tent's design make it impossible to heat the interior during the night.

The Changthang region of the Himalayas (elevation: 4,000 to 5,000 metres) and the High Arctic have similar winter temperatures. Like the Korzokpa nomads, the Independence people survived the punishing winter nights solely on body heat and the insulation of natural fibres.

Ivory Mask, oil on canvas, 22" x 36", 1995

After climbing to the top of the moraine, I spent the afternoon doing two watercolours. One was of the glacier as it swung down and around various mountain peaks. The ice was traced with delicate charcoal lines, in parallel lanes that merged and separated with others like interstate highways. The other watercolour was a view over the top of the glacier's face onto the silt and rivulets of the glacial delta.

I took a different route back to camp, staying high and moving away from the glacier. I found and followed an old esker that took me back down to the lake valley, coming out far past my destination.

As I wandered back I came across what looked like three old tent rings — rocks to anchor tents, placed in a circle. Some of the rocks were missing, but their memory was still in the ground. The large stones in the ring were covered in lichen. The circles were about three metres in diameter and had a few flat stones in the middle, most of which were covered in soil. One of the park staff at Lake Hazen had told us that archaeologists had recently made a series of major Palaeo-Eskimo site discoveries in the area. The results indicated that the region had been a place of much longer-term occupation by the Independence people than had been previously thought.

I wondered what life was like back then and how the glacier, the surrounding mountains, and the sprawling river delta would have looked

to someone walking along that ridge 4,000 years ago. It might have been totally different, with the glacier extending all the way to and perhaps over Lake Hazen. As I walked the ridge, strange images began to float through my mind. Footprints dissolving into wind-blown swirls of silted sand, rocks positioned carefully in small circles to anchor shelters of shaggy hides. Frayed muskox leather, like prayer flags, flapping against tents in the cold Arctic wind. Its air carrying the scent of roasted flesh to the nostrils of the hunted. Beyond the flickering flames, long lances, edged with fluted basalt, razor-honed, sinew-bound and blood-encrusted, move across the empty tundra, following the sound of yelping dogs.

<p style="text-align:center">⤳⟋⟍</p>

In the morning, from the warmth of my sleeping bag, I needed confirmation regarding the sound I was hearing on the tent walls. Poking my head out the zippered door, my face met a freezing drizzle falling from a thick, overcast sky. A stiff wind off the glacier flooded the tent's interior. While rezipping the flaps I asked myself how the hell this could be—wasn't this supposed to be a polar desert?

It is mainly the extreme cold and low precipitation, not a lack of standing water, that defines the High Arctic as a desert. In fact, in one state or another, water is everywhere. It comes with the infrequent snow, rain, and sleet that melts and flows into rivers, ponds, lakes, and the ocean. Even on "dry" land, glaciers, ice caps, and permafrost, although solidly frozen, are everywhere.

There was no room in our itinerary for more delay. We breakfasted without much chatter, packed our camp, put it on our backs, and made our way down the steep moraine to the edge of the delta. We dressed in water-crossing attire, which meant bathing trunks or underwear and rubber sandals. We tied our hiking boots to the tops of our packs. Upper-body clothing was as usual. Since our packs extended below the waist, we had to avoid wading through water deeper than that. Beyond getting a wet pack, and suffering groin shock, standing and fording fast-moving water above one's waist is exceedingly difficult and dangerous.

A daunting route lay before us. I silently wished we had crossed the day before—a thought likely shared by each member of our group.

To our right, 60 metres away, the dirty-white marbled face of the Henrietta Nesmith Glacier loomed vertically, blocking the western sky.

It disappeared to the far side of the delta like telephone poles down a prairie road. The crossing was 4 or 5 kilometres. A hundred or more tributaries braided the delta, carrying ice-cold water from the glacier to Lake Hazen 8 kilometres away. Most of the streams were short, 5 to 15 metres wide, divided with sandbars of roughly the same width. That, from what we could see, was the pattern all the way across: in and out, in and out, again and again.

We found that the best technique for wading across the deeper streams was for us to divide into four groups of three people each. If one person out of the three was particularly strong they would be in the middle, with the other two people on each side, linking arms at the elbows. That gave stability in case someone lost their balance. The two outside people used walking sticks in their free hands. Chest and waist backpack buckles were undone. If you fell in, you didn't want to be anchored to the bottom by the weight of your own pack.

I teamed up with Sandy, a short, stocky doctor from Sioux Look-out, and Bill, a currency trader from Philadelphia. Shuddering in our underwear and with our bare knees knocking, it seemed that every comment or movement we made during that locked-arm procedure sent us into fits of chortling and giggling. After a few crossings we dubbed ourselves the Three Amigos. As in the movie of the same name, we used the hip-slapping, pelvic-thrusting salute.

Finely ground silt gave the water the translucency of diluted choco-late milk. Some of the rivulets were fast-flowing, particularly the deeper ones, which held the chutes and dells of significant rapids. Semi-sub-merged glacial blocks—chunks and bits of ice—constantly sped by like surface torpedoes. Their greyish translucence blended into the water, making the job of spotting and avoiding collisions more difficult.

Streams less than half a metre in depth could be crossed confidently, almost in a sprint, keeping the pain to a minimum. For deeper water we had no choice but to lock arms, breathe calmly, keep our balance, go slowly, not panic, and endure the pain. The consequences of falling in were serious.

As we went, we stayed together, making sure everyone was across before starting the next tributary. With crossings that looked deep, Mike Pardy, the assistant guide, waded out alone without his pack, probing the river bottom with his pole for the best route. Although Mike was young, he was an experienced trekker with tree-trunk thighs.

For the three-person crossings, Mike centred Jake Kent and Mary Nan McHose, a couple in their fifties from St. Louis. They were both tall and somewhat gangly. At times during the trek they struggled with balance and needed help over precarious terrain. For the river crossings, Mike's solidness evened things out.

The rain had let up, but a uniformly cold, grey, low-lying sky remained. We had been crossing for about an hour when someone pointed out two black dots in the middle of the far end of the delta. The merging clouds reflecting off the distant lake and watery delta cast a sheet of silver-grey behind the strange dark points. The lack of a horizon line gave the two spots an ungrounded reality—like two black eyes hovering in space, watching us.

The objects were far enough away to be difficult to identify, even with binoculars, whatever they were. Finally, after everyone had focused their binoculars on the subjects, it was agreed that the eyes were two muskoxen. They were crossing the outer delta, moving towards the shore we had just left.

Muskoxen are members of the goat family, and even at 350 kilograms, they retain a goat's amazing agility for climbing nearly vertical rock. In Greenland I have found them high up on a glacial plateau that can only be reached by a climbing a steep rock wall. They usually feed in family groups on grasses and tundra. They maintain their body temperature during the Arctic winter with two distinct coats: the outer, a dark layer of coarse hair, and an inner coat made of fine wool, called *qiviut*, which is lighter in colour. The *qiviut* is a renowned fibre, prized as the warmest in the world.

Several years back, at one of my openings, a collector of my work heard my complaints about cold hands while painting in the north. The following year she presented me with gloves that she had knitted from pure muskox *qiviut*. They were the colour of wet beach sand, almost weightless, and nearly disappeared when compressed, only to instantly return to their original form when released, as if each hair were a recoiling spring. The gloves had no fingertips so I could feel my pencil and brush. The sensation I have wearing them in the Arctic is hard to describe. It is like being on a cold porch with the windows wide open, surrounded with lots of radiant heat. You are completely warm, unable to feel the cold, while any excess heat is comfortably escaping.

We watched the two muskoxen for a while until our shivering bodies implored us to get moving. We were not yet halfway across.

As we continued, everyone's body temperature was steadily dropping from the constant immersions. Stopping to warm up would have been a long procedure, involving changing clothes and footwear and getting stoves and utensils out to heat water for soup or drinks. Everyone wanted to get the crossing over with and then change, eat, and warm up. We kept going.

The muskoxen seemed to have changed their route. They had turned to come upstream towards the glacier. Eventually the distinct details of their profiles were recognizable.

They looked truly prehistoric, like time travellers dropping in from the Late Pleistocene. Layers of multicoloured, mangy hair of burnt sienna, deep charcoal, and beige spilled to the ground like winter clothes piled too high. The strands and ends of their thick uneven fleece waved behind them as they moved, like wash on a line. They were losing their summer coats, which would soon be replaced by an even heavier winter version. Their dark, massive faces were set against handlebar horns that sensuously curved downward from a thick base and then outward to sharp points. Muskoxen had outlasted mammoths and mastodons, persevered in the company of the bear, wolf, and sabre-toothed tiger, and endured the lances of the two-legged hunter. They are true survivors.

As we observed the two muskoxen crossing the outer delta, it was apparent that they had not randomly changed their course—they were coming directly towards us. For the group, that was exciting, since most of the group had never seen a muskox before. We flung our packs off our backs and dug out cameras to document what was becoming a reasonably close sighting. We watched them from a distance of ten sandbars. They did the same.

But because we had stopped moving, we were getting colder. We replaced our packs on our backs and continued on. After crossing a few more streams, we looked back to find that our two friends were following us; in fact, they had drawn much closer. That triggered another barrage of photos by some and a feeling of unease for others.

Again, with our bodies shivering, we kept moving, looking back repeatedly to see what the muskoxen were doing. They continued following us, just a couple of crossings behind and getting closer. Our anxiety continued to rise.

Wendy Grater, our guide, had seen lots of muskoxen, as had I. Two summers before, we had hiked and camped among a couple of hundred in the lush, freshwater ponds of the True Love Lowlands on Devon Island. The muskoxen there would consistently run from us unless we remained still for a long time, in which case they might slowly approach as they wandered around looking for grass to munch.

My own limited experience told me that muskoxen presented no threat whatsoever, although they could be formidable against one another.

In West Greenland I had watched males in rutting season charging each other, heads lowered, ramming at full speed. After each collision they slowly walked back to their duelling positions. Then, with their backs to each other, they simultaneously wheeled around and charged. This head-on jousting was repeated over and over to the sound of a sharp, hard crack each time their heads collided. The charge was always prefaced by snorting and bellowing.

The muskox is the only survivor of a group of ox species that entered North America from Siberia at the end of the last Ice Age. This particular species' population grew as the animals spread across the tundra from Alaska to Greenland. That was indeed fortunate, for even while they were prospering in the New World, they were dwindling in northern Asia, disappearing there around 2,000 years ago.

In the nineteenth and early-twentieth centuries, their numbers greatly dwindled in the American Arctic as well. Arctic peoples had long hunted them, but now they were also easy fodder for the rifles and shotguns of explorers and whalers. Arctic expeditions often included hundreds of dogs to pull sledges during winter. Huge quantities of meat were required to feed those teams. Muskoxen made for a ready supply of dog food. Robert Peary's Arctic expeditions alone accounted for the slaughter of more than six hundred muskoxen.

Their population declined rapidly until the mid-1900s, when government protection and a decline in Arctic exploration allowed their numbers to rebound. By the year 2000 there were an estimated 120,000 in the world, with most of them in Canada.

In 1974 the Ice Age migration went full circle: Canada sent ten muskoxen to Russia, the place of their origin. They were reintroduced to the Taimyr region on the central Siberian coast. Twenty-five years later, under the protection of the Russian government, they numbered more than 2,500.

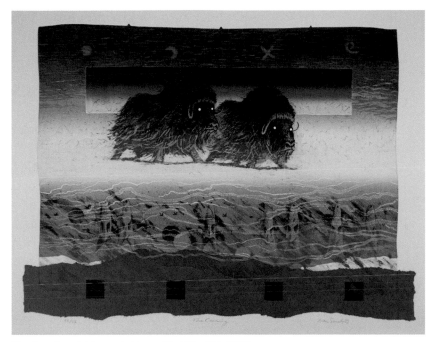

The Crossing, etching and chine collé, 19" x 25", 1994

As the standoff continued, we changed course so as to move perpendicular to our muskoxen, in effect letting the beasts pass if that was what they wanted. It wasn't what they wanted. As we moved back and forth along a narrow sandbar, they did the same on the gravel spit opposite us. In case we still hadn't got the message, they bellowed and snorted at us. Their flared nostrils released plumes of vapour into the cold air. In a pre-charge gesture, they pawed the ground and rubbed their facial scent glands against their front legs.

I had seen lots of waiting-room posters in Arctic airports warning of the dangers of charging muskoxen. I had figured that was more to prevent camera-clicking tourists from harassing the poor creatures than anything else. I was rapidly reassessing that notion.

As they stared at us, I wondered, "Why are they doing this? Why are they stalking us?" Were they being pushed themselves, possessed by a prehistoric impulse, driven by some distant memory of fear and loathing? Haunted perhaps by the spirits of ancient hunts, when humans pursued them with dogs, arrows, and lances? For the muskoxen of

the Arctic, it would have been a time of terror and carnage, a time when the ground was infused with the scent of their own blood. The instincts from centuries past still imprinted, their reality blackened and inseparable from a deep subconsciousness.

We waited. For twenty minutes we eyed each other across ten metres of water. We readied our little arsenal of bear mace, location flares, and bear-bammers. After long discussion, we decided to fire one of the spring-loaded bear-bammers at them, or at least towards them.

The projectile sailed above their heads, followed by a loud *KABOOM*. Sending them galloping away in terror... it did not. They didn't move. Their unblinking black eyes were still riveted on us.

It was midday. We had crossed little more than half the delta. With the delays, everyone in the group was cold to the bone and shivering noticeably. We were hungry and badly needed nourishment. Our allotment of snacks had already been munched. It was finally agreed that we couldn't stand around waiting any longer.

The muskoxen had backed us up against a particularly wide and swift-flowing tributary. From the size of the curling rush of eddies, it appeared to be the deepest crossing yet. Distracted by the muskoxen, we started across without the benefit of Mike's usual testing and probing. We watched Mary Nan and Jake Kent link elbows on each side of Mike and start into the water. Some of the group kept a watch on the muskoxen directly behind us.

I stayed on the sandbar watching the progress of our three comrades, seeing if it was, in fact, a navigable route. Their backs were to us as they moved very slowly in the torrent. The river depth rapidly crept up to their knees. The threesome moved carefully as the grey water streamed past them. With every tentative step the depth increased: knees, thighs, crotch, and then the bottoms of their packs.

Mike was talking to Mary Nan and Jake Kent, but his words were lost to us in the sound of the rushing flow. We watched the water rise up their packs 15 centimetres, then 30. We hadn't seen anything like that before. And they still weren't to the middle of the river.

It was too deep, way too deep. Mike instructed Mary Nan and Jake Kent to turn around. That was accomplished by the three of them pivoting 180 degrees, still with elbows linked, something that is very hard to do. Apart from the difficulty of balancing 25-kilogram backpacks, it meant turning into the face of a swift-flowing river. With the pace

and depth of the water, that manoeuvre was practically impossible to pull off, but Mike thought it was their only option, as he didn't want to let go of Jake Kent and Mary Nan to turn around independently.

As they started to swing around, Jake Kent and then Mary Nan, as if in slow motion, sunk out of Mike's linked-arm grip and slid down into the flowing turbulence.

They were both up to their chests in water.

Mike braced himself. He remained standing and with all his strength hung on to them both. Mary Nan stayed motionless, clinging to Mike's waist. Jake Kent tried to stand up. He still had his pack on, not wanting to slip it off and let it go. Full of water, it would have weighed close to a hundred kilograms. He tried to pull himself up using his walking stick and Mike's support. Mike told him to stay put and to remove his pack. Jake Kent thought he could get back up. He tried. His walking stick snapped and he slipped back into the torrent. This time Mike couldn't hold him. Jake, with his pack still on his back, was swept downstream. His bobbing head and the top of his pack periodically disappeared below the tumbling surface of the icy grey water.

Wendy, Bill, Sandy, I, and the others flung off our packs and galloped into the water. Some headed for Mike and Mary Nan, who were still frozen in place, Mike standing and Mary Nan holding on, her head above the water.

Wendy, Sandy, and I went to Jake Kent. In a panic we waded through the flow as quickly as possible. He had been swept downstream another 50 metres, where we found him washed up in shallower water. He had released his pack and it had continued downstream.

When we got to Jake we found him pale, incoherent, and in shock, and his lips had turned an angry purple. I heard Sandy, who is a doctor, mutter to himself, "Oh, shit…" Coming from a doctor, that scared me as much as Jake's appearance.

Jake's life now rested in our hands, and what we did in the next fifteen minutes would determine whether he survived.

Sandy recognized that Jake was in an advanced state of hypothermia. He was immobile and drowsy; his speech was slurred; his complexion was bleached; and he was convulsing. His inner core had cooled, triggering a collapse of his systems, both mental and physical. Hypothermia is caused by exposure to cold, but exhaustion, wind, and being wet worsen the condition. Jake had experienced all of the above. Given his

extremely thin body type and the hours he had already spent in the stream crossings during the morning, he'd undoubtedly been experiencing hypothermia even before going under.

The survival time for a normal body type at room temperature immersed in water at one degree Celsius is around fifteen minutes.

Hypothermia is a concern for anyone who is hiking, kayaking, or camping. In the Arctic the concern increases, not just because of the cold but also because it is so difficult to rewarm the body. In the Arctic there is low solar strength; usually there are few buildings or shelters handy; and most often there is no wood to burn. Even out of the water the body's core temperature will often continue to drop.

We hauled Jake out of the water onto a large sandbar that fortunately was nearby. He was mumbling that he needed his walking stick and that we should go and find it. The others brought Mary Nan to the same spot—she was in better shape than her husband.

Within minutes, a tent was up, sleeping bags were out, and a stove was heating a kettle of water. Both Mary Nan and Jake had been stripped and smothered in layers of down sleeping bags and with as many other people as the small tent would hold. The warmth of bodies, not that ours were all that warm, was the only immediate source of heat. Later, hot soup and food were passed into the tent.

An hour later, Mary Nan emerged saying she was fine. Jake followed two hours later. Coming out of the tent, he gave the group his heartfelt thanks for saving his life. Then, with a big smile, he said he hadn't realized it would take something that extreme to get two women to agree to go to bed with him.

Small streams of sunlight broke through the overcast sky as we slowly packed up the tent and the wet clothes that were scattered everywhere and started across the rest of the delta. By early evening we were camped on the far shore, the crossing finally behind us.

Before supper I sat on the river's lateral moraine and did an evening watercolour looking back across the delta. A blotch of dark umber in the middle-right of my small watercolour defined our emergency first aid post—our momentary struggle for life.

After Jake Kent's near-death experience, no one remembered seeing the muskoxen again, or even what happened to them. When we finally had things under control we looked around for them but they were simply gone. As though we'd awakened from a bad dream, the two dark eyes had vanished back to wherever they had come from. Their

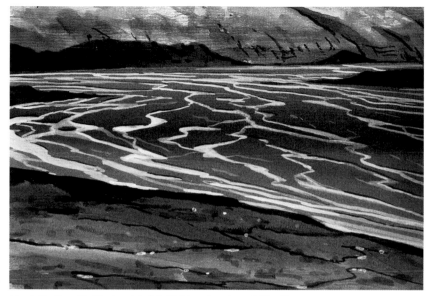

Henrietta Nesmith Glacier, July 26, 1994, watercolour, 6.5" x 9"

arrival, behaviour, and departure were like haunted spirits—intersecting timelines, the past and the present, theirs and ours.

The great warming that melted the last Ice Age lasted 6,000 years. By the time the Independence people entered the Arctic, that long period of warmth was nearing its end. In all regions of the northern hemisphere as far south as India and Egypt, civilizations began to be buffeted by dramatic cooling. The organism Gaia was rebalancing.

The temperature reversal saw a huge swath of polar life disappear from the High Arctic within a few centuries. Snow cover replaced Arctic wildflowers and new shoots of grass. Winter ice on freshwater streams and lakes refused to melt in the summer. Underground, permafrost thickened and the thin layer of active soil turned rock hard. Muskoxen, along with all other life, either relocated southward or perished.

Unable to adapt to a shifting climate, the Independence culture declined and then disappeared. Thousands of years later, their dwelling sites, their artifacts, and the animals they depended upon, like rediscovered memoirs, still tell the story: of settlement and abandonment, of the spirit of life and of our mercurial world.

BIBLIOGRAPHY

Alexander, Bryan, and Cherry Alexander. *The Inuit-Hunters of the North*. City: Boring, OR: Bramley Books, 1988.

Arima, E.Y. *Contributions to Kayak Studies*. Ottawa: Canadian Museum of Civilization, 1991.

Arima, E.Y. *Inuit Kayaks in Canada*. Ottawa: National Museums of Canada, 1987.

Berton, Pierre. *The Arctic Grail*. Toronto: McClelland & Stewart, 1988.

Bruemmer, Fred. *The Narwhal*. Toronto: Key Porter Books, 1993.

Coulston, Pamela, and Mike Beedell. Kayak Nunavut '99 Arctic Expedition. *Ottawa Citizen, Montreal Gazette, Edmonton Journal, Calgary Herald*. July 11, 18, 25, Aug. 1, 8, 15, 22, 29, Sept. 5, 12, 1999.

Dyer, Geoff. *Jeff in Venice, Death in Varanasi*. New York: Vintage/Random, 2009.

Eber Harley, Dorothy. *When the Whalers Were Up North: Inuit Memories from the Eastern Arctic*. Montreal: McGill-Queen's University Press, 1989.

Eck, Diana. *Banaras*. New York: Columbia University Press, 1999.

Folkes, Patrick. *Shipwrecks of the Saugeen 1828–1938*. Willowdale, ON: Patrick Folkes, 1970.

Francis, Daniel. *Discovery of the North*. Edmonton: Hurtig, 1986.

Godwin, Sara. *Seals*. New York: Mallard Press, 1990.

Harper, Kenn. *Give Me My Father's Body: The Life of Minik, the New York Eskimo*. Iqaluit: Blackhead Books, 1996.

Houston, James A. *Spirit Wrestler*. Toronto: McClelland & Stewart, 1980.

Hunter, Douglas. *God's Mercies: Rivalry, Betrayal, and the Dream of Discovery*. New York: Doubleday, 2007.

Huntford, Roland. *Nansen*. London: Duckworth & Co., 1997.

Ihssen, P.E., M. Casselman, G.W. Martin, and R.B. Phillips. "Biochemical Genetic Differentiation of Lake Trout (Salvelinus namaycush) Stocks of the Great Lake Region." *Canadian Journal of Fishers and Aquatic Sciences* 45, no. 6 (1988): 1018–29.

King, Paul, and Raymond de Coccola. *Ayorama*. New York: Oxford University Press, 1955.

Kwiatkowski, P.E. *Naki'i Pohaku (Hawaiian Petroglyph Primer)*. Honolulu: Ku pa 'a Incorporated, 1991.

Lovelock, James. *The Vanishing Face of Gaia*. London: Allen Lane, 2009.

Lowenstien, Tom. *Ancient Land: Sacred Whale The Inuit Hunt and Its Rituals*. New York: Farrar, Straus and Giroux, 1994.

MacLean, Harrison John. *The Fate of the Griffon*. Toronto: Griffin Press, 1974.

Mary-Rousselière, Guy. Qitdlarssuaq: *The Story of a Polar Migration*. Winnipeg: Wuerz Publishing, 1991.

McAleese, Kevin E. *Full Circle: First Contact*. Newfoundland Museum, 2000.

McCrohan, D. Singh, S. *India*. London: Lonely Planet, 2010

McGhee, Robert. *Ancient People of the Arctic*. Vancouver: University of British Columbia Press, 1996.

Michener, James. *Hawaii*. New York: Random House, 1959.

Millman, Lawrence. *A Kayak Full of Ghosts*. Santa Barbara, CA: Capra Press, 1987.

Morrison, David. *Arctic Hunters*. Ottawa: Canadian Museum of Civilization, 1992.

Morrison, David, and Georges-Hébert Germain. *Inuit: Glimpses of an Arctic Past*. Ottawa: Canadian Museum of Civilization, 1995.

Mowat, Farley. *Westviking*. Toronto: McClelland & Stewart, 1990.

Nooter, Gert. *Leadership and Headship: Changing Authority Patterns in an East Greenland Hunting Community*. Leiden: E.J. Brill, 1976.

Okihiro, Gary Y. *Island World*. California World History Library. Berkeley: University of California Press, 2009.

Petersen, H.C. *Instruction in Kayak Building*. Greenland Provincial Museum and Viking Ship Museum. Roskilde, Denmark, 1992.

Peterson, H.C., and Hans Ebbesen. *Skinboats of Greenland*. Copenhagen: Arktisk Institute, 1987.

Petersen, H.C. *Skinboats of Greenland*, Vol. 1. Roskilde, Denmark, 1986.

Pielou, E.C. *A Naturalist's Guide to the Arctic*. Chicago: University of Chicago Press, 1994.

Sage, Byran. *The Arctic & Its Wildlife*. New York: Facts on File, 1986.

Schledermann, Peter. *Crossroads to Greenland*. Calgary: Arctic Institute of North America, 1990.

Schledermann, Peter. *Voices in Stone*. Calgary: Arctic Institute of North America, 1996.

Silis, Ivars. *Frozen Horizons: The World's Largest National Park*. Trans. Tim Davies. Nuuk, Greenland: Atuakkiorfik, 1995.

Simon, Alvah. *North to the Night*. City: New York: Broadway Books/Bantam, 1998.

Smutylo, Allen. *Wild Places Wild Hearts: Nomads of the Himalaya*. Owen Sound, ON: Tom Thomson Art Gallery, 2007.

Swain, Harry, and J.K. Stager. *Canada North: Journey to the High Arctic*. Piscataway, NJ: Rutgers University Press.

York, Geoffrey. "How Chrétien's Creatures Tamed Siberia's Tundra." *Globe and Mail*, June 2001.

LIFE WRITING SERIES

In the **Life Writing** Series, Wilfrid Laurier University Press publishes life writing and new life-writing criticism and theory in order to promote auto-biographical accounts, diaries, letters, and testimonials written and/or told by women and men whose political, literary, or philosophical purposes are central to their lives. The Series features accounts written in English, or translated into English from French or the languages of the First Nations, or any of the languages of immigration to Canada.

From its inception, **Life Writing** has aimed to foreground the stories of those who may never have imagined themselves as writers or as people with lives worthy of being (re)told. Its readership has expanded to include scholars, youth, and avid general readers both in Canada and abroad. The Series hopes to continue its work as a leading publisher of life writing of all kinds, as an imprint that aims for both broad representation and scholarly excellence, and as a tool for both historical and autobiographical research.

As its mandate stipulates, the Series privileges those individuals and communities whose stories may not, under normal circumstances, find a welcoming home with a publisher. Life Writing also publishes original theoretical investigations about life writing, as long as they are not limited to one author or text.

Series Editor
Marlene Kadar
Humanities Division, York University

Manuscripts to be sent to
Lisa Quinn, Acquisitions Editor
Wilfrid Laurier University Press
75 University Avenue West
Waterloo, Ontario N2L 3C5, Canada

Books in the Life Writing Series
Published by Wilfrid Laurier University Press

Haven't Any News: Ruby's Letters from the Fifties edited by Edna Staebler with an Afterword by Marlene Kadar • 1995 / x + 165 pp. / ISBN 0-88920-248-6

"I Want to Join Your Club": Letters from Rural Children, 1900–1920 edited by Norah L. Lewis with a Preface by Neil Sutherland • 1996 / xii + 250 pp. (30 b&w photos) / ISBN 0-88920-260-5

And Peace Never Came by Elisabeth M. Raab with Historical Notes by Marlene Kadar • 1996 / x + 196 pp. (12 b&w photos, map) / ISBN 0-88920-281-8

Dear Editor and Friends: Letters from Rural Women of the North-West, 1900–1920 edited by Norah L. Lewis • 1998 / xvi + 166 pp. (20 b&w photos) / ISBN 0-88920-287-7

The Surprise of My Life: An Autobiography by Claire Drainie Taylor with a Foreword by Marlene Kadar • 1998 / xii + 268 pp. (8 colour photos and 92 b&w photos) / ISBN 0-88920-302-4

Memoirs from Away: A New Found Land Girlhood by Helen M. Buss / Margaret Clarke • 1998 / xvi + 153 pp. / ISBN 0-88920-350-4

The Life and Letters of Annie Leake Tuttle: Working for the Best by Marilyn Färdig Whiteley • 1999 / xviii + 150 pp. / ISBN 0-88920-330-x

Marian Engel's Notebooks: "Ah, mon cahier, écoute" edited by Christl Verduyn • 1999 / viii + 576 pp. / ISBN 0-88920-333-4 cloth / ISBN 0-88920-349-0 paper

Be Good Sweet Maid: The Trials of Dorothy Joudrie by Audrey Andrews • 1999 / vi + 276 pp. / ISBN 0-88920-334-2

Working in Women's Archives: Researching Women's Private Literature and Archival Documents edited by Helen M. Buss and Marlene Kadar • 2001 / vi + 120 pp. / ISBN 0-88920-341-5

Repossessing the World: Reading Memoirs by Contemporary Women by Helen M. Buss • 2002 / xxvi + 206 pp. / ISBN 0-88920-408-x cloth / ISBN 0-88920-410-1 paper

Chasing the Comet: A Scottish-Canadian Life by Patricia Koretchuk • 2002 / xx + 244 pp. / ISBN 0-88920-407-1

The Queen of Peace Room by Magie Dominic • 2002 / xii + 115 pp. / ISBN 0-88920-417-9

China Diary: The Life of Mary Austin Endicott by Shirley Jane Endicott • 2002 / xvi + 251 pp. / ISBN 0-88920-412-8

The Curtain: Witness and Memory in Wartime Holland by Henry G. Schogt • 2003 / xii + 132 pp. / ISBN 0-88920-396-2

Teaching Places by Audrey J. Whitson • 2003 / xiii + 178 pp. / ISBN 0-88920-425-x

Through the Hitler Line by Laurence F. Wilmot, M.C. • 2003 / xvi + 152 pp. / ISBN 0-88920-448-9

Where I Come From by Vijay Agnew • 2003 / xiv + 298 pp. / ISBN 0-88920-414-4

The Water Lily Pond by Han Z. Li • 2004 / x + 254 pp. / ISBN 0-88920-431-4

The Life Writings of Mary Baker McQuesten: Victorian Matriarch edited by Mary J. Anderson • 2004 / xxii + 338 pp. / ISBN 0-88920-437-3

Seven Eggs Today: The Diaries of Mary Armstrong, 1859 and 1869 edited by Jackson W. Armstrong • 2004 / xvi + 228 pp. / ISBN 0-88920-440-3

Love and War in London: A Woman's Diary 1939–1942 by Olivia Cockett, edited by Robert W. Malcolmson • 2005 / xvi + 208 pp. / ISBN 0-88920-458-6

Incorrigible by Velma Demerson • 2004 / vi + 178 pp. / ISBN 0-88920-444-6

Auto/biography in Canada: Critical Directions edited by Julie Rak • 2005 / viii + 264 pp. / ISBN 0-88920-478-0

Tracing the Autobiographical edited by Marlene Kadar, Linda Warley, Jeanne Perreault, and Susanna Egan • 2005 / viii + 280 pp. / ISBN 0-88920-476-4

Must Write: Edna Staebler's Diaries edited by Christl Verduyn • 2005 / viii + 304 pp. / ISBN 0-88920-481-0

Pursuing Giraffe: A 1950s Adventure by Anne Innis Dagg • 2006 / xvi + 284 pp. (photos, 2 maps) / 978-0-88920-463-8

Food That Really Schmecks by Edna Staebler • 2007 / xxiv + 334 pp. / ISBN 978-0-88920-521-5

163256: A Memoir of Resistance by Michael Englishman • 2007 / xvi + 112 pp. (14 b&w photos) / ISBN 978-1-55458-009-5

The Wartime Letters of Leslie and Cecil Frost, 1915–1919 edited by R.B. Fleming • 2007 / xxxvi + 384 pp. (49 b&w photos, 5 maps) / ISBN 978-1-55458-000-2

Johanna Krause Twice Persecuted: Surviving in Nazi Germany and Communist East Germany by Carolyn Gammon and Christiane Hemker • 2007 / x + 170 pp. (58 b&w photos, 2 maps) / ISBN 978-1-55458-006-4

Watermelon Syrup: A Novel by Annie Jacobsen with Jane Finlay-Young and Di Brandt • 2007 / x + 268 pp. / ISBN 978-1-55458-005-7

Broad Is the Way: Stories from Mayerthorpe by Margaret Norquay • 2008 / x + 106 pp. (6 b&w photos) / ISBN 978-1-55458-020-0

Becoming My Mother's Daughter: A Story of Survival and Renewal by Erika Gottlieb • 2008 / x + 178 pp. (36 b&w illus., 17 colour) / ISBN 978-1-55458-030-9

Leaving Fundamentalism: Personal Stories edited by G. Elijah Dann • 2008 / xii + 234 pp. / ISBN 978-1-55458-026-2

Bearing Witness: Living with Ovarian Cancer edited by Kathryn Carter and Lauri Elit • 2009 / viii + 94 pp. / ISBN 978-1-55458-055-2

Dead Woman Pickney: A Memoir of Childhood in Jamaica by Yvonne Shorter Brown • 2010 / viii + 202 pp. / ISBN 978-1-55458-189-4

I Have a Story to Tell You by Seemah C. Berson • 2010 / xx + 288 pp. (24 b&w photos) / ISBN 978-1-55458-219-8

We All Giggled: A Bourgeois Family Memoir by Thomas O. Hueglin • 2010 / xiv + 232 pp. (20 b&w photos) / ISBN 978-1-55458-262-4

Just a Larger Family: Letters of Marie Williamson from the Canadian Home Front, 1940–1944 edited by Mary F. Williamson and Tom Sharp • 2011 / xxiv + 378 pp. (16 b&w photos) / ISBN 978-1-55458-323-2

Burdens of Proof: Faith, Doubt, and Identity in Autobiography by Susanna Egan • 2011 / x + 200 pp. / ISBN 978-1-55458-333-1

Accident of Fate: A Personal Account 1938–1945 by Imre Rochlitz with Joseph Rochlitz • 2011 / xiv + 226 pp. (50 b&w photos, 5 maps) / ISBN 978-1-55458-267-9

The Green Sofa by Natascha Würzbach, translated by Raleigh Whitinger • 2012 / xiv + 240 pp. (5 b&w photos) / ISBN 978-1-55458-334-8

Unheard Of: Memoirs of a Canadian Composer by John Beckwith • 2012 / x + 393 pp. (74 illus., 8 musical examples) / ISBN 978-1-55458-358-4

Borrowed Tongues: Life Writing, Migration, and Translation by Eva C. Karpinski • 2012 / viii + 274 pp. / ISBN 978-1-55458-357-7

Basements and Attics, Closets and Cyberspace: Explorations in Canadian Women's Archives edited by Linda M. Morra and Jessica Schagerl • September 2012 / x + 338 pp./ ISBN 978-1-55458-632-5

The Memory of Water by Allen Smutylo • January 2013 / x + 262 pp. (50 colour illus.) / ISBN 978-1-55458-842-8

The Unwritten Diary of Israel Unger by Carolyn Gammon and Israel Unger •
forthcoming 2013 / 226 pp. (b&w illus.) / ISBN 978-1-55458-831-2

Not the Whole Story: Challenging the Single Mother Narrative edited by Lea
Caragata and Judit Alcalde • forthcoming 2013 / 176 pp. / ISBN
978-1-55458-624-0